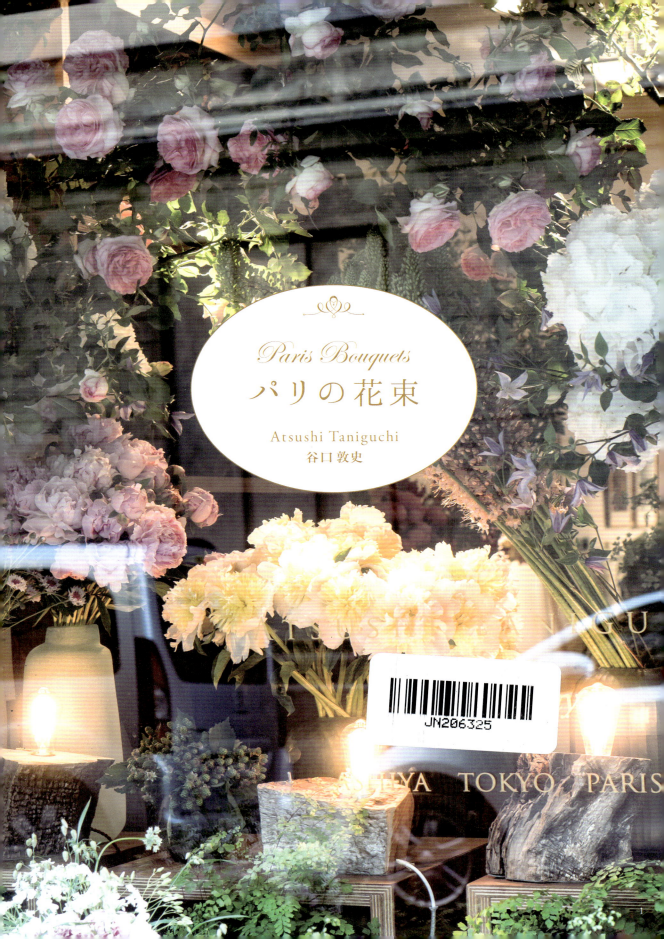

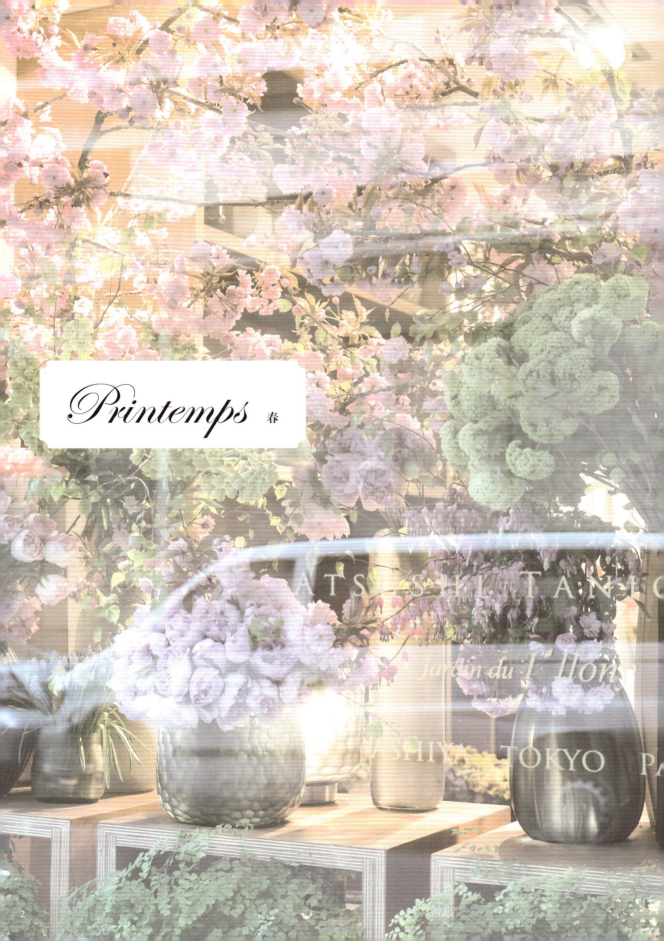

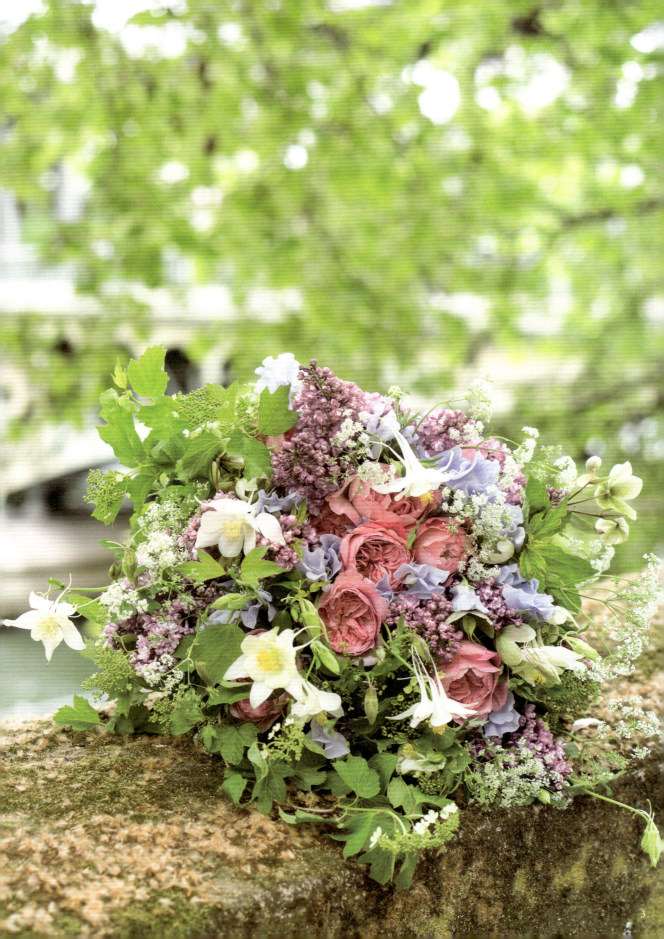

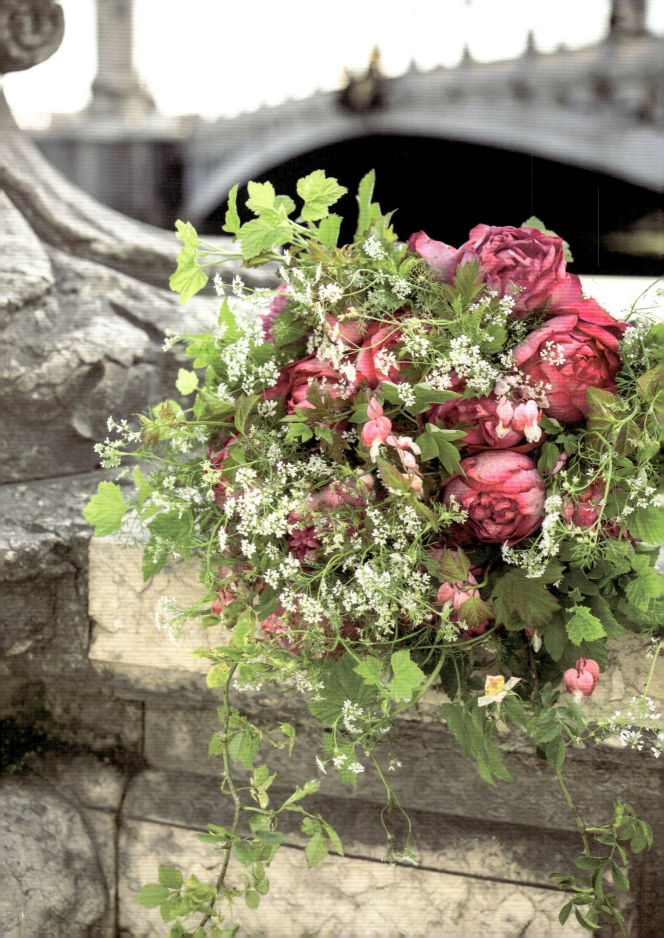

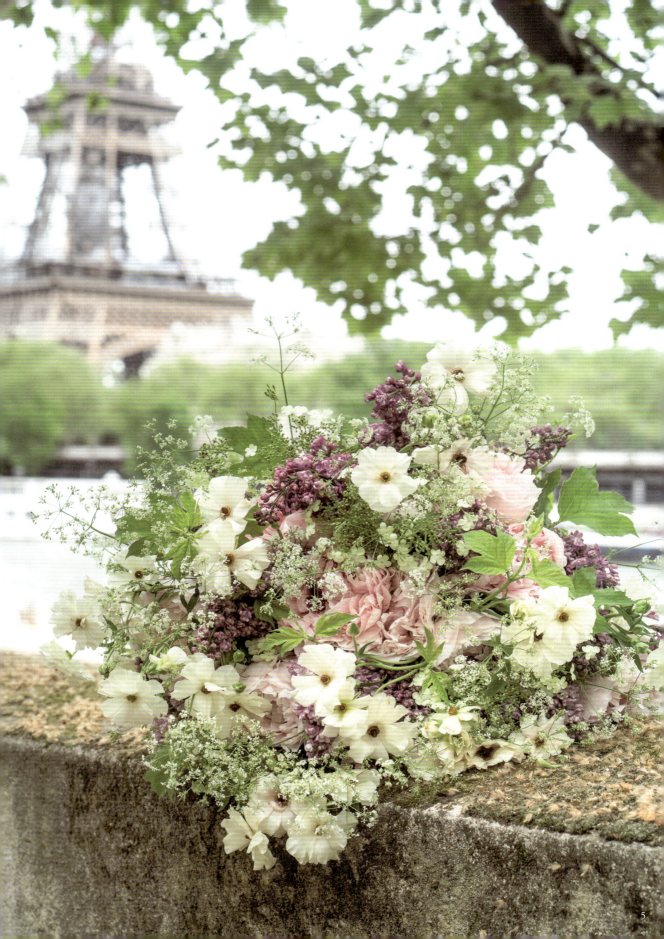

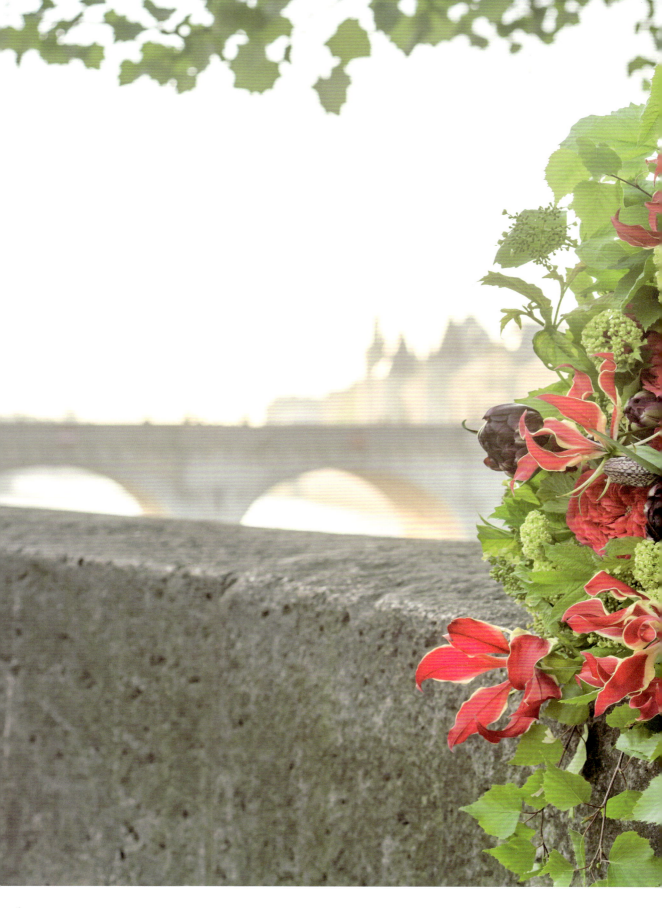

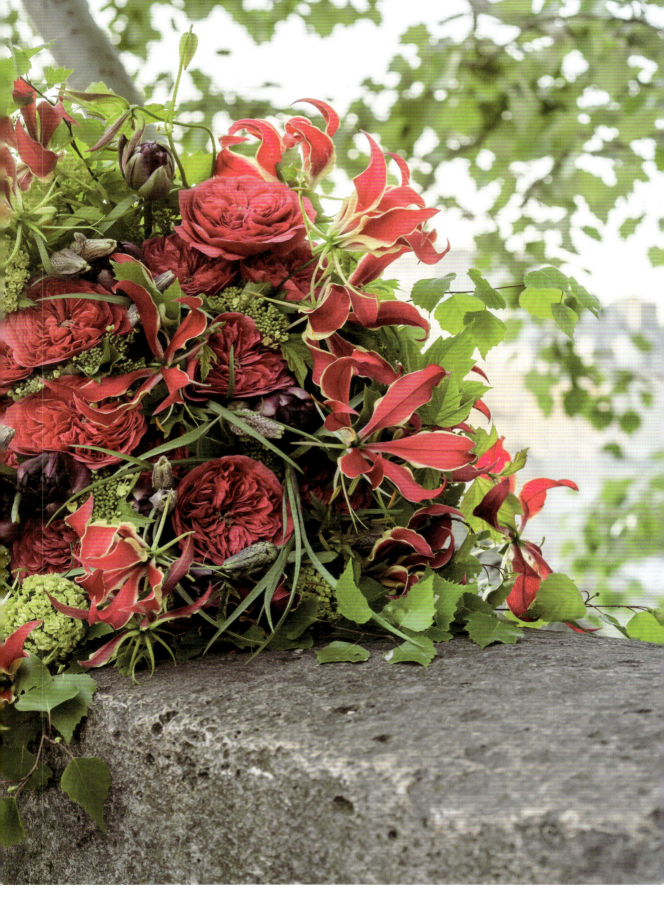

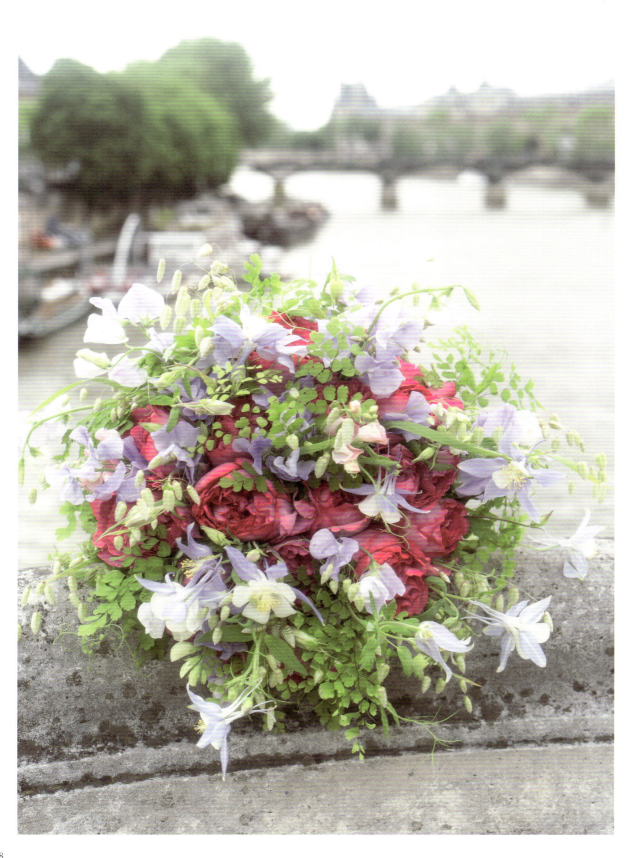

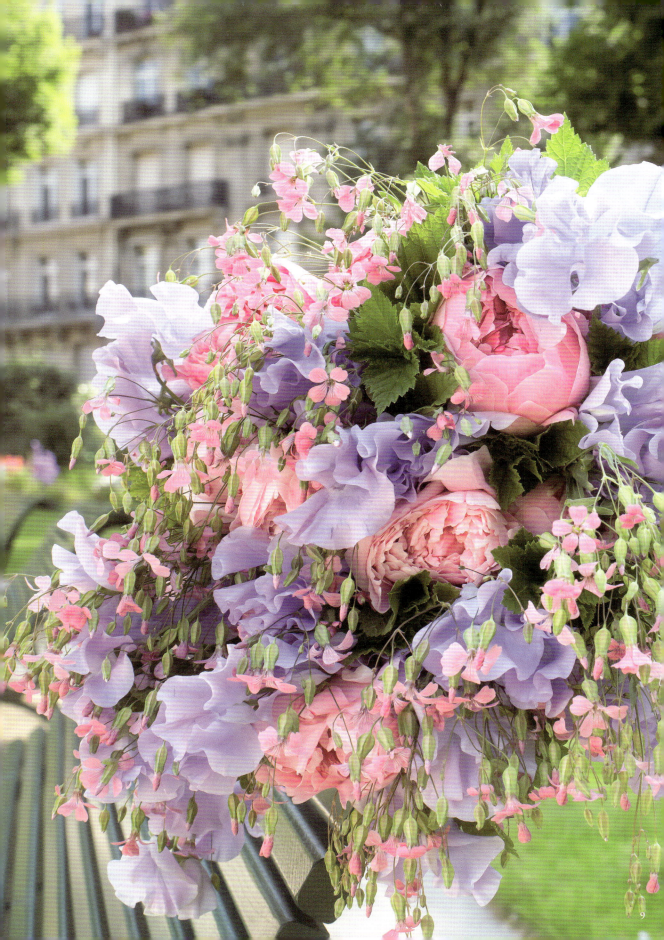

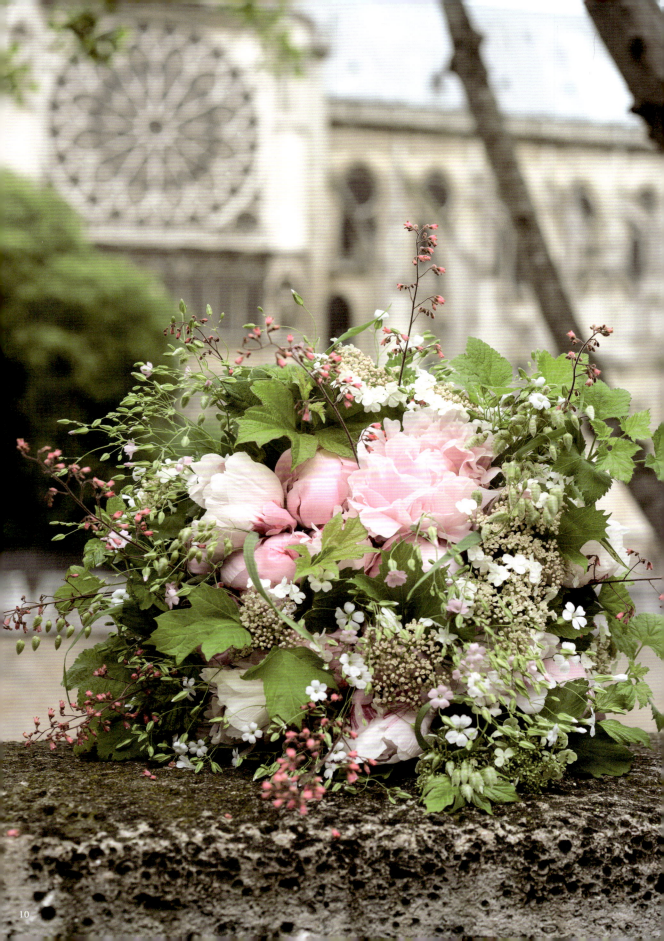

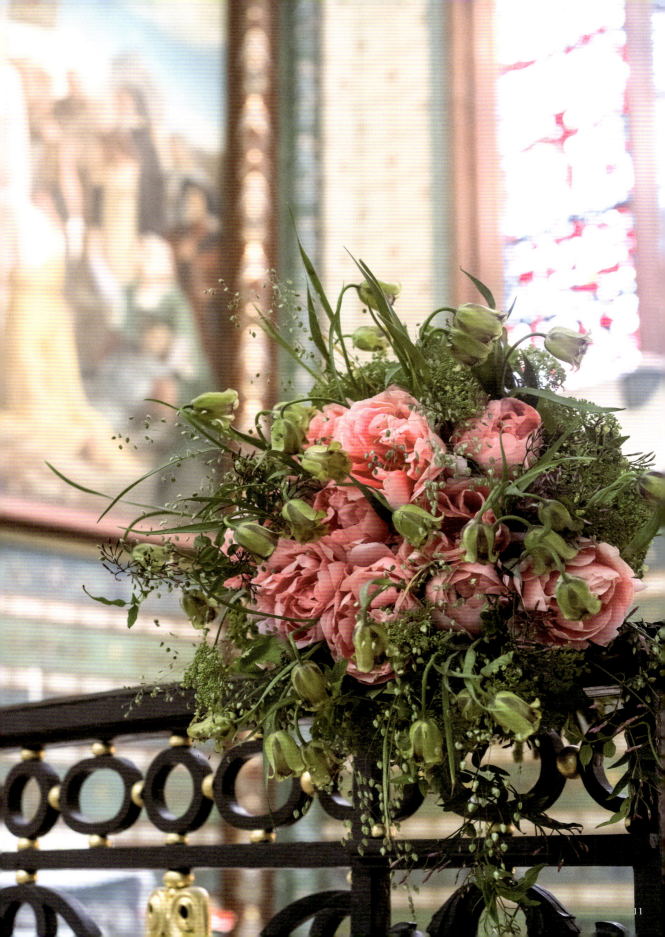

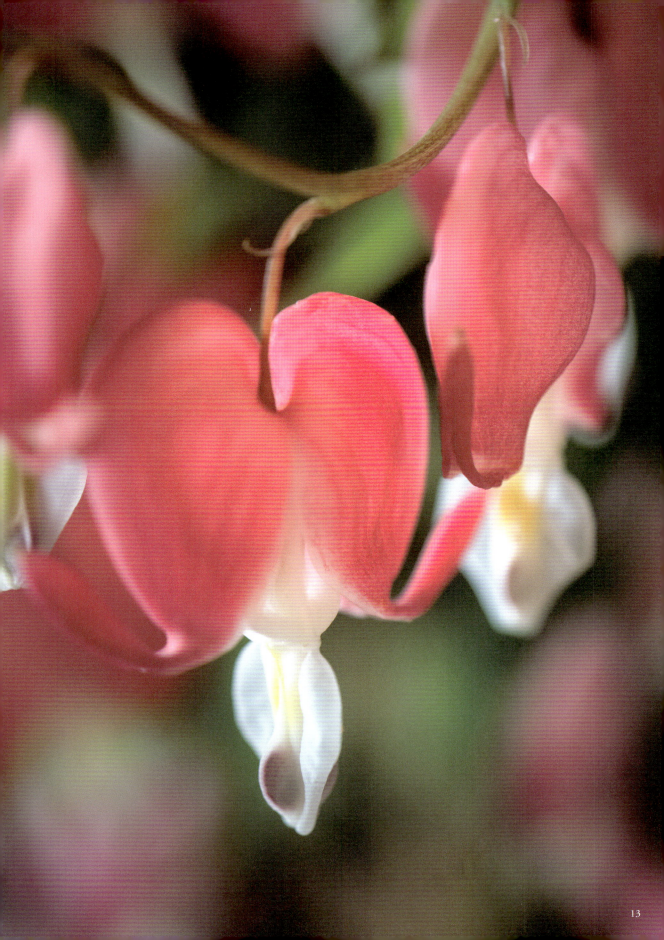

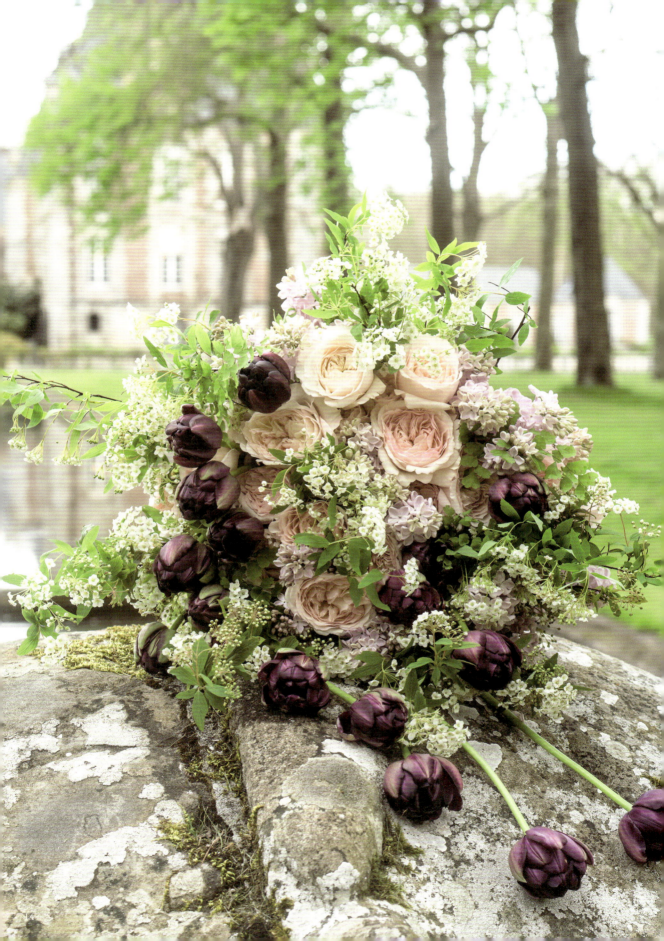

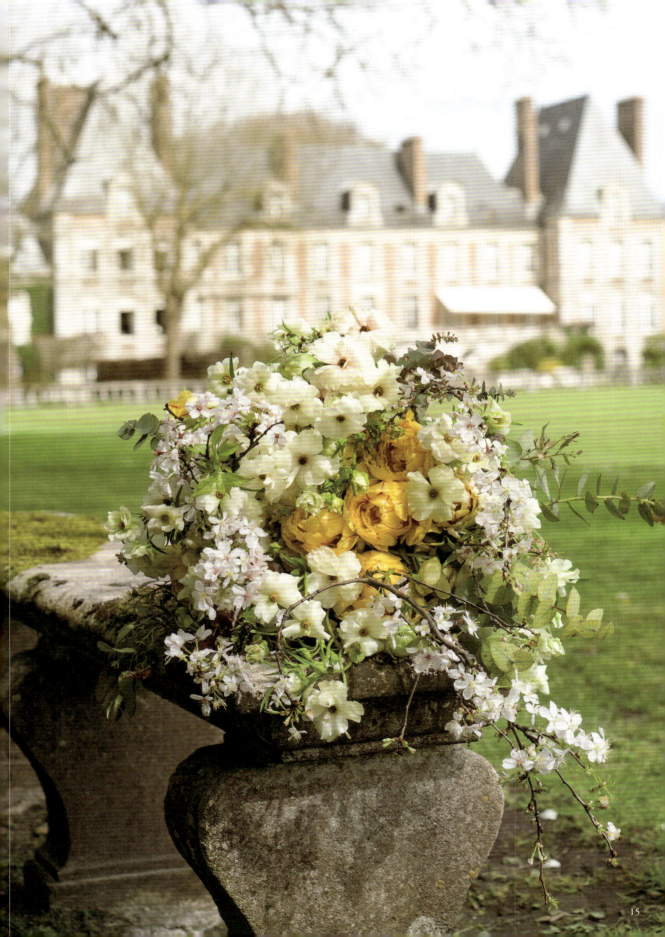

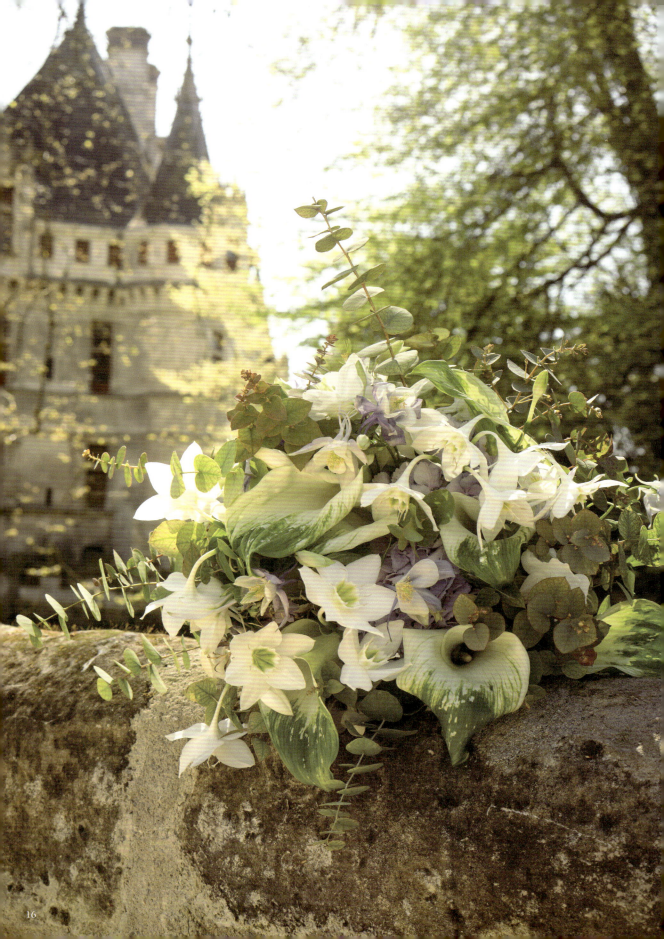

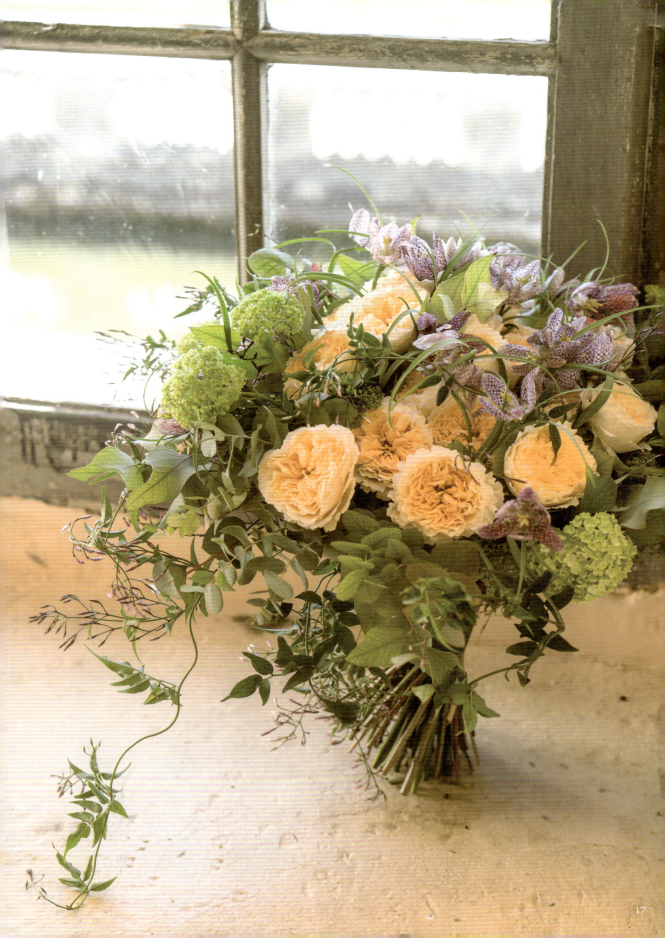

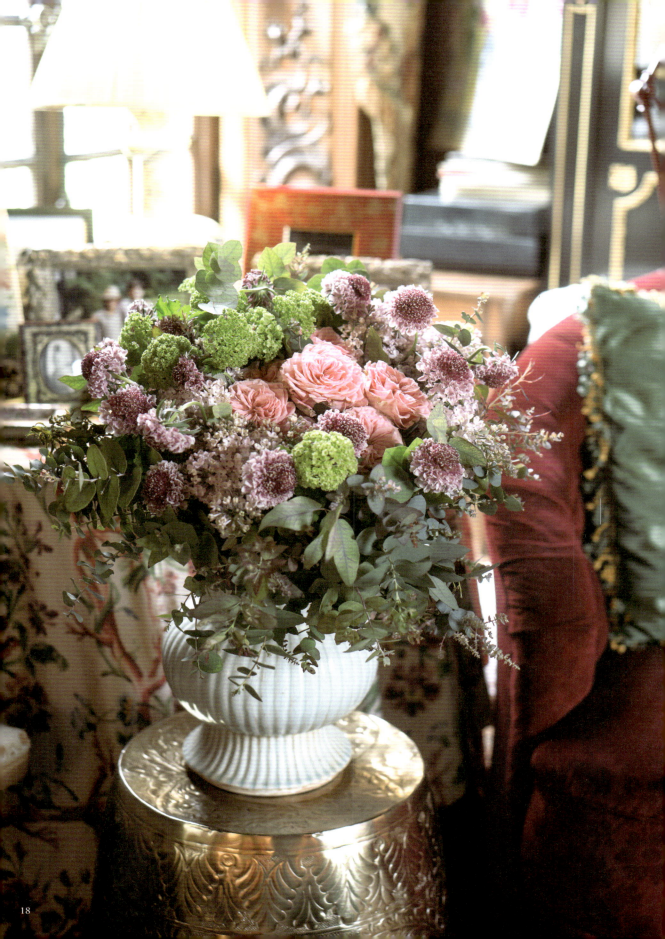

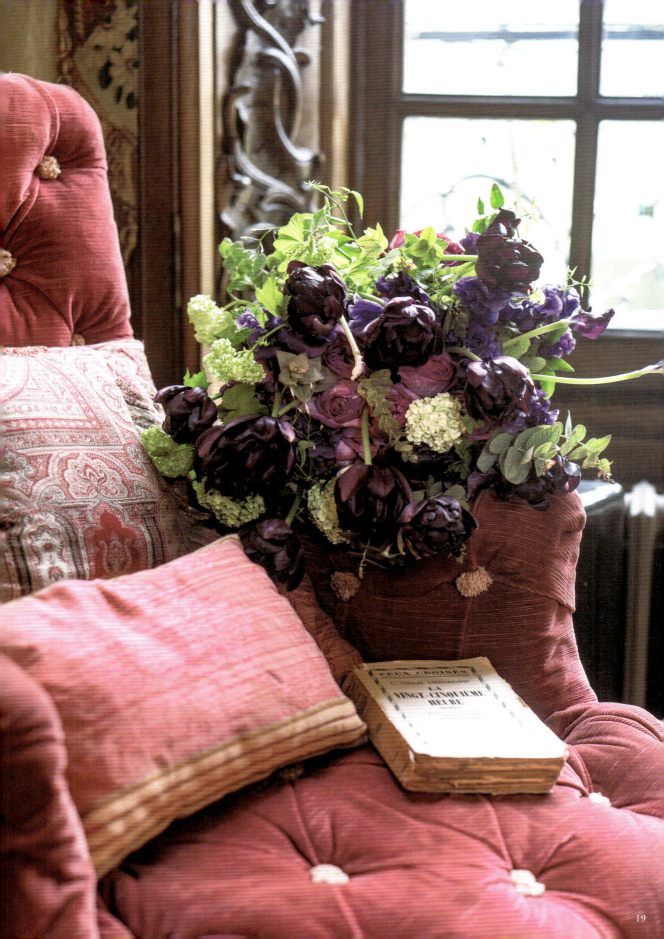

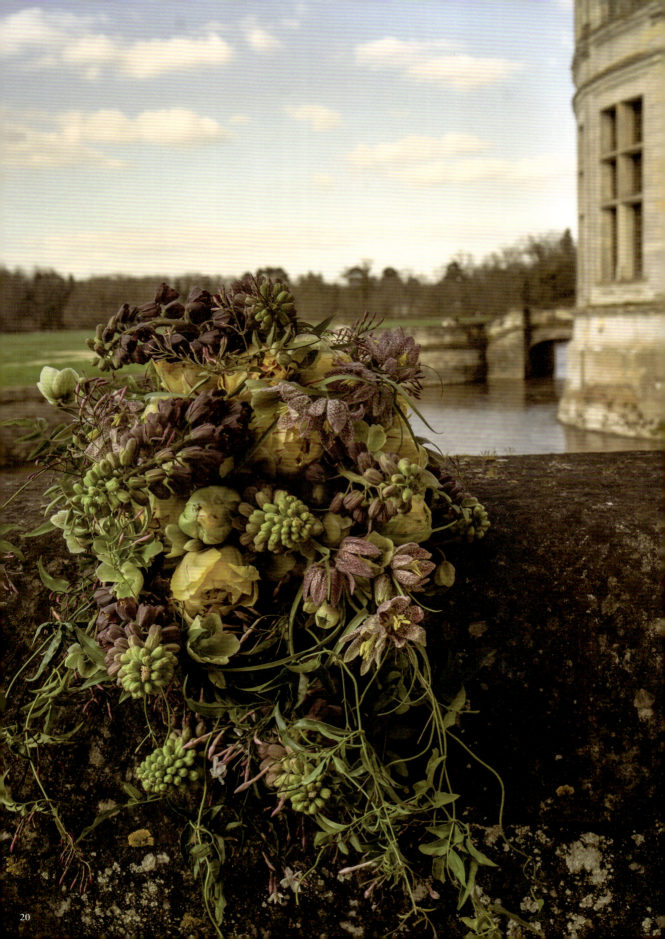

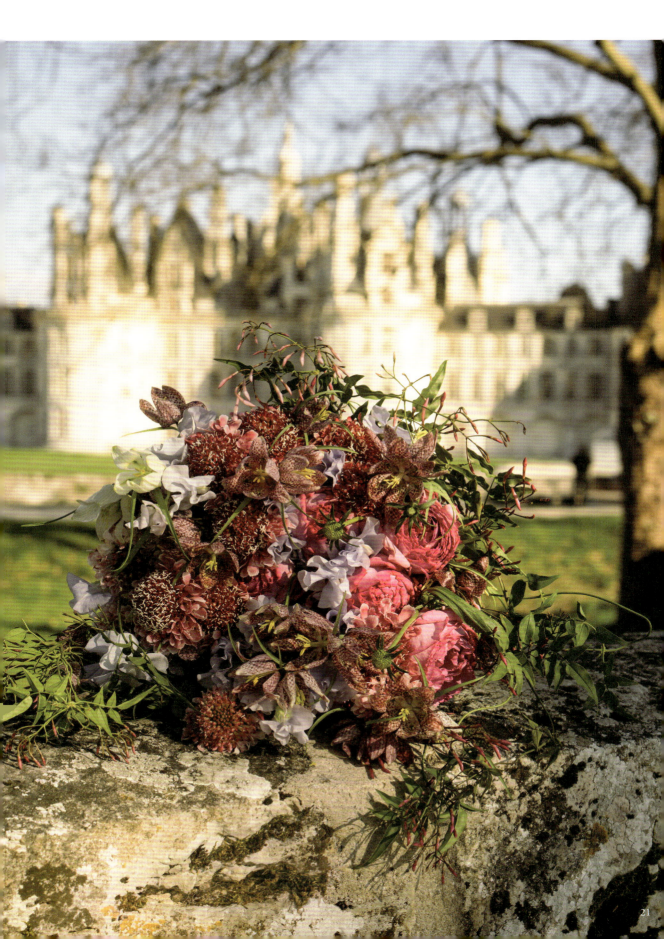

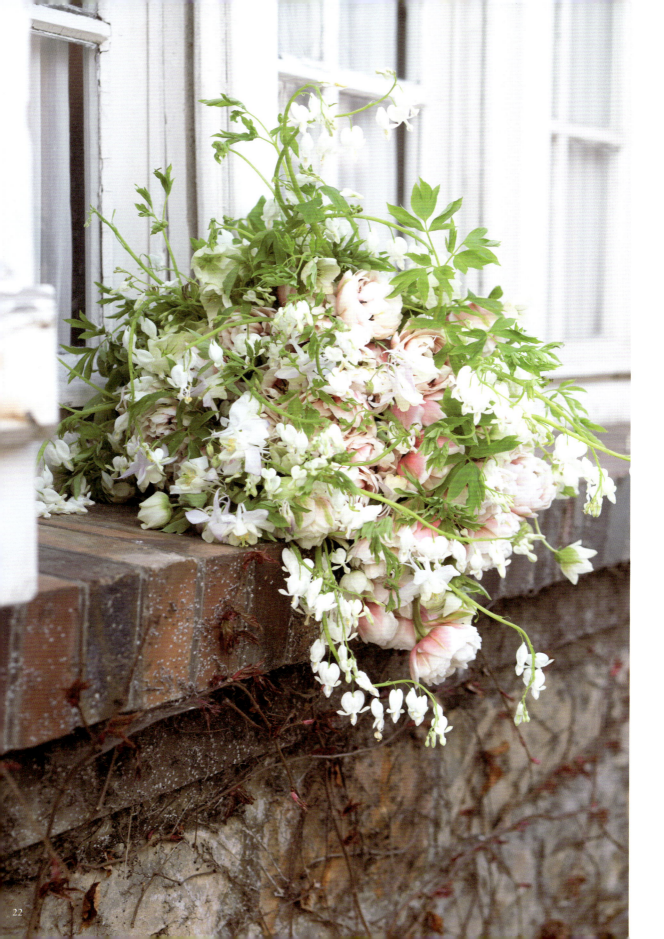

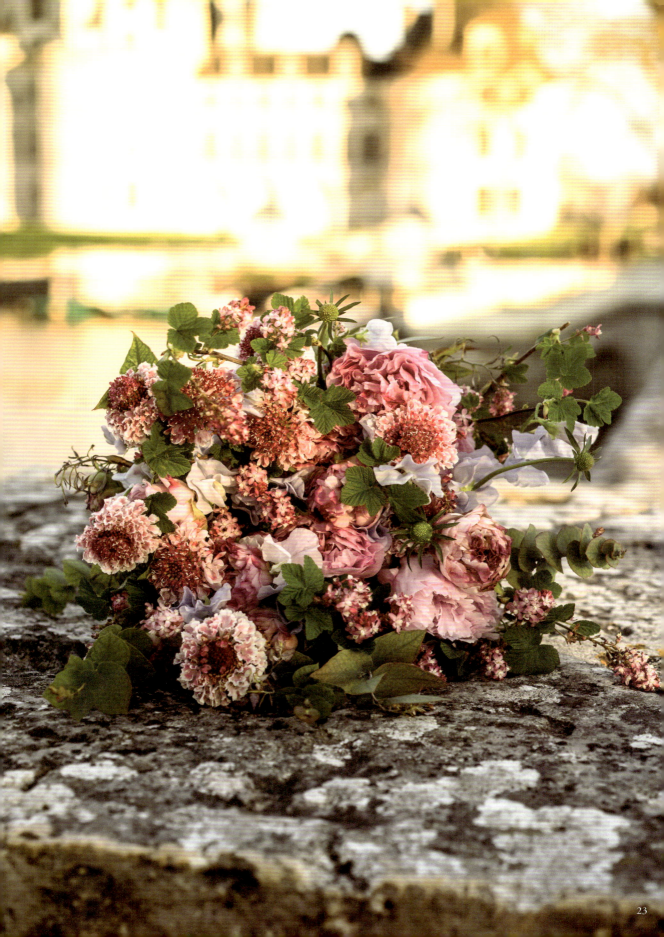

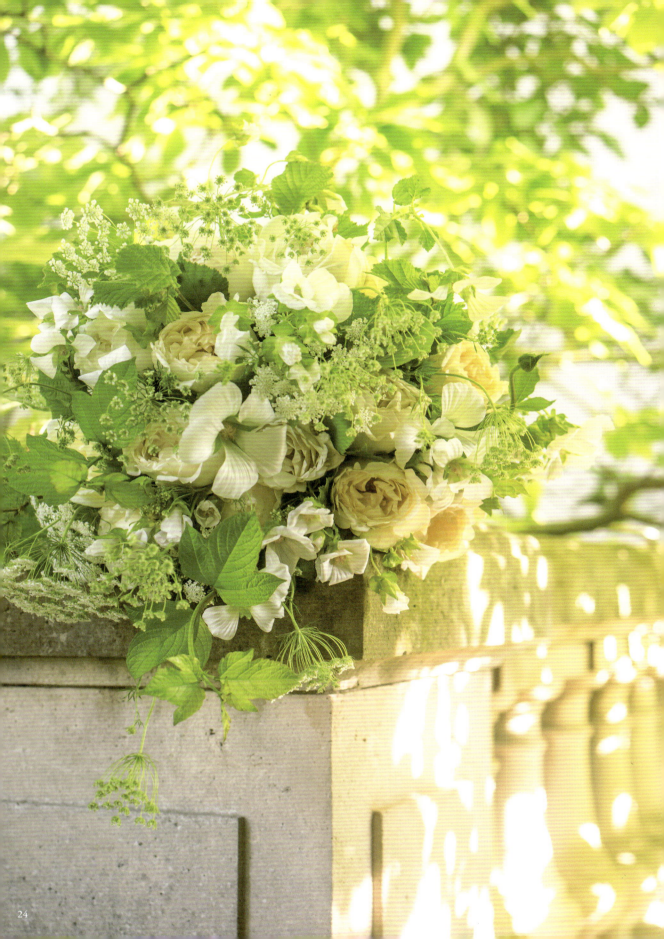

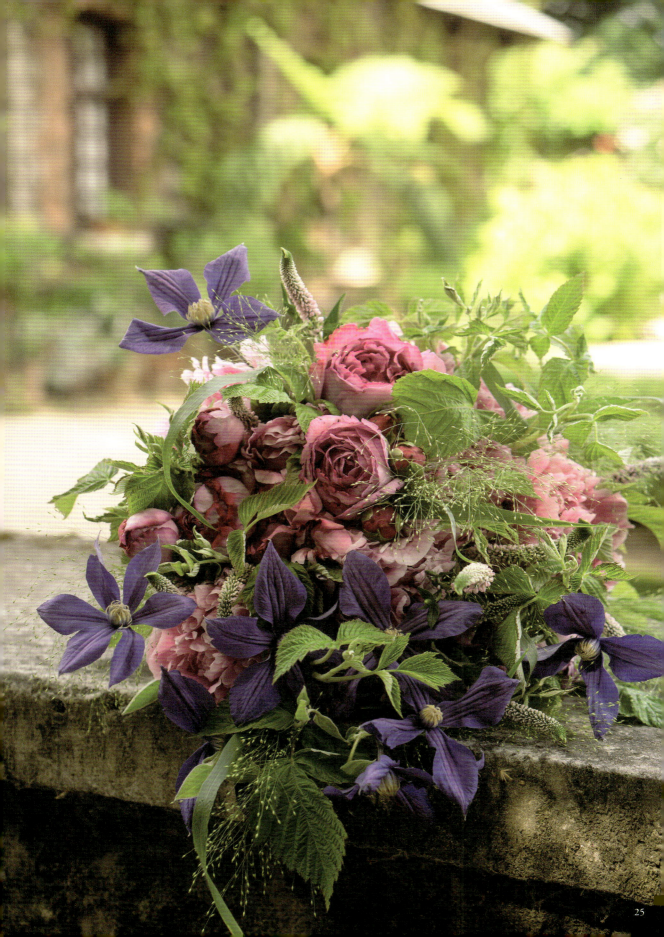

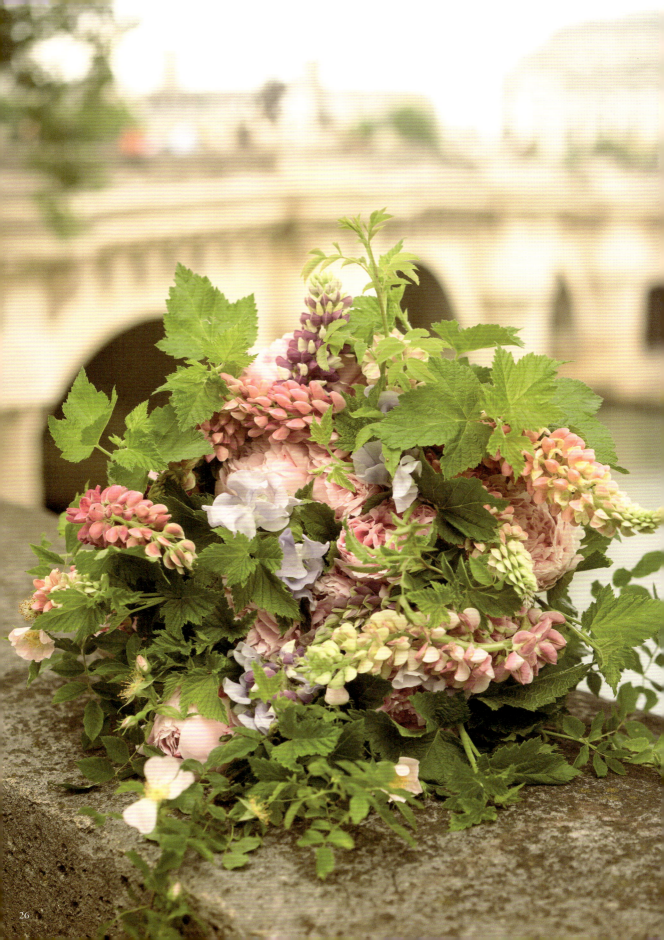

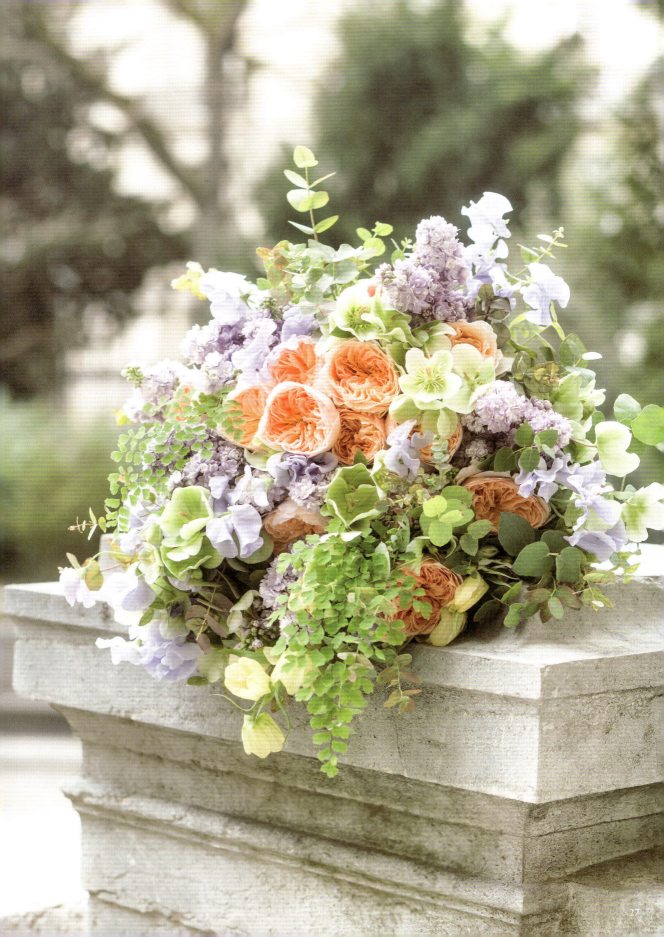

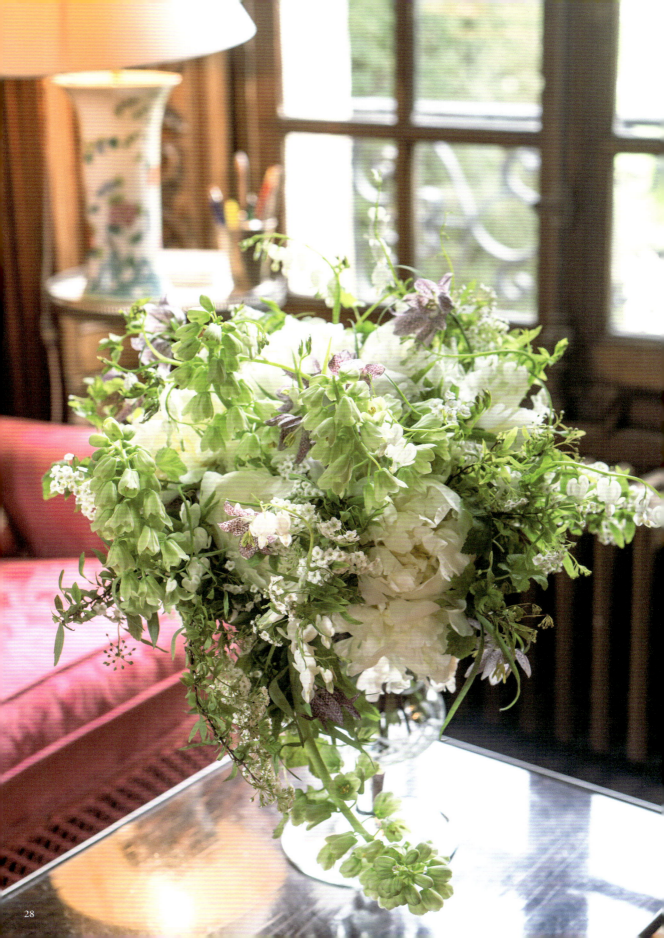

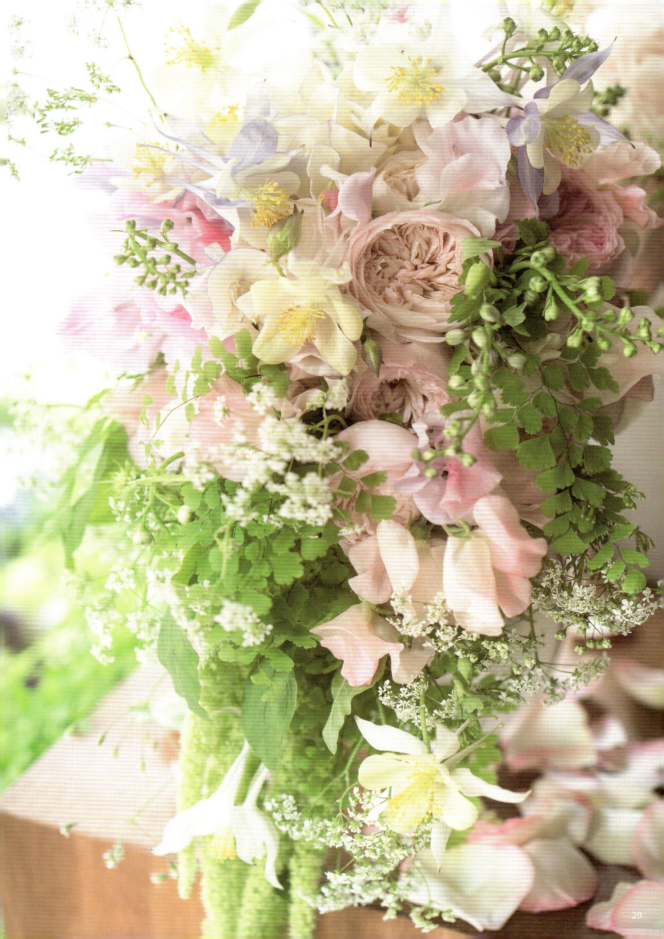

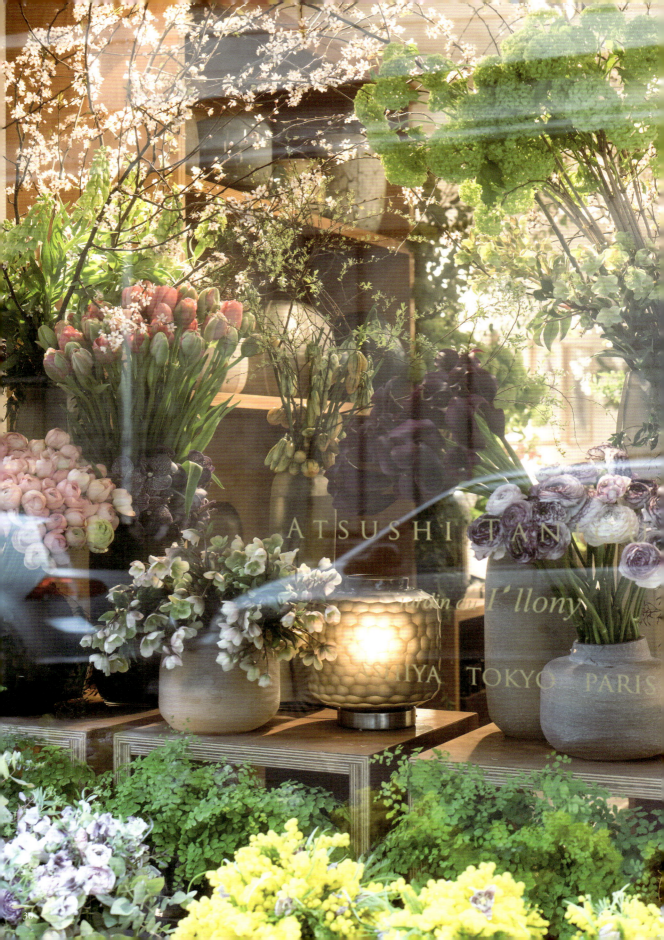

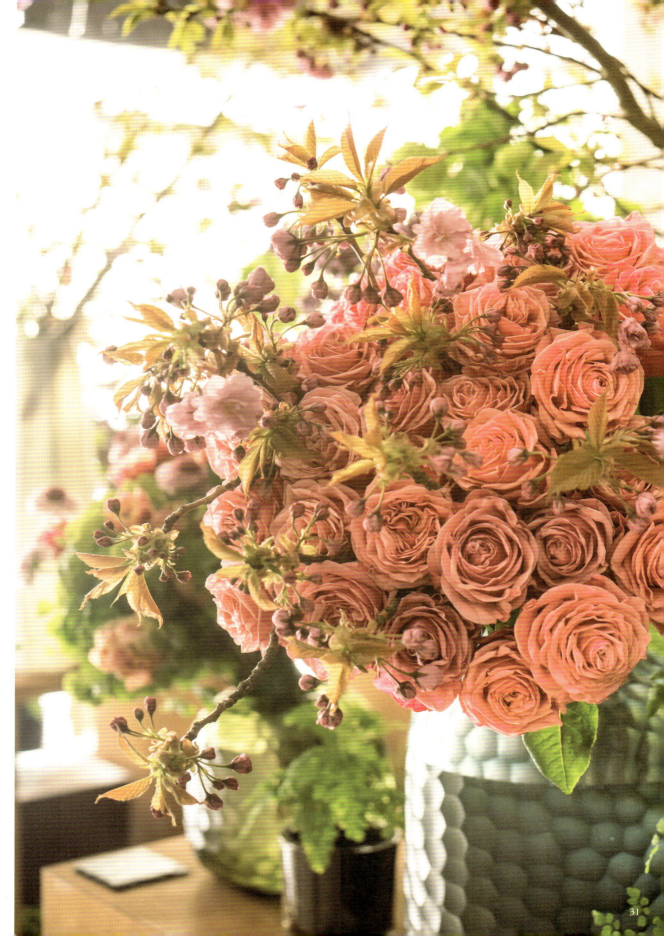

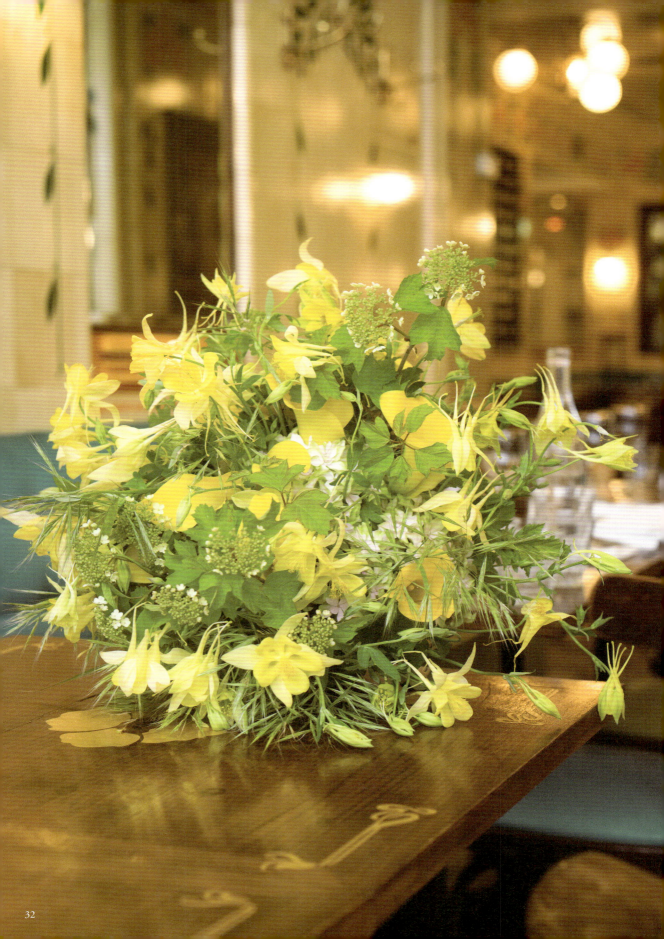

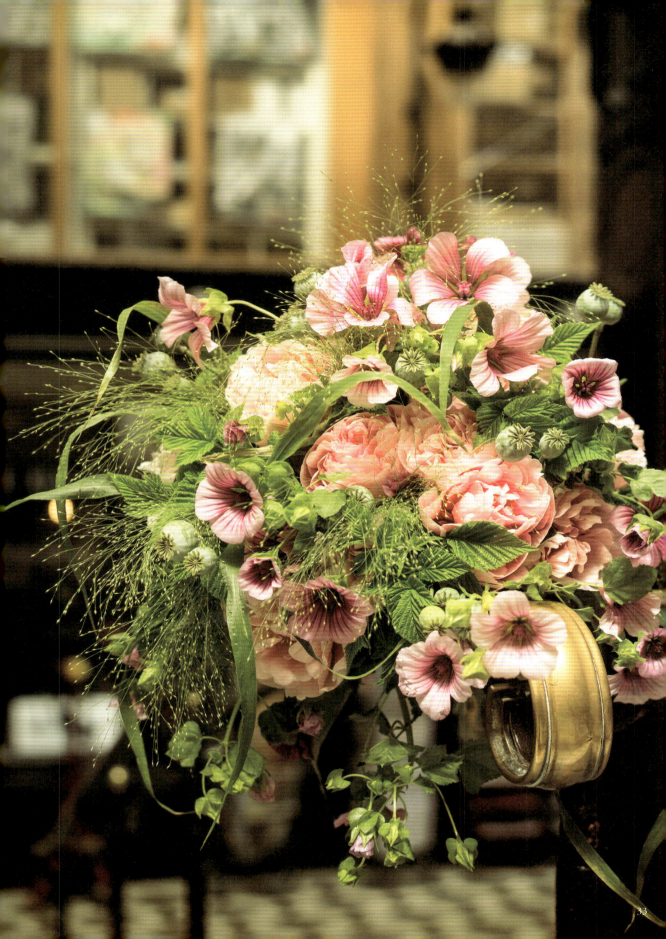

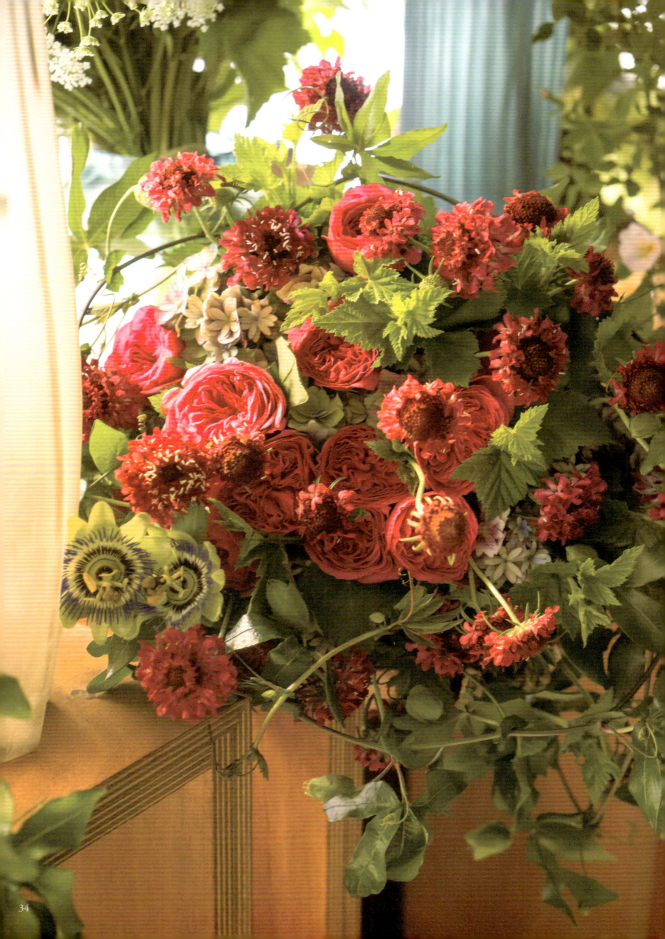

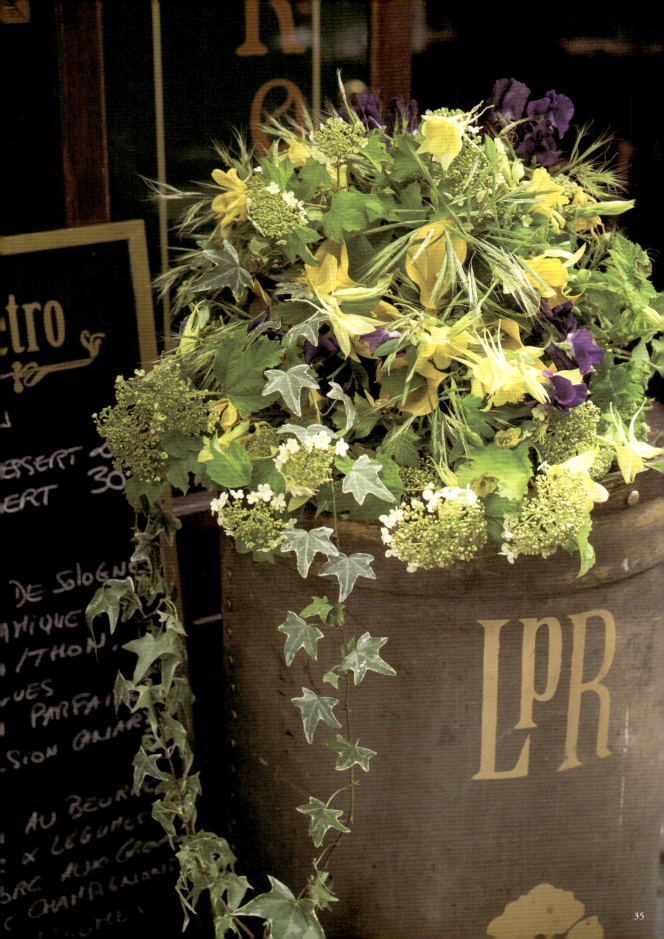

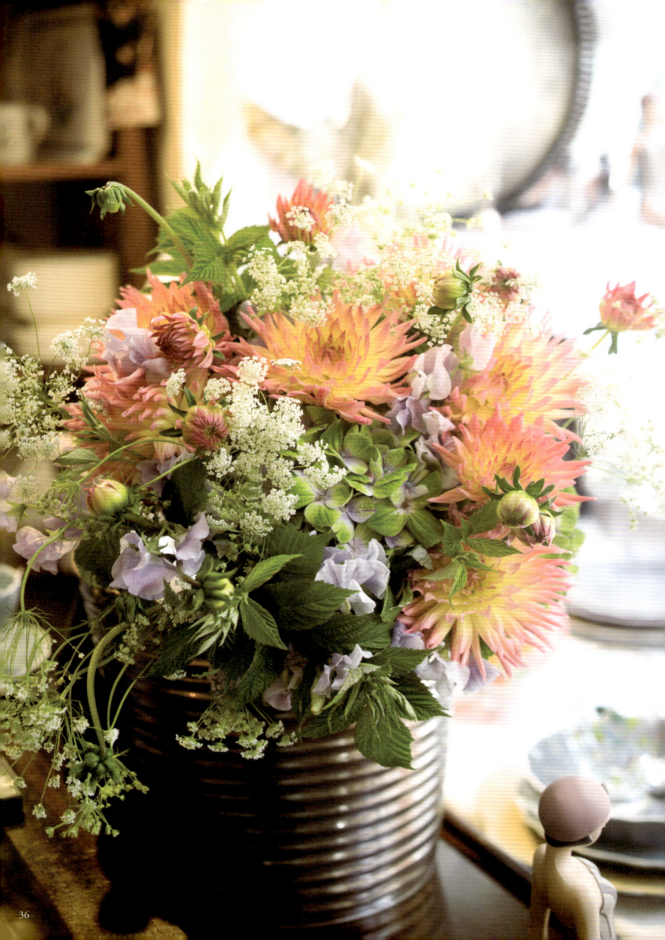

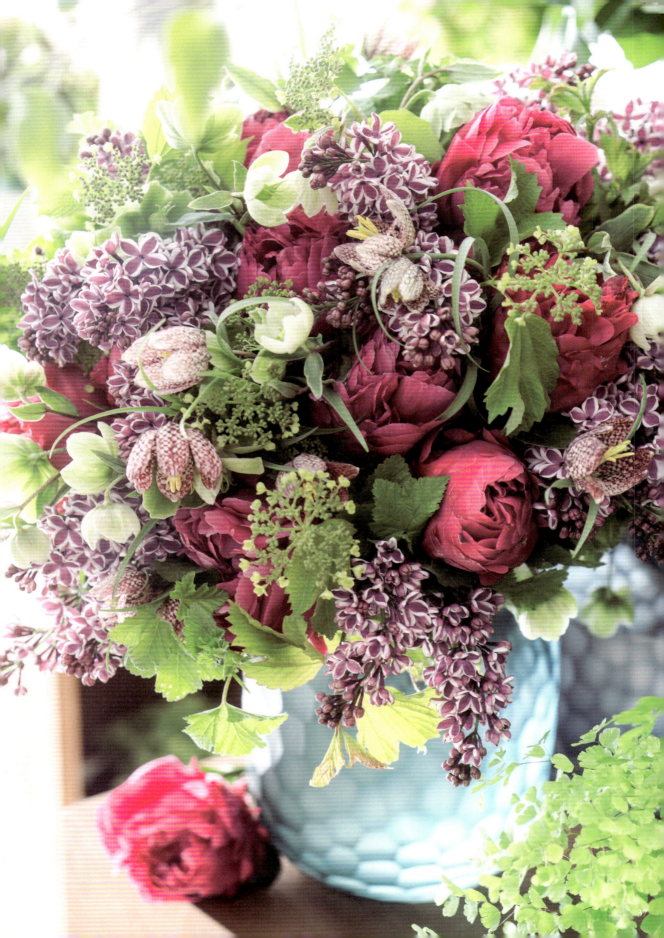

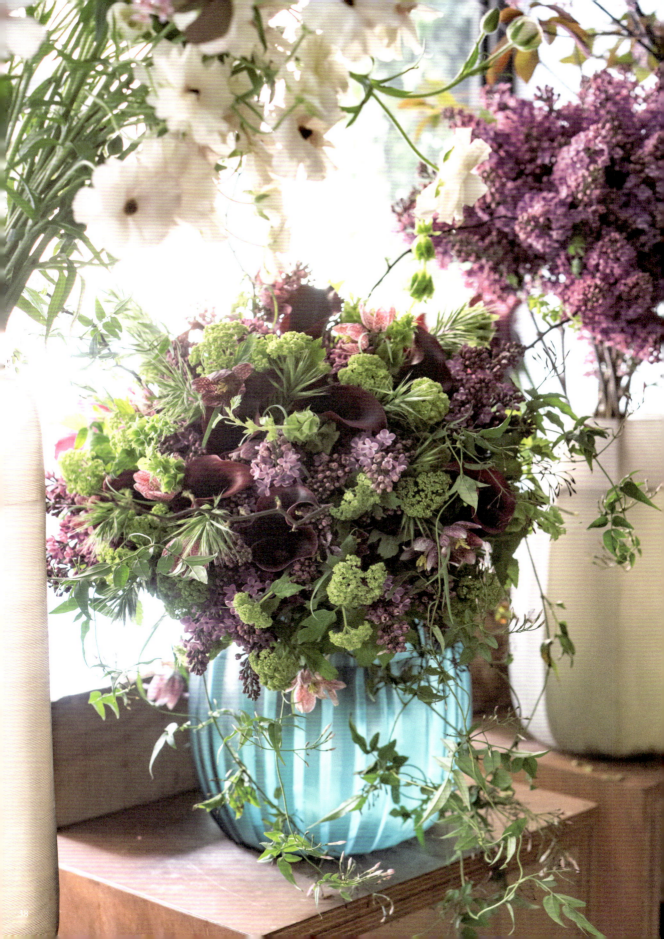

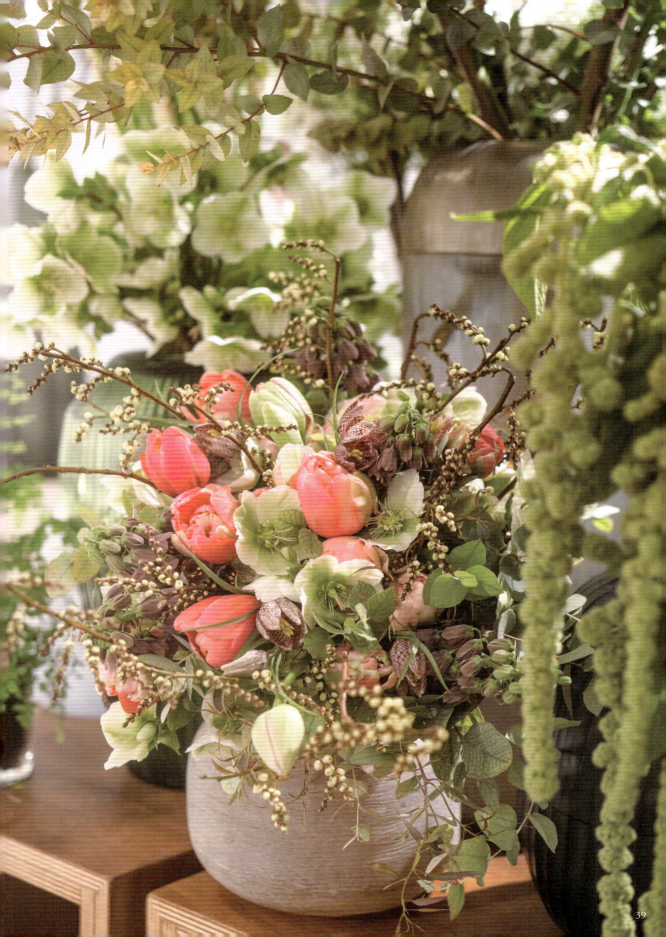

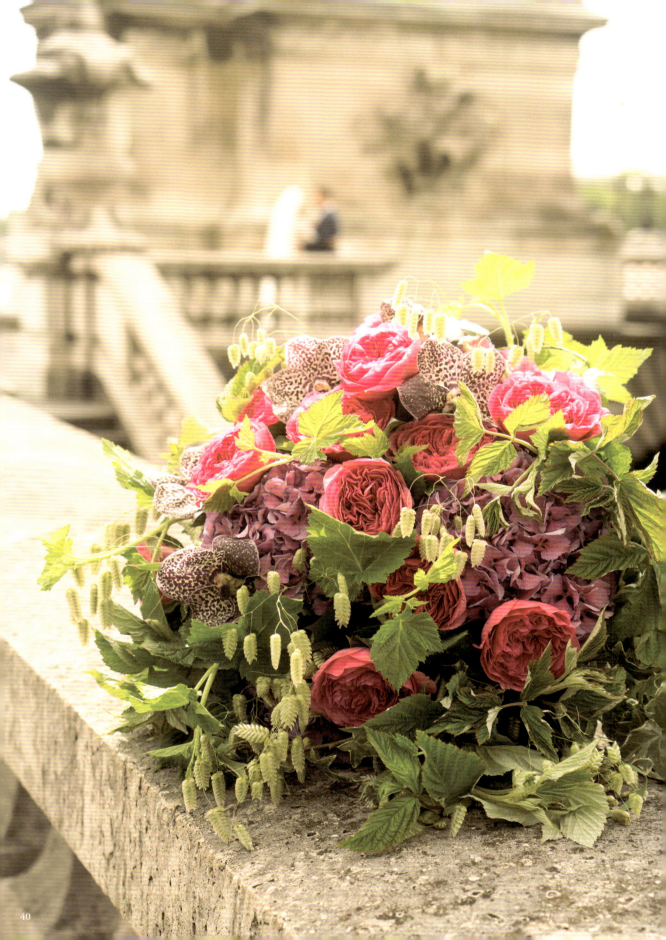

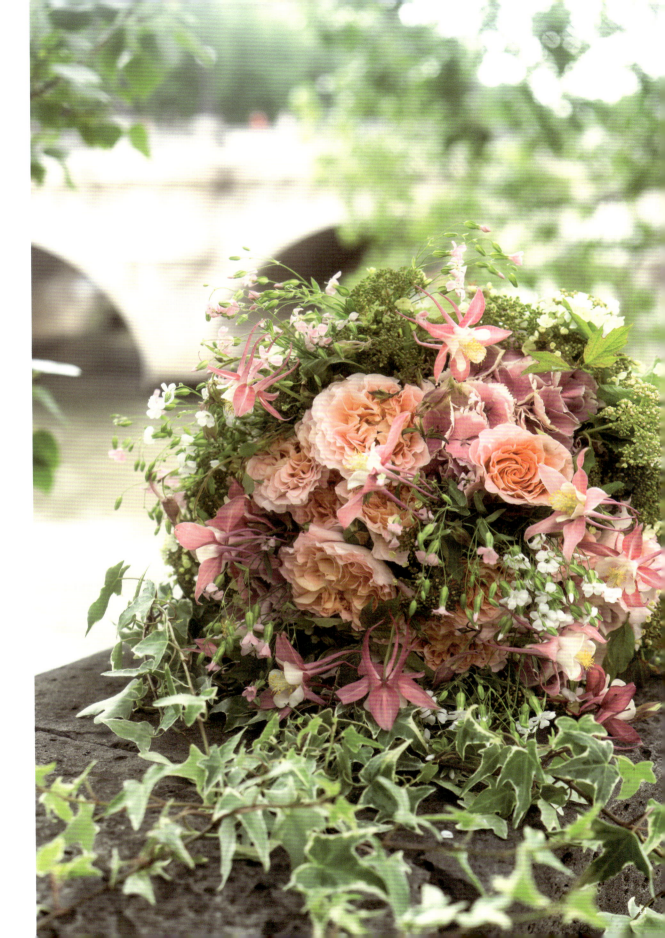

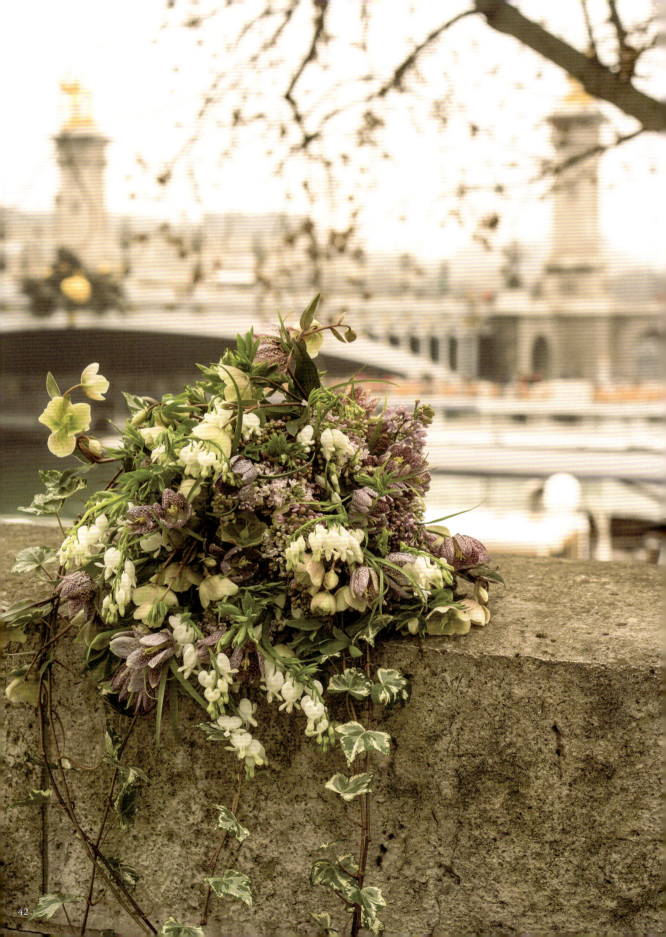

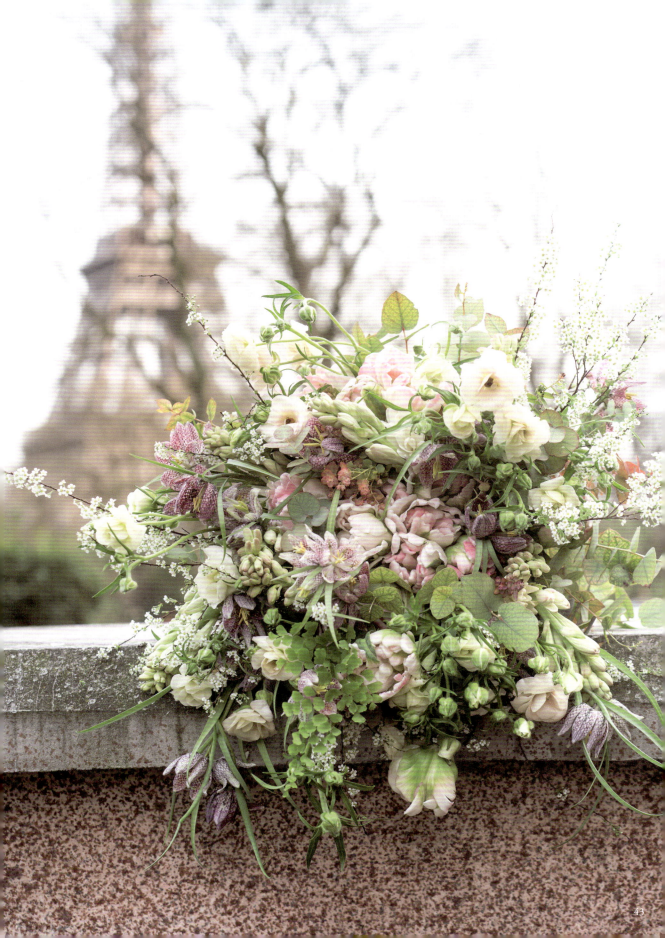

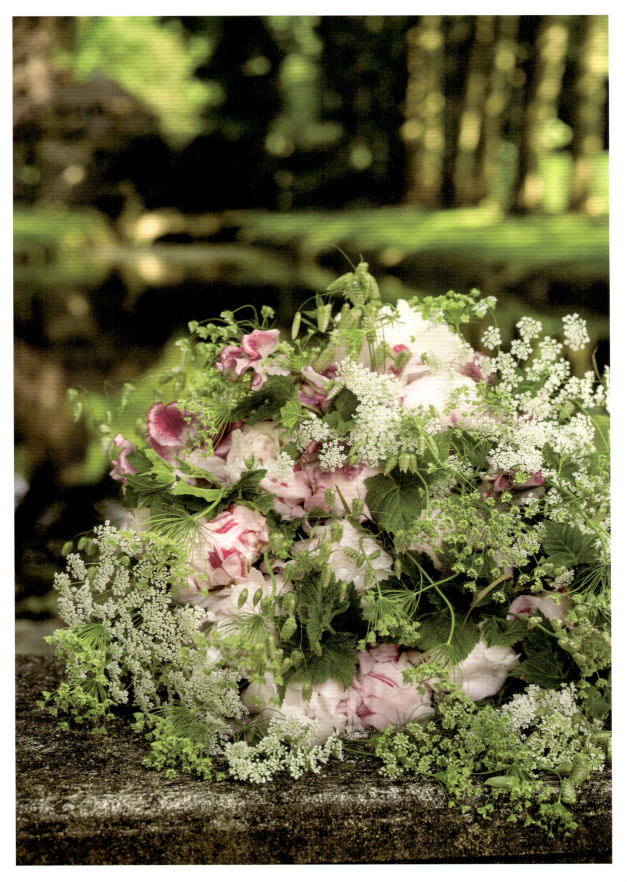

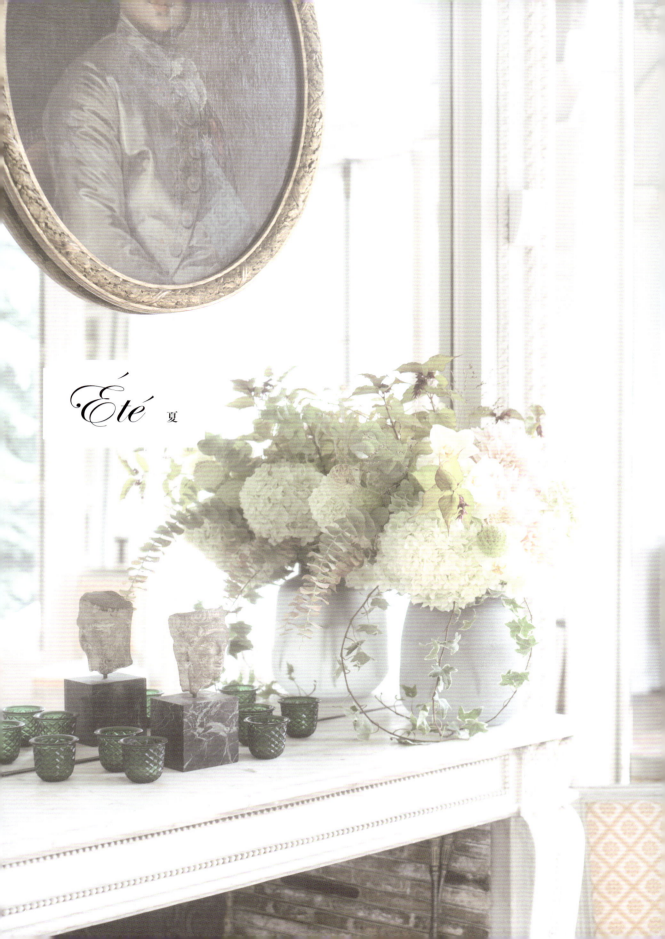

Été 夏

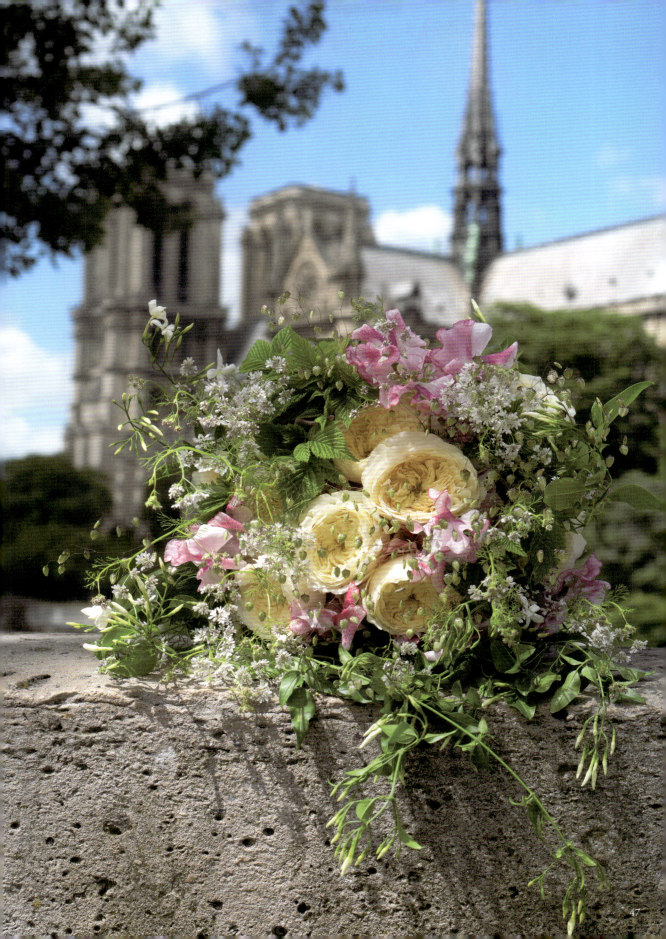

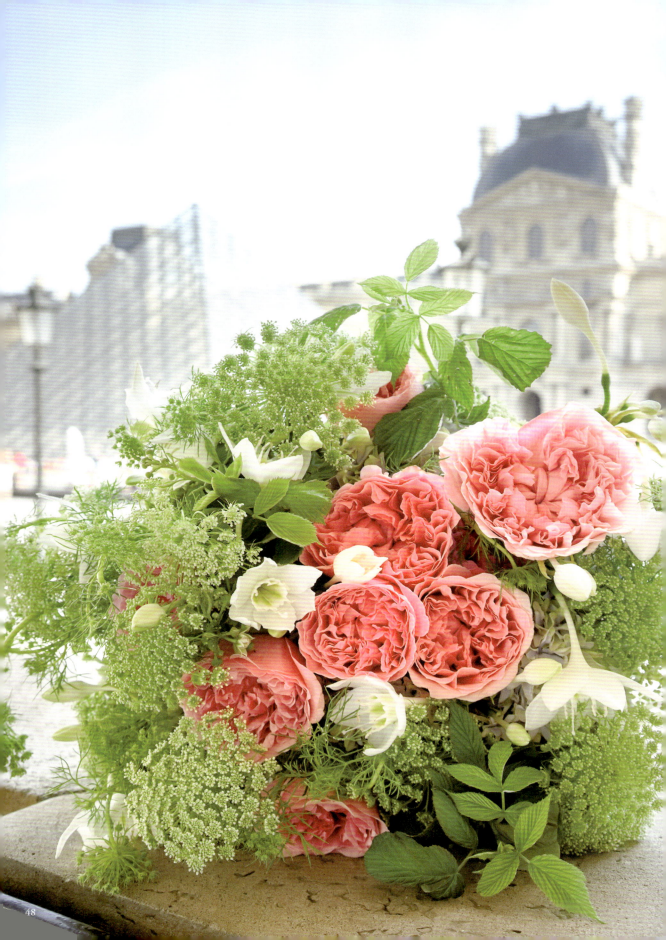

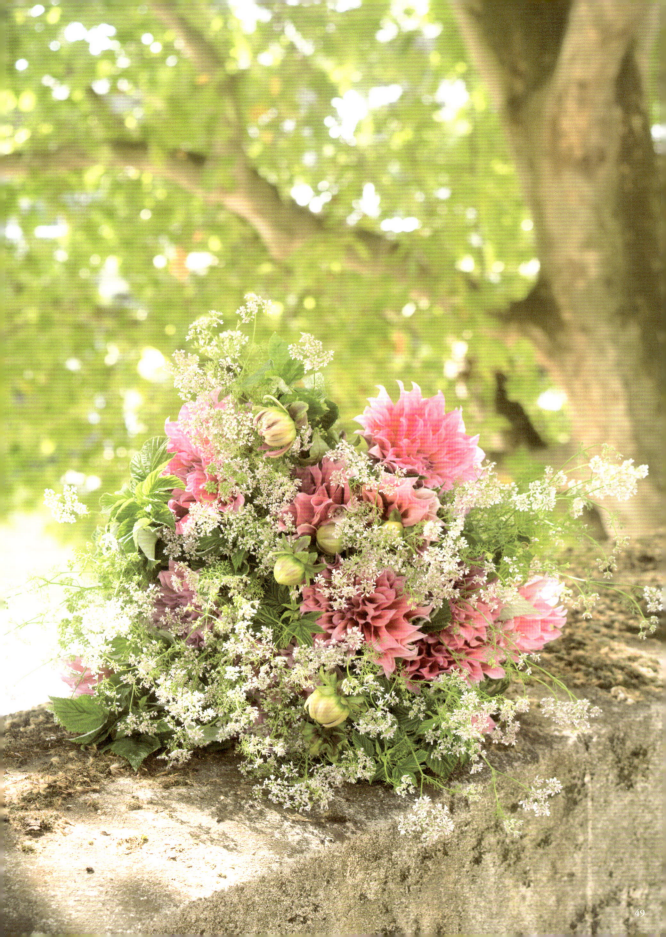

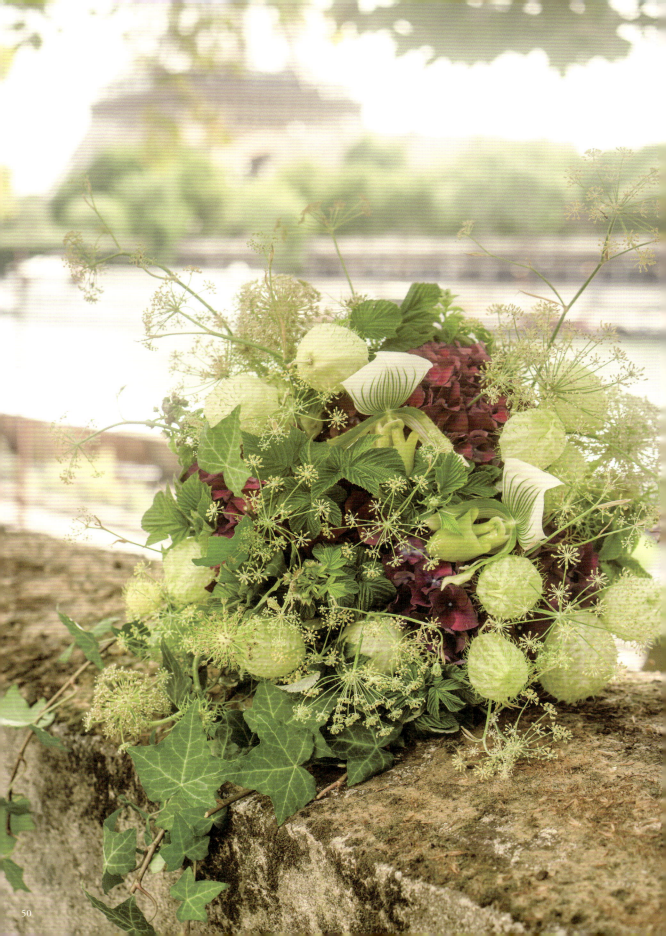

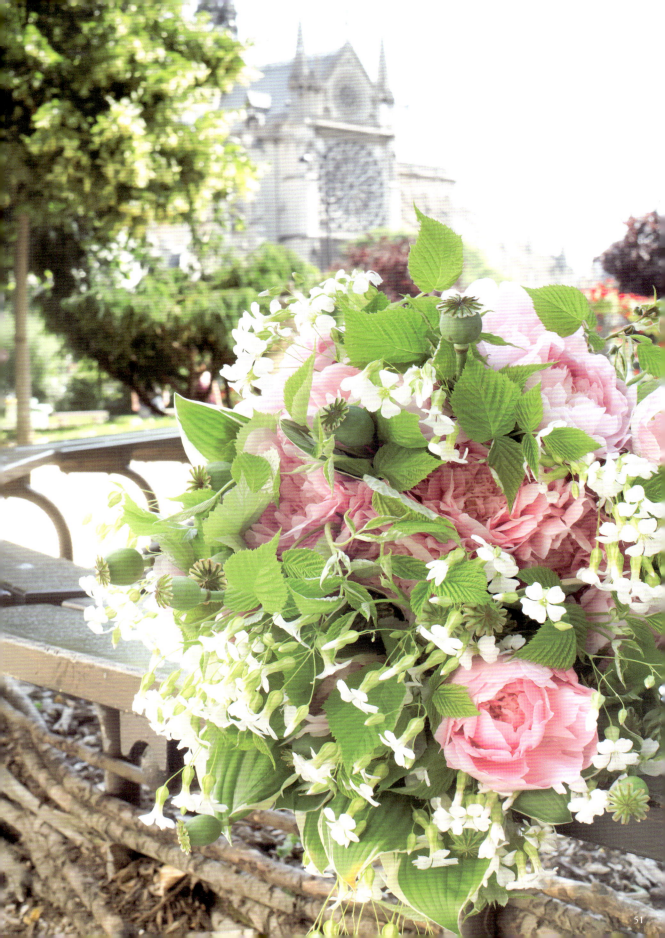

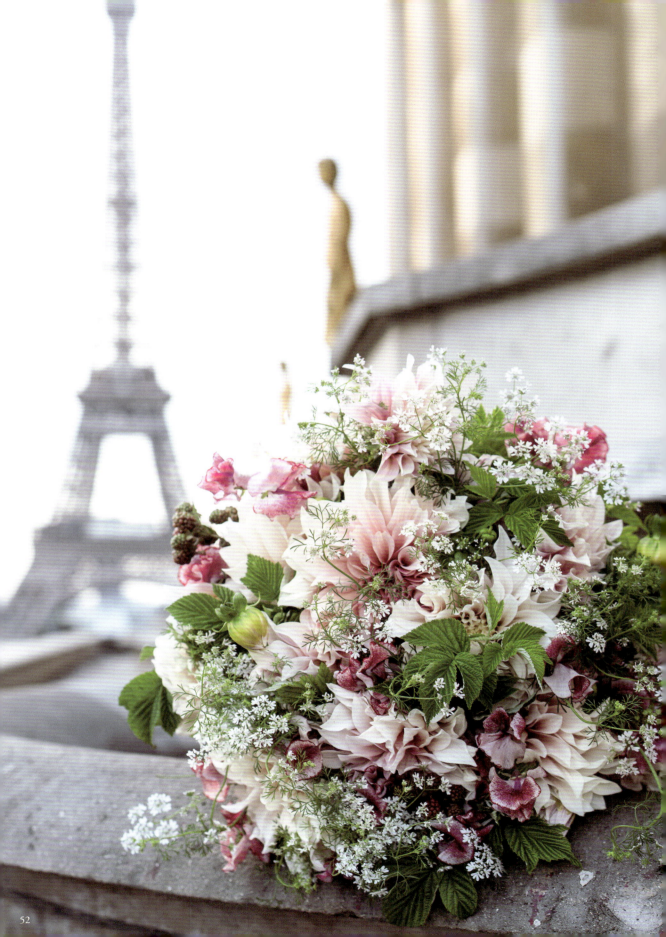

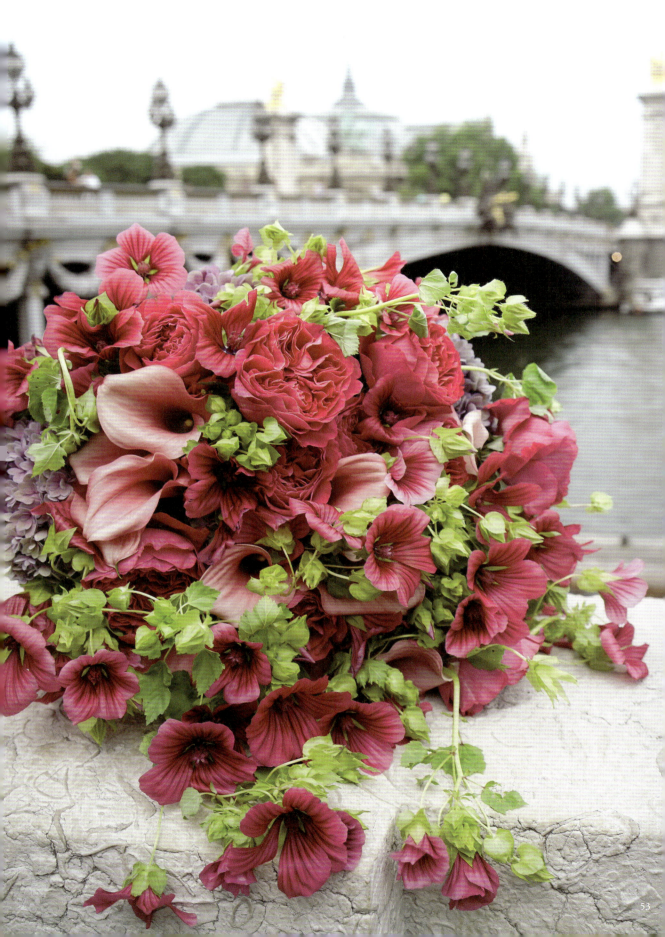

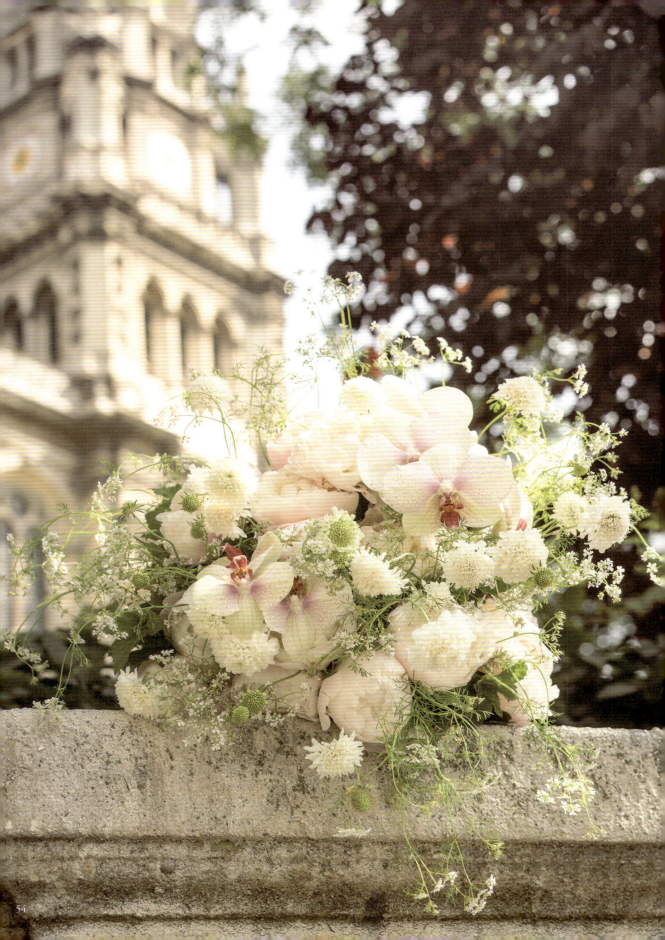

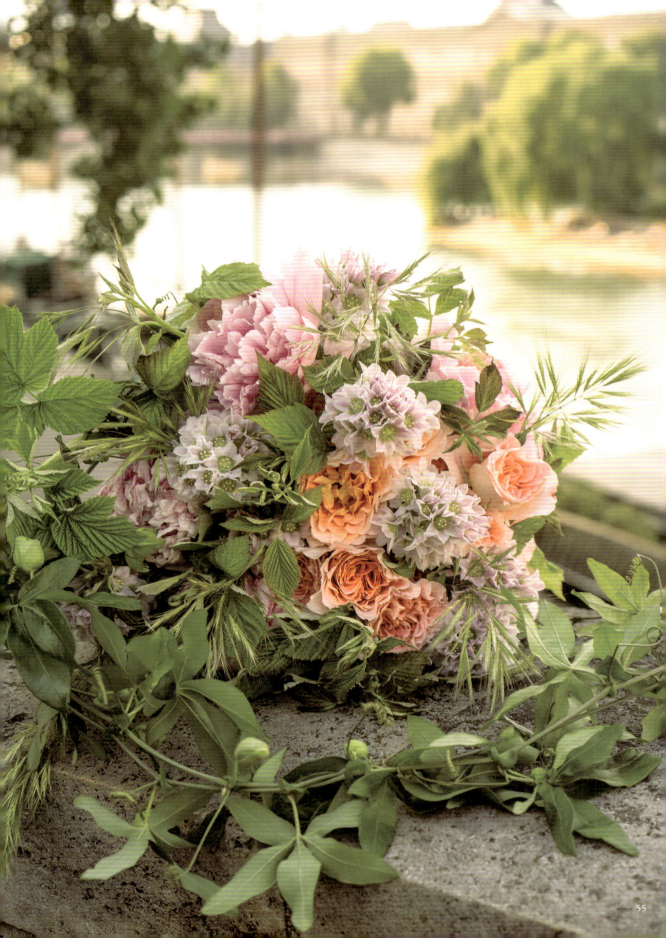

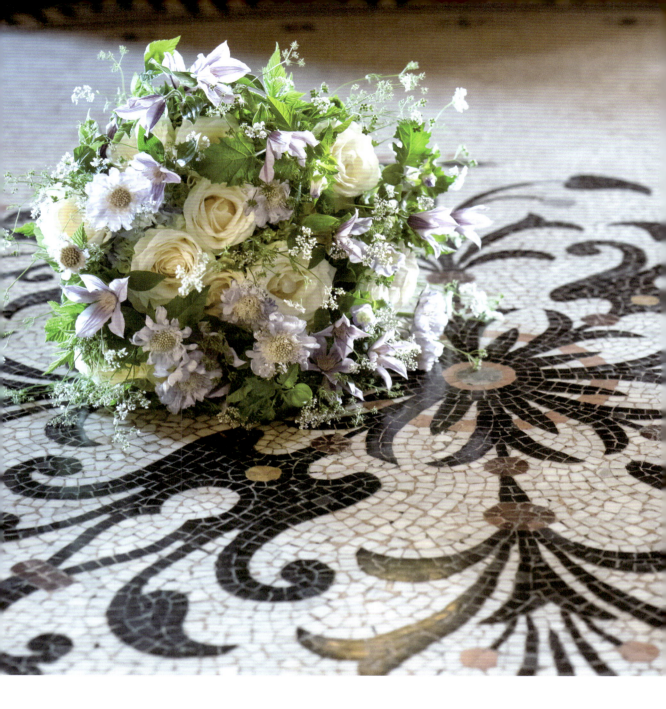

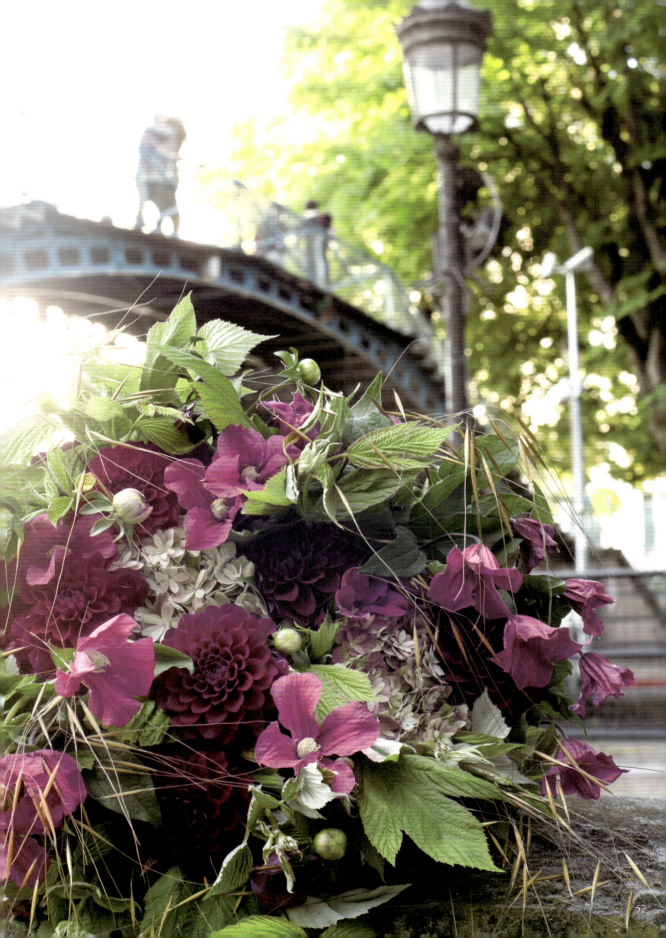

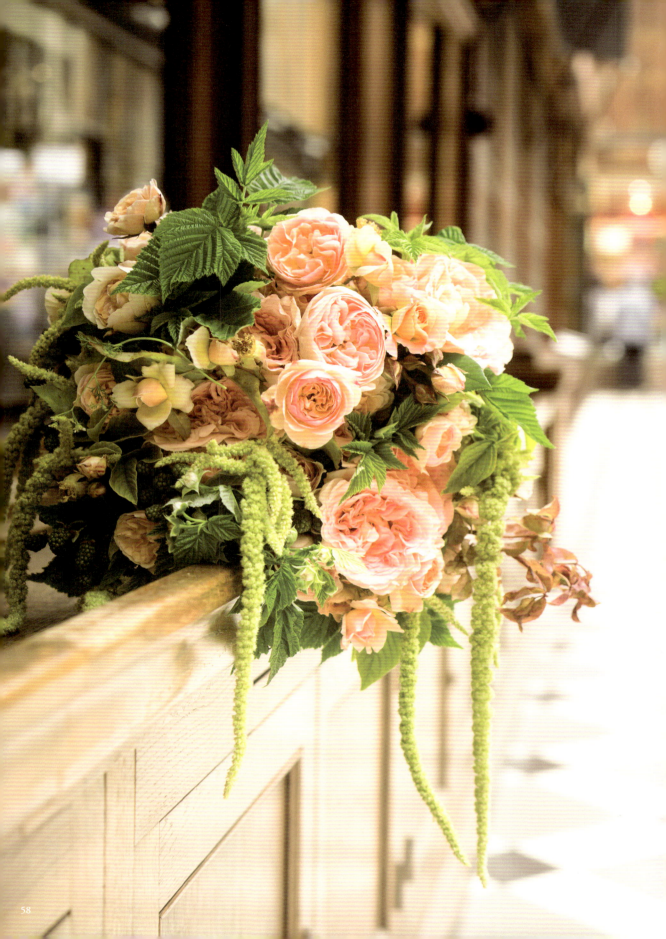

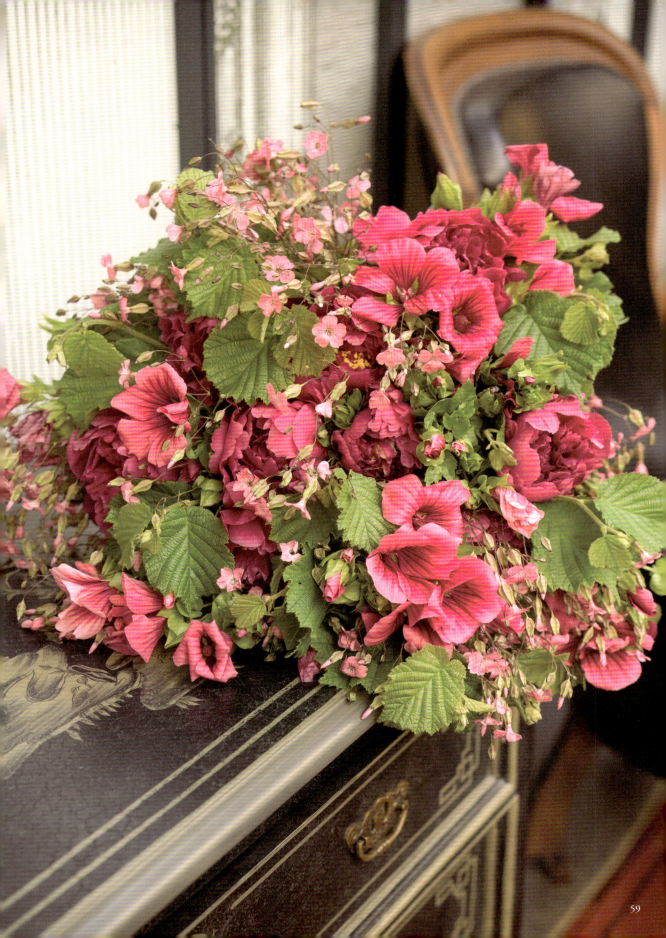

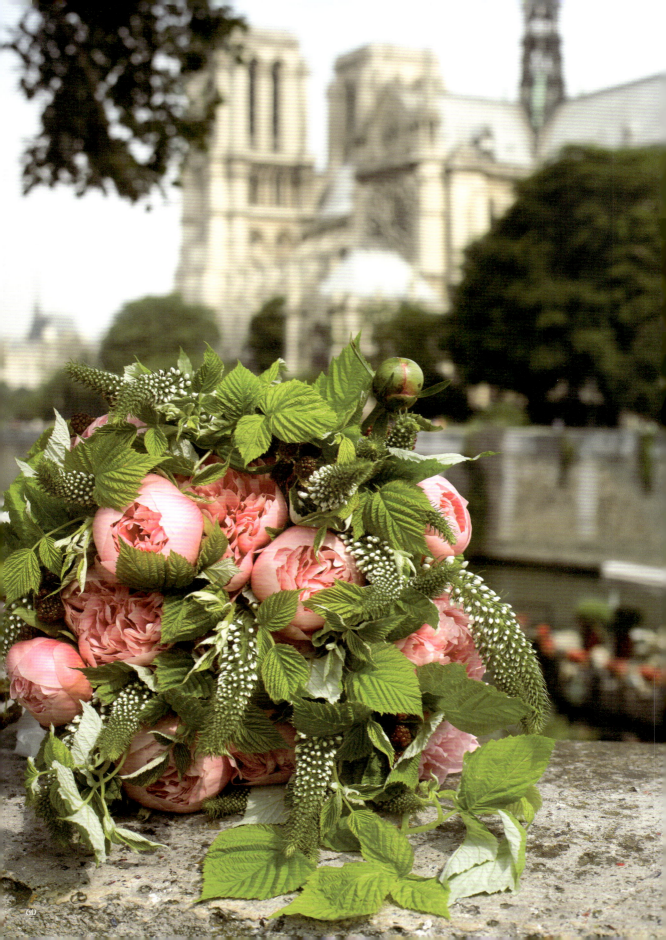

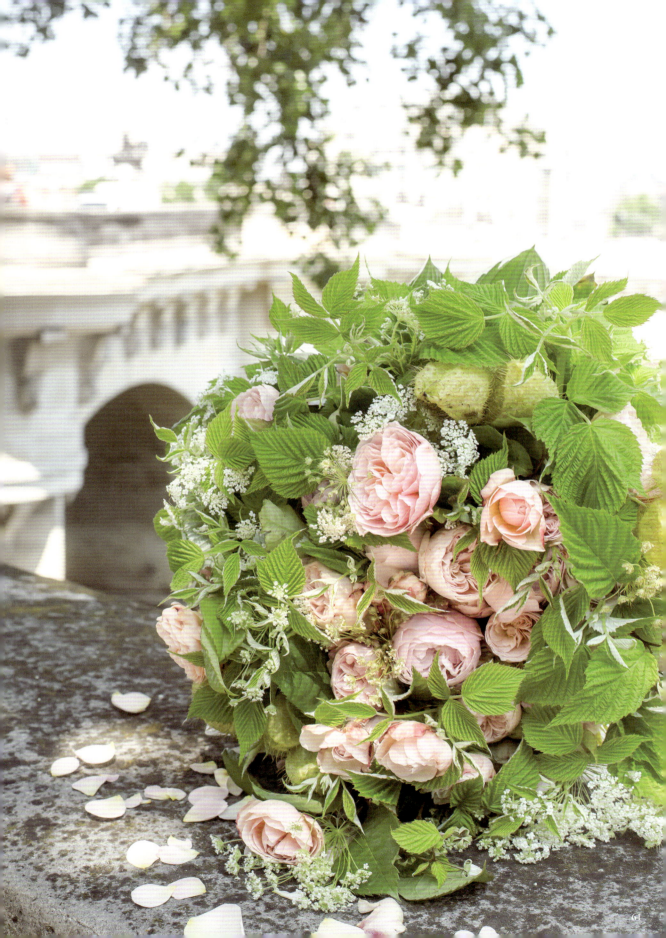

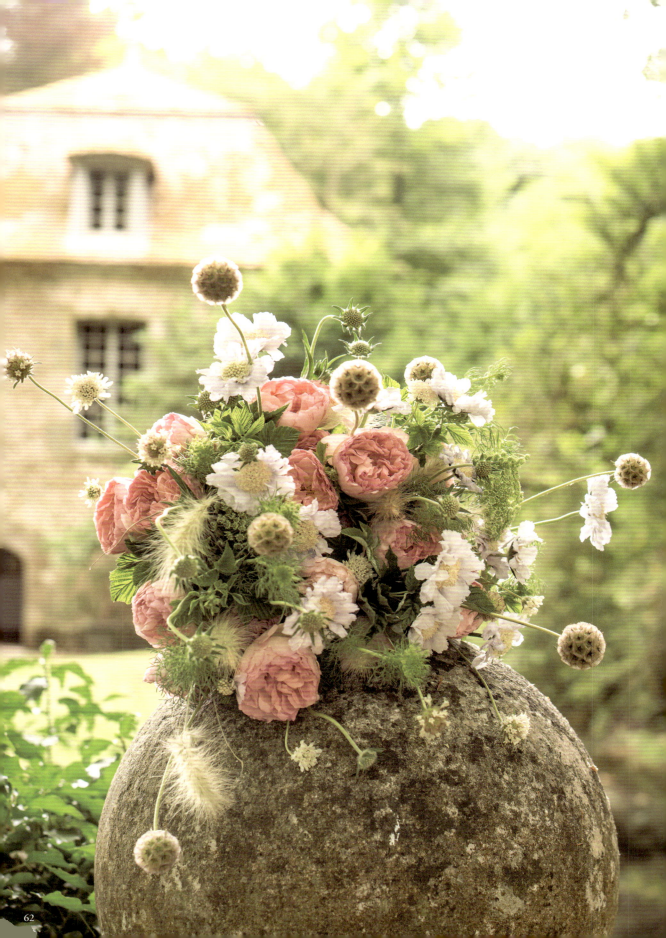

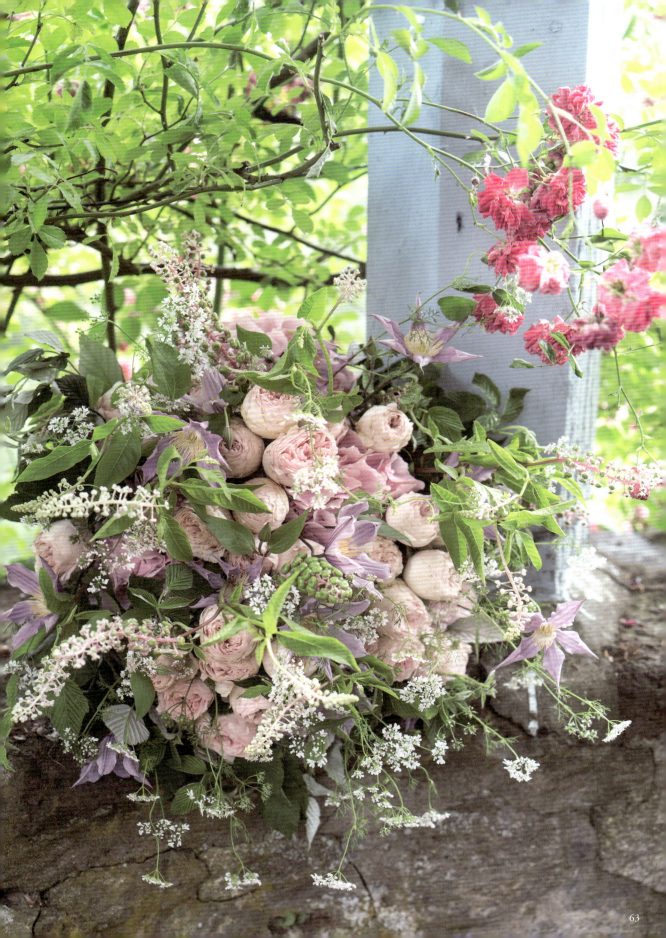

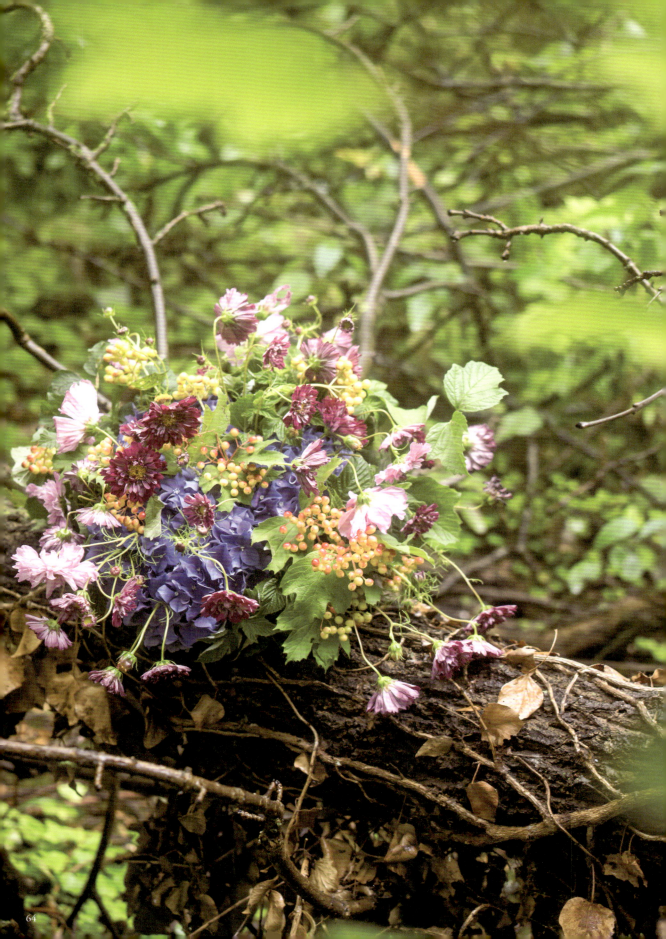

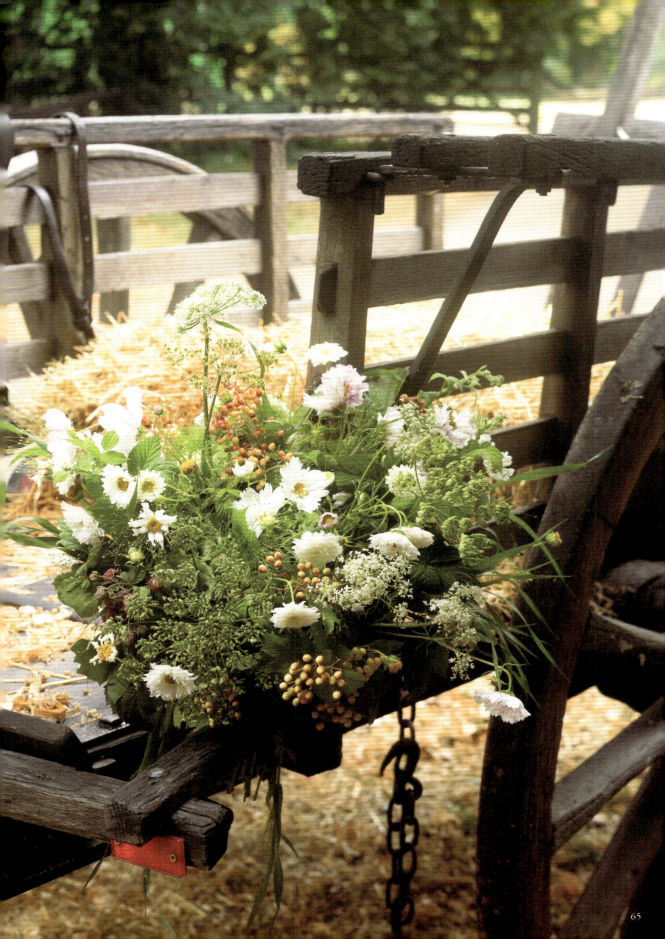

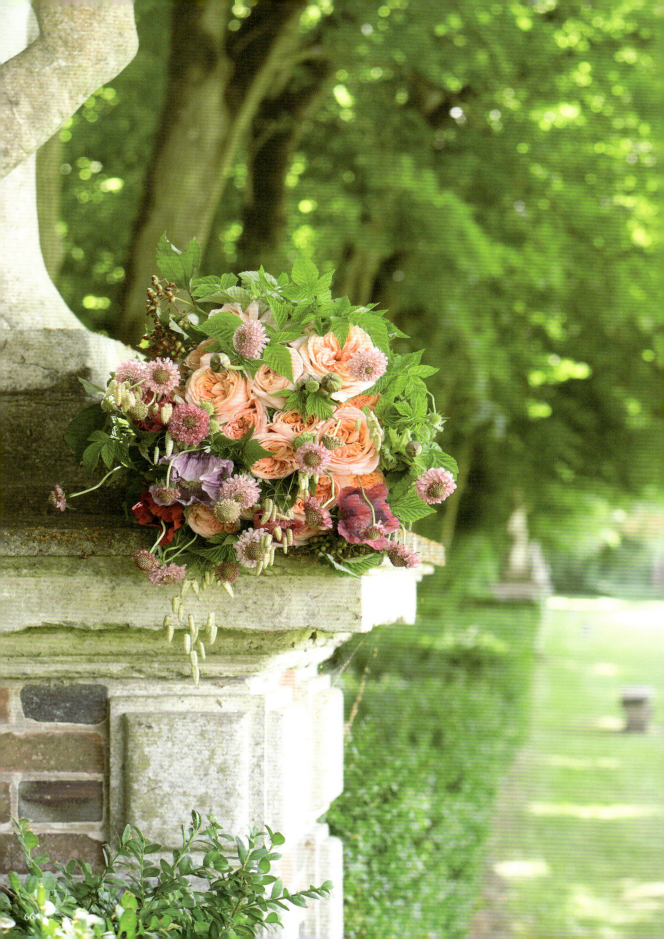

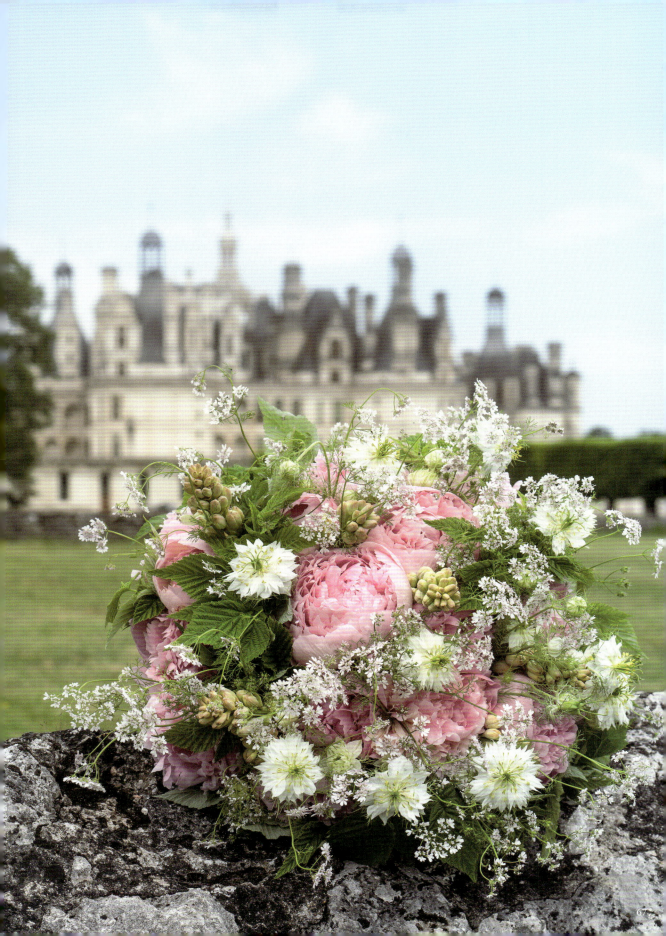

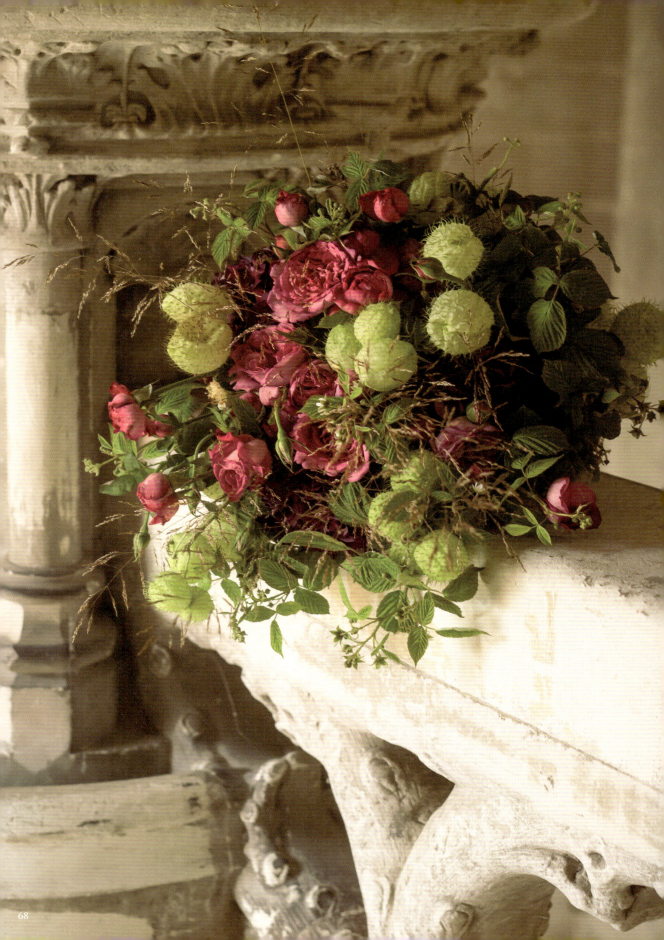

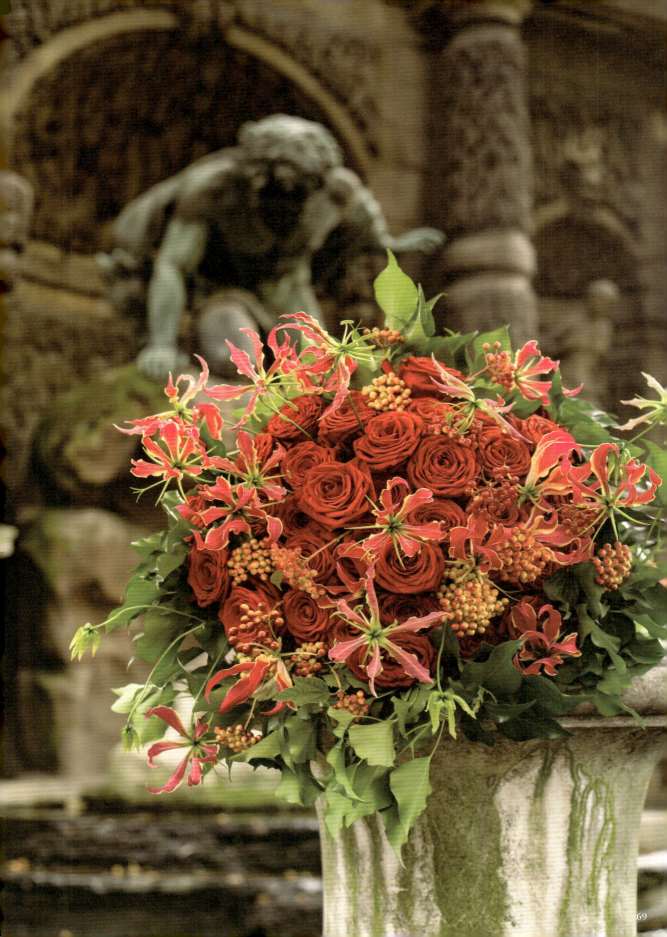

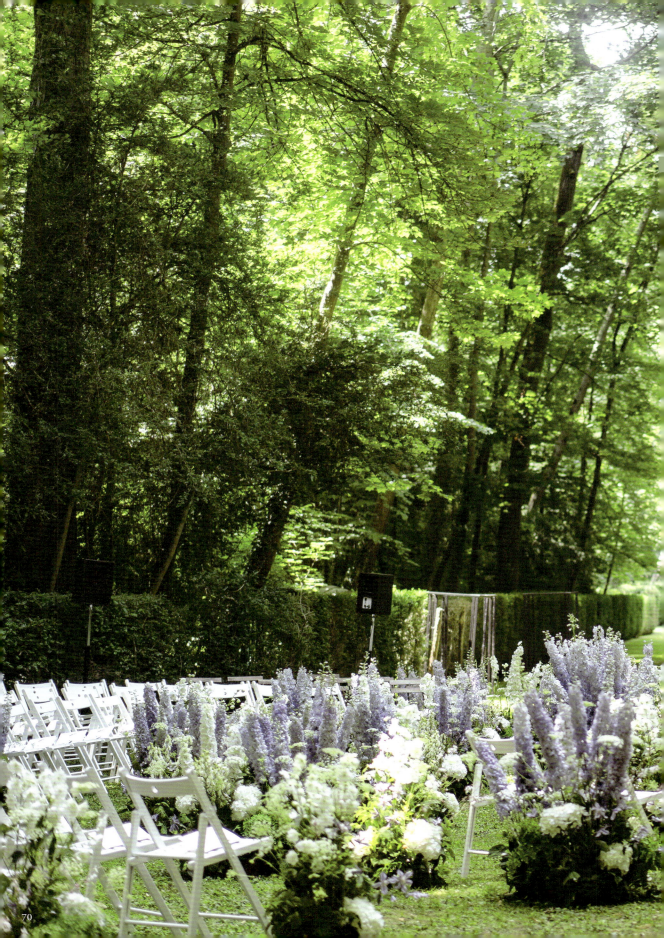

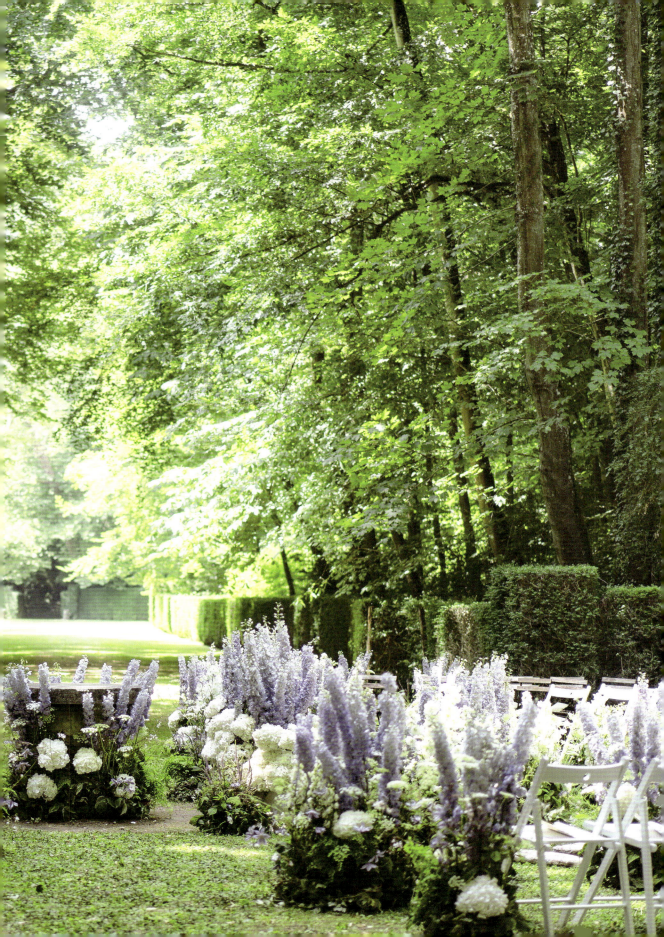

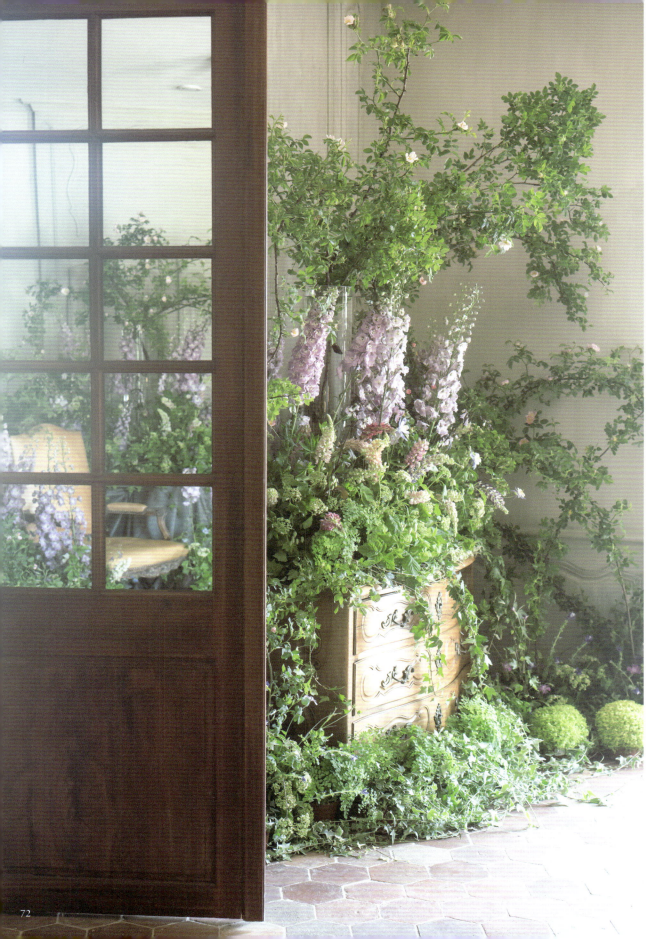

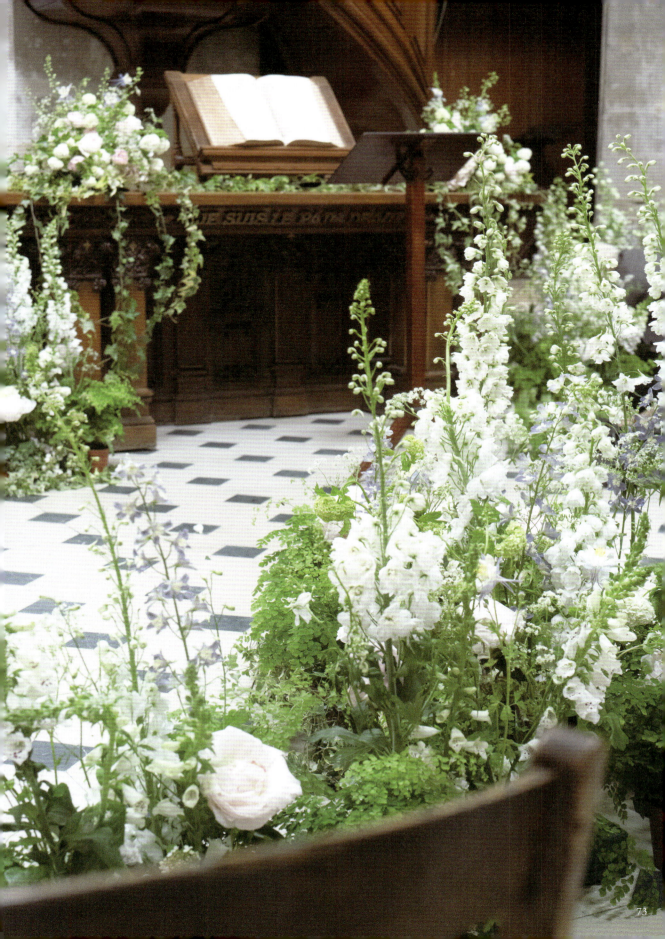

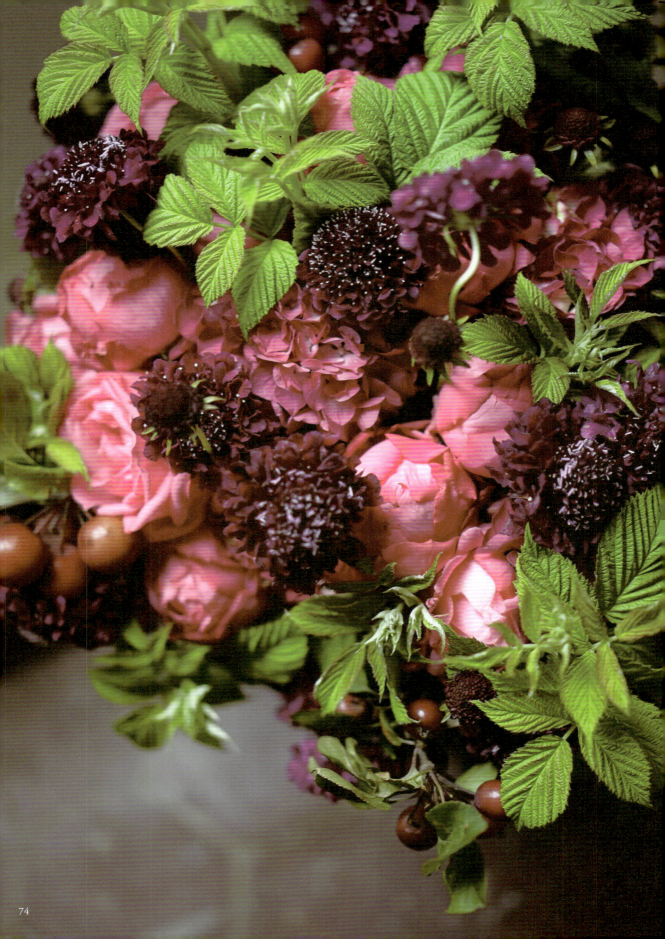

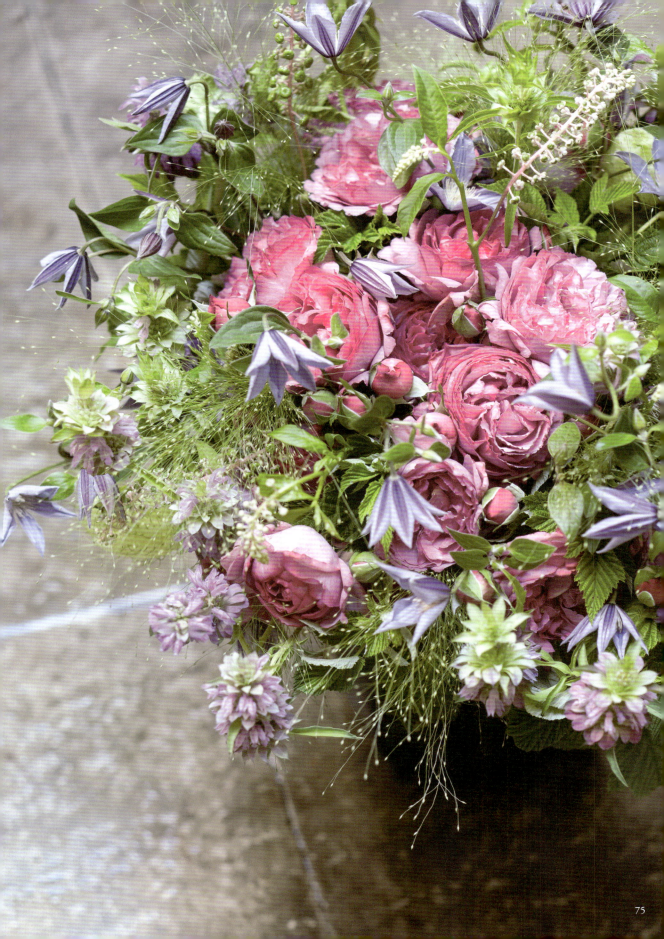

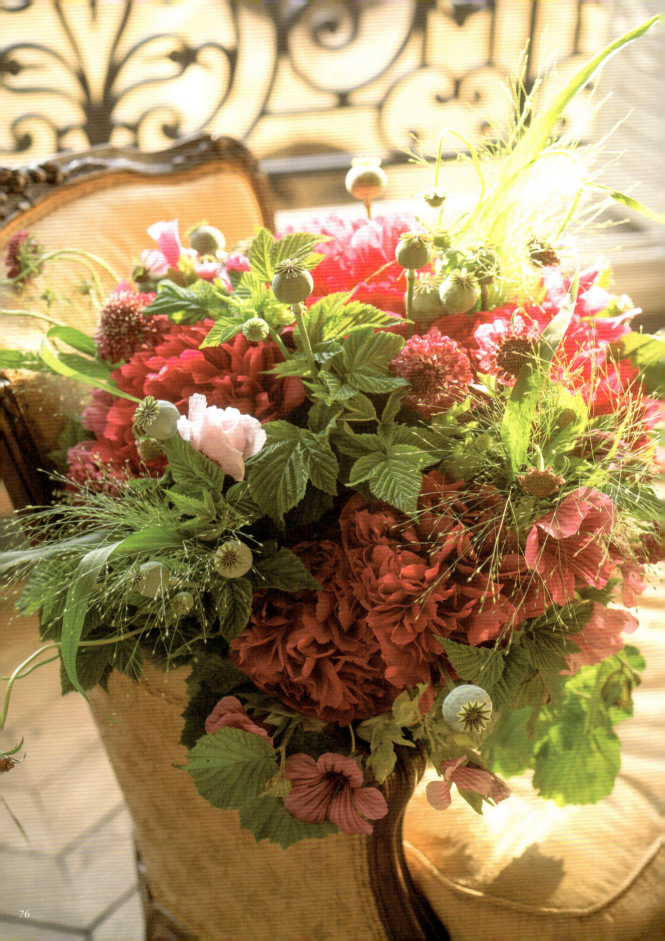

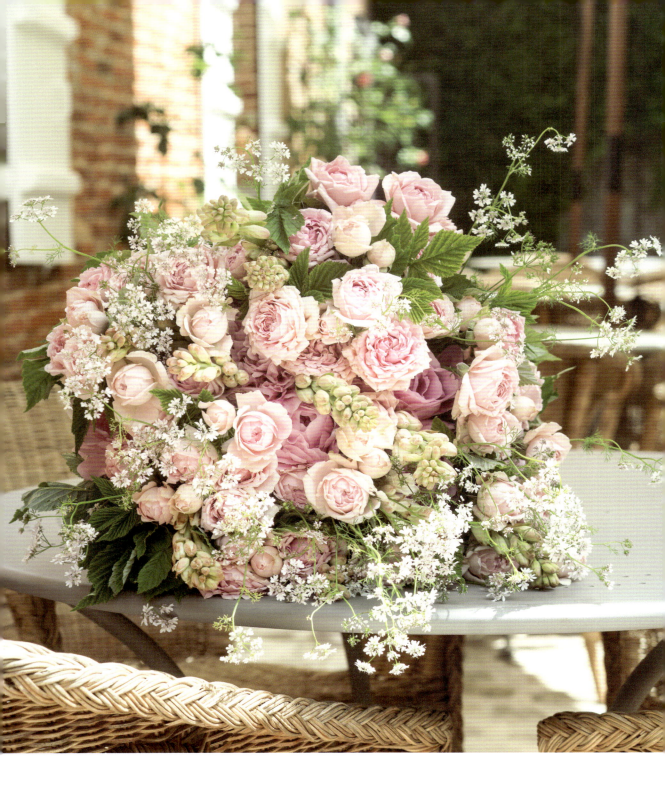

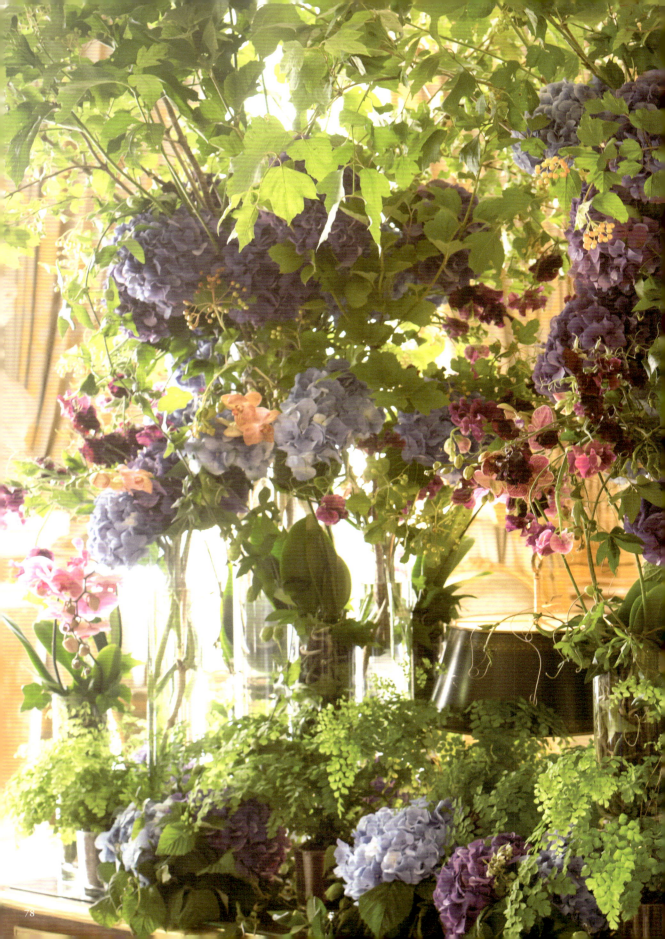

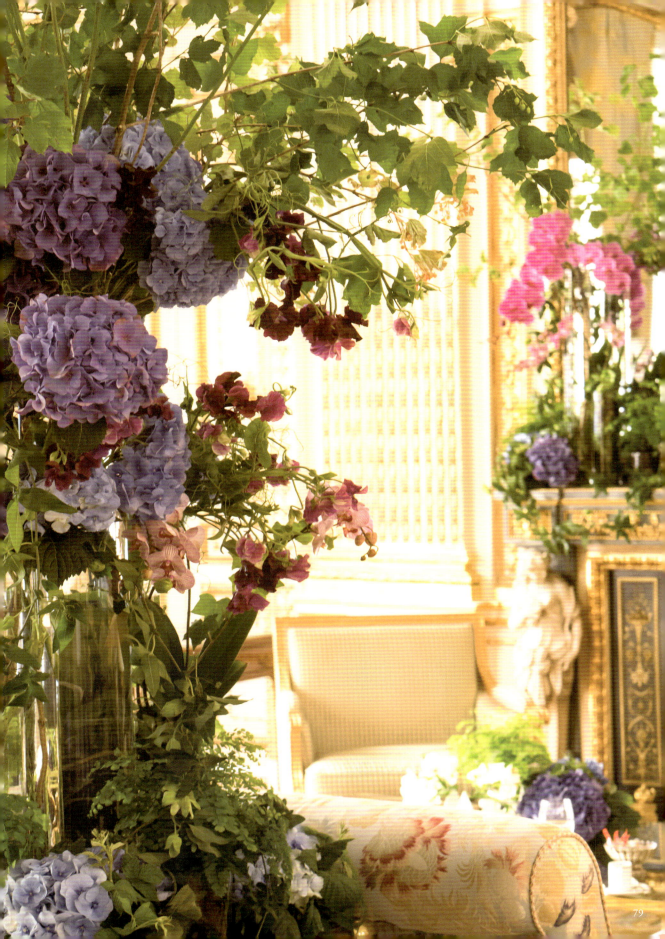

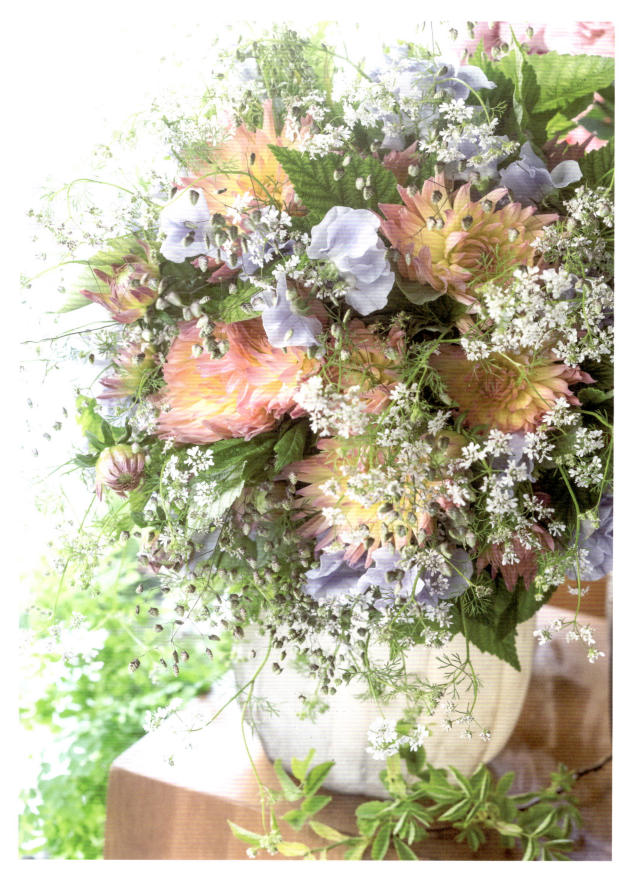

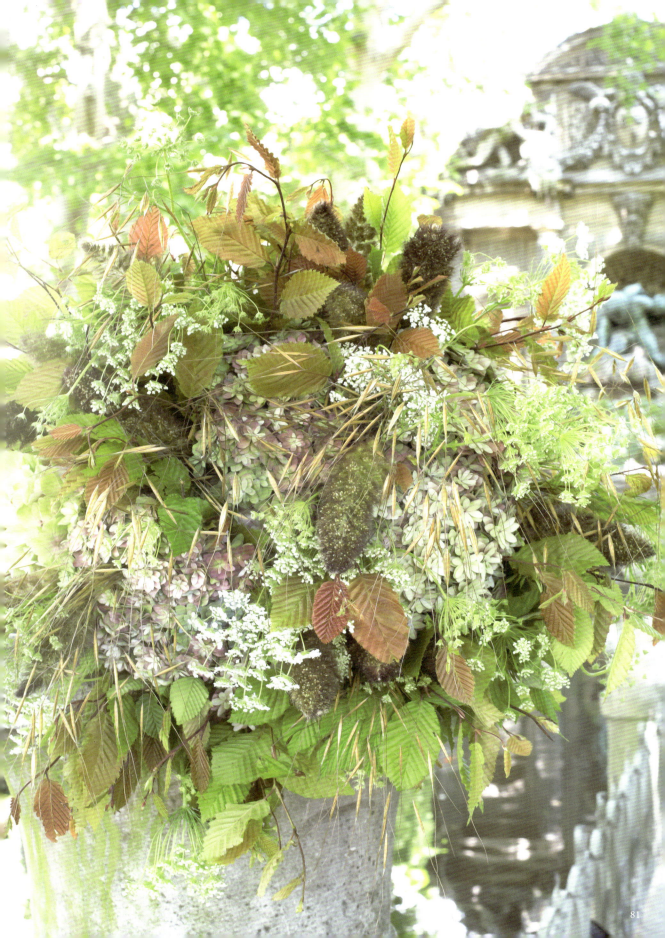

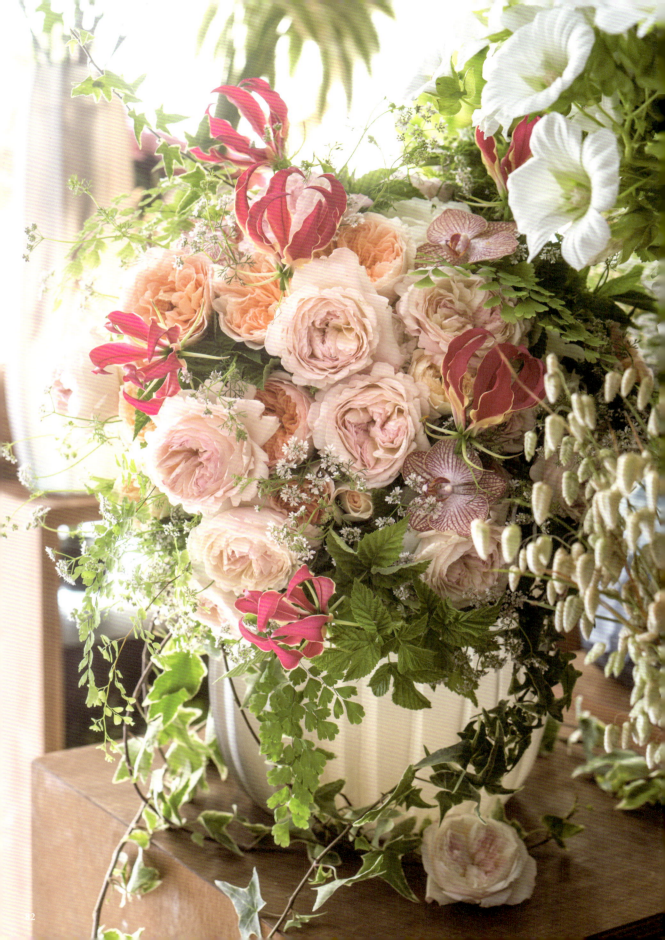

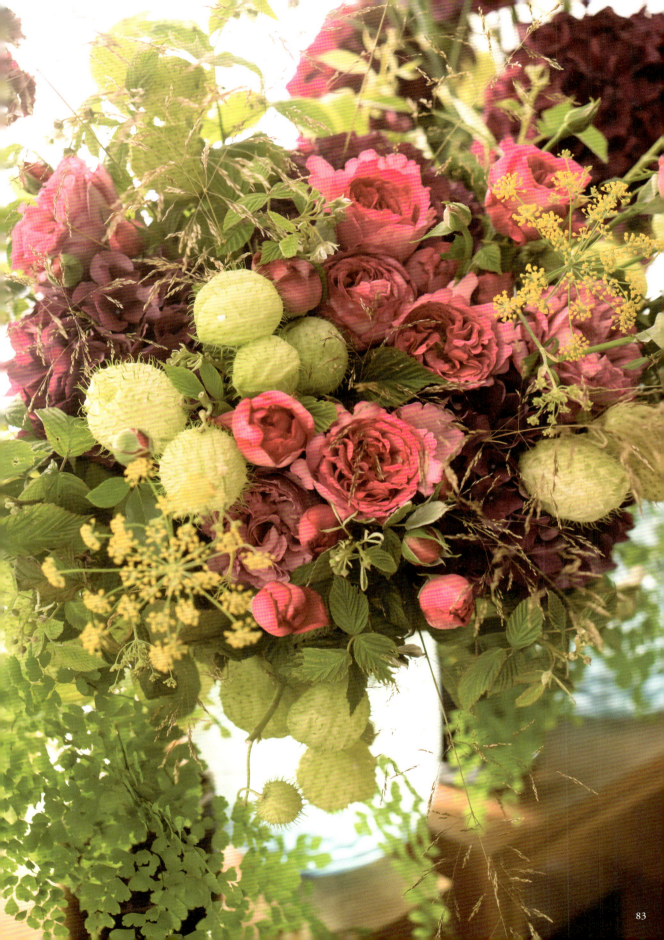

83

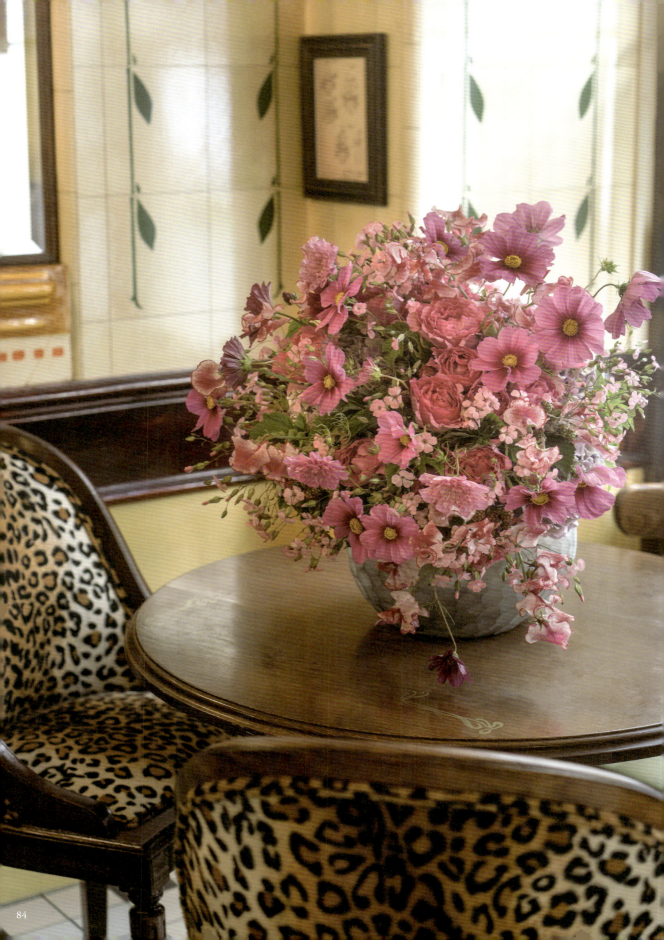

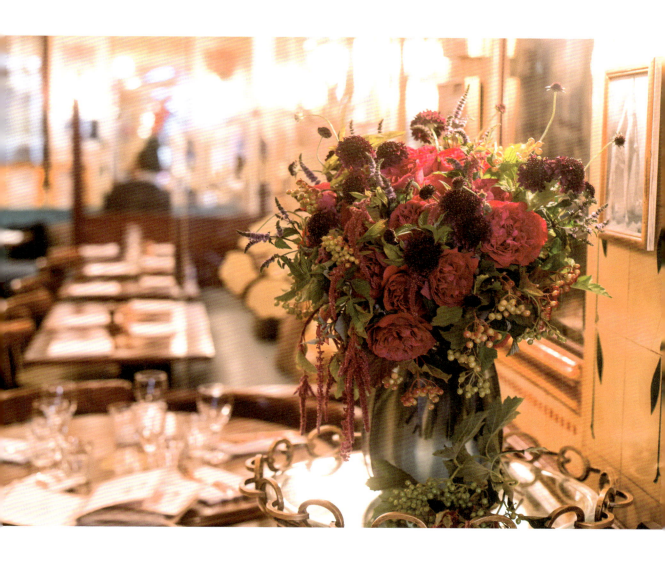

Automne 秋

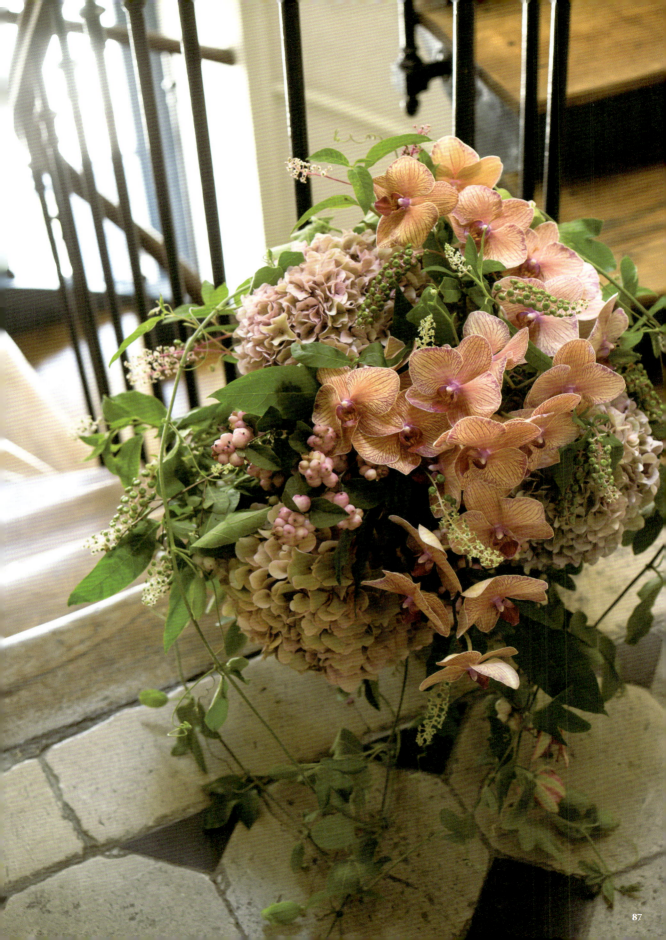

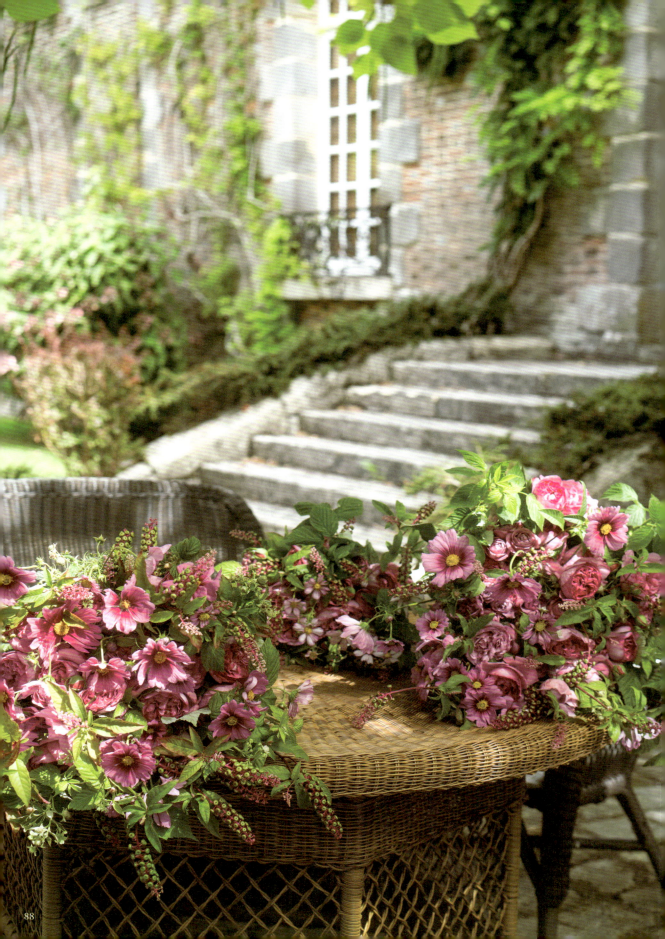

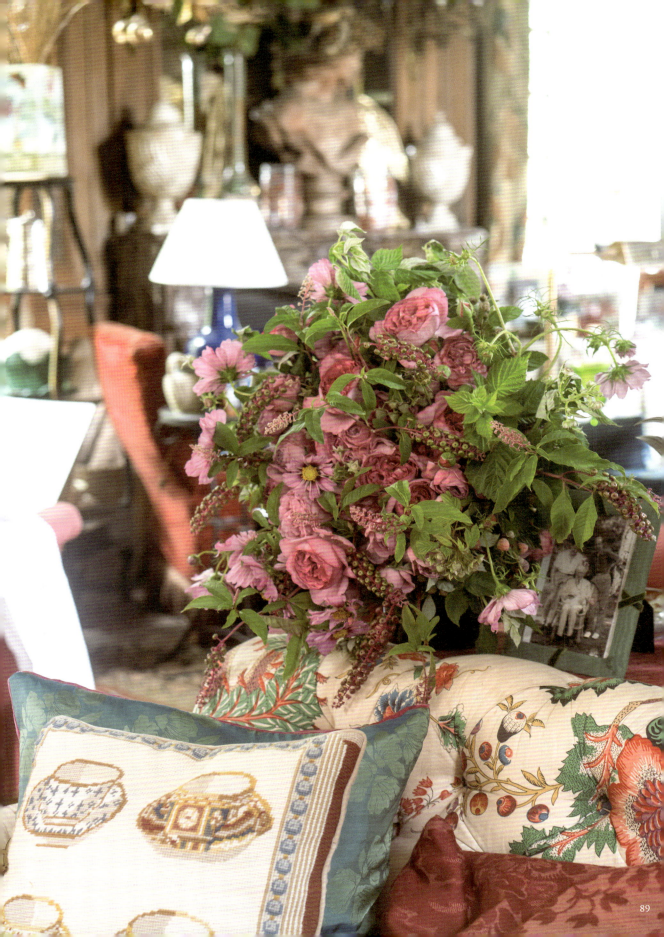

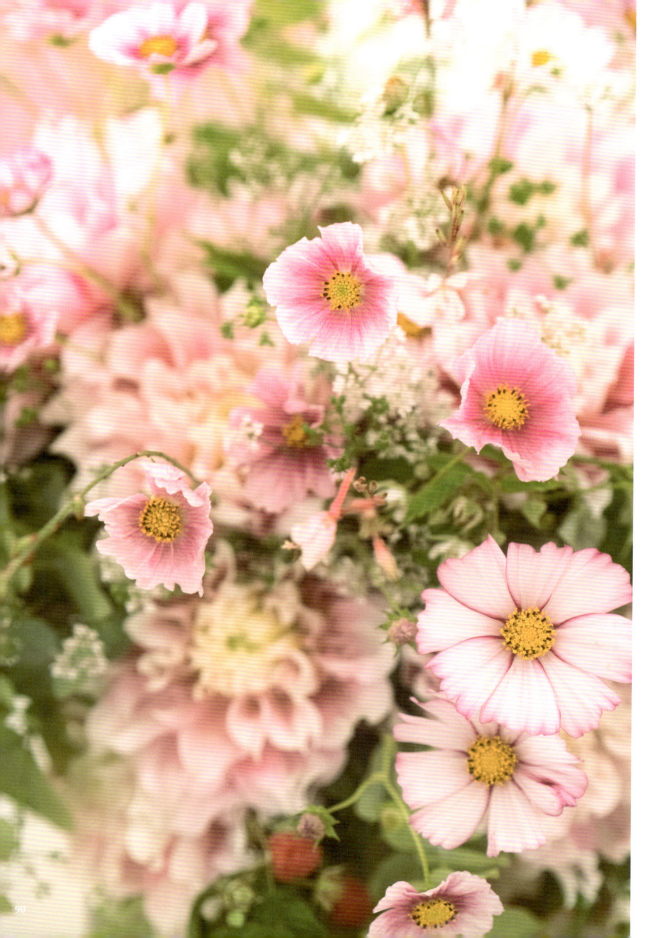

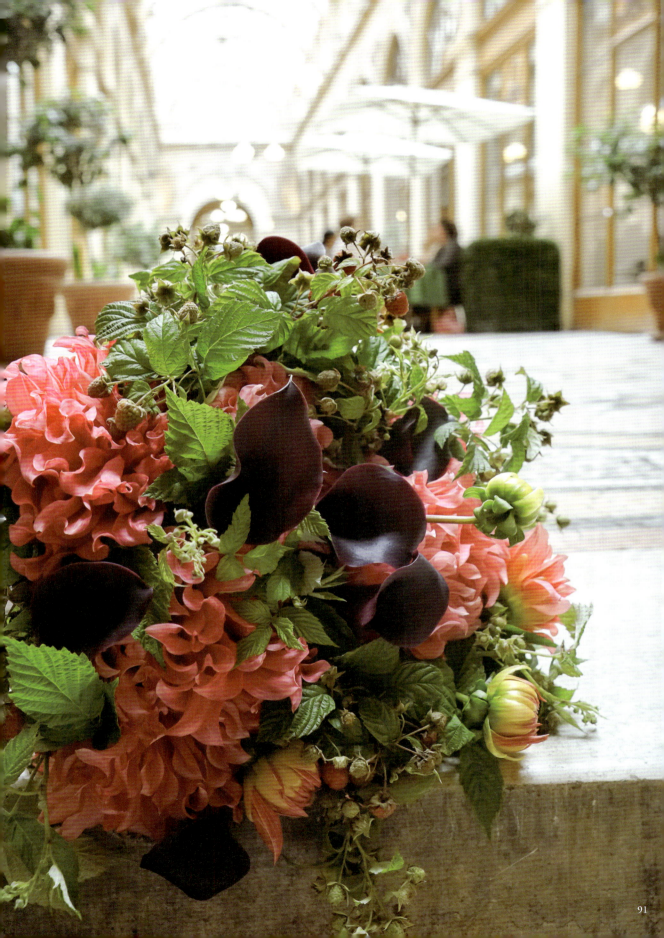

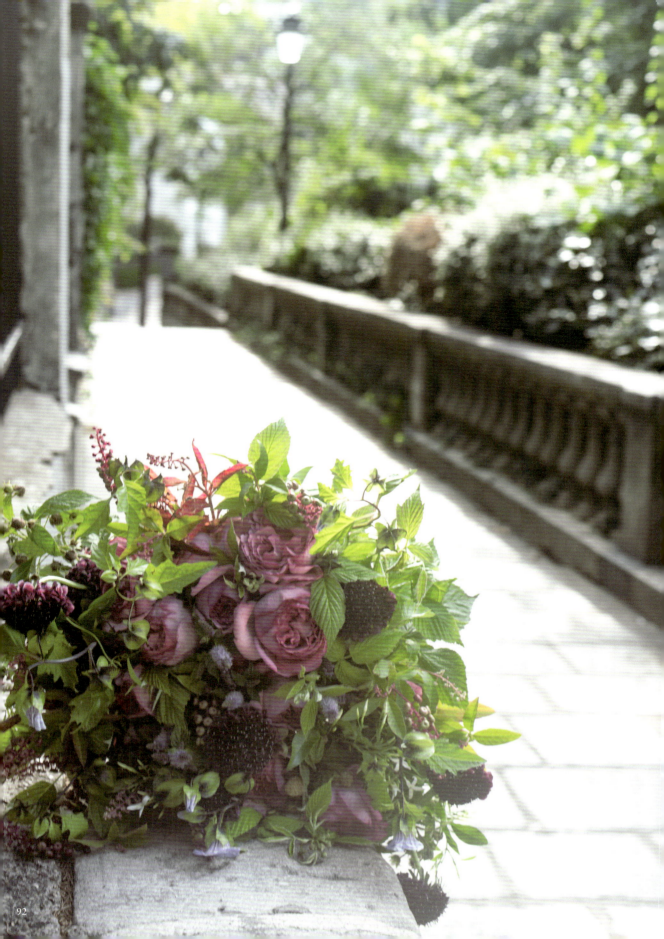

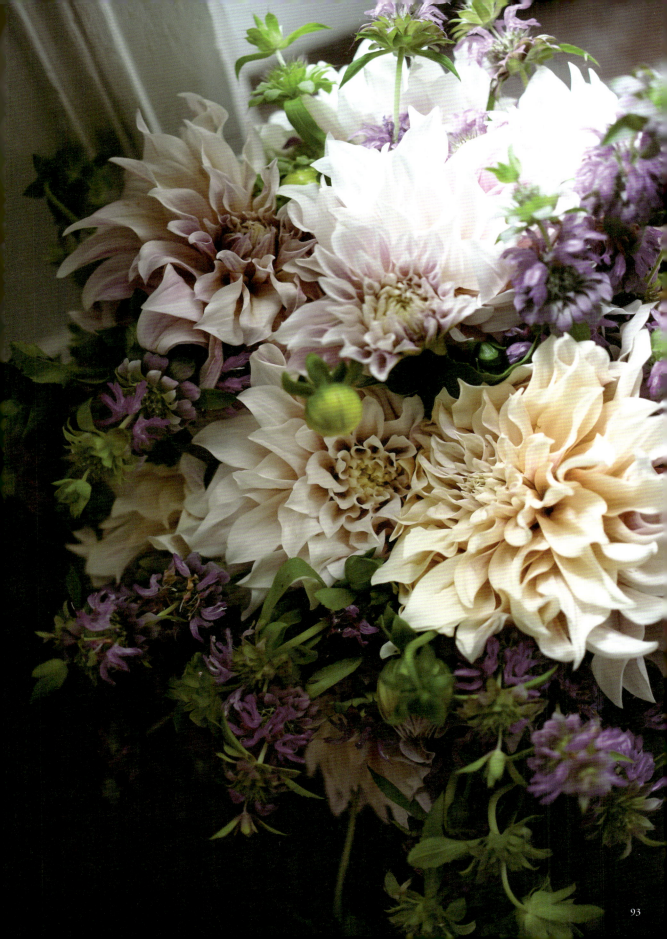

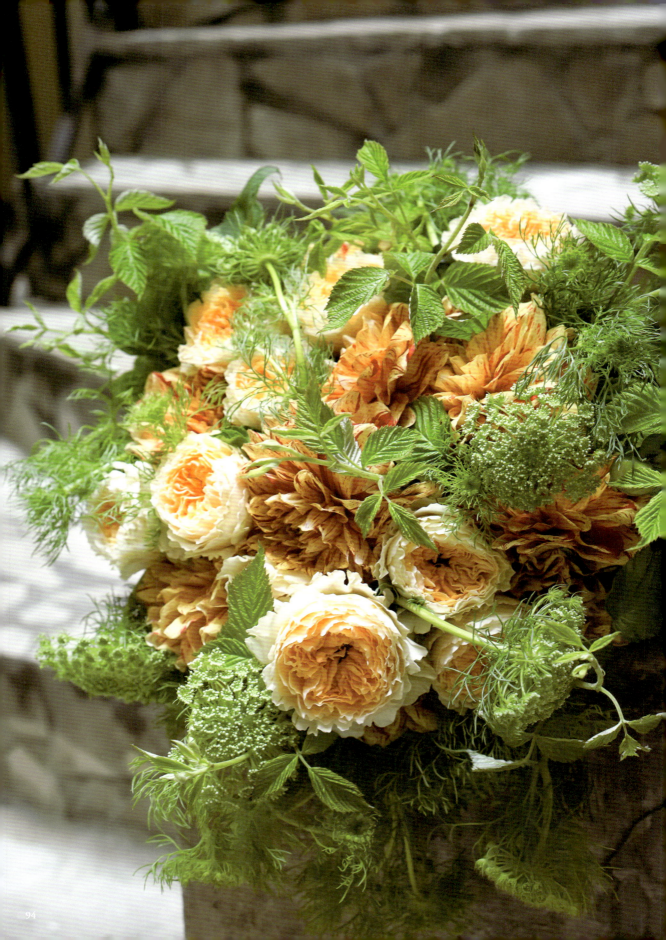

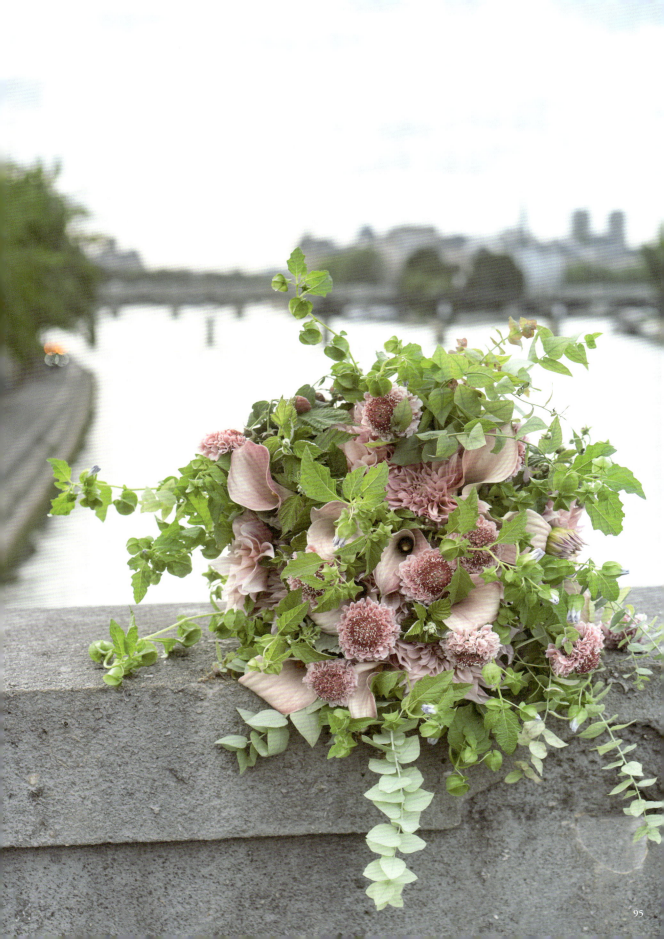

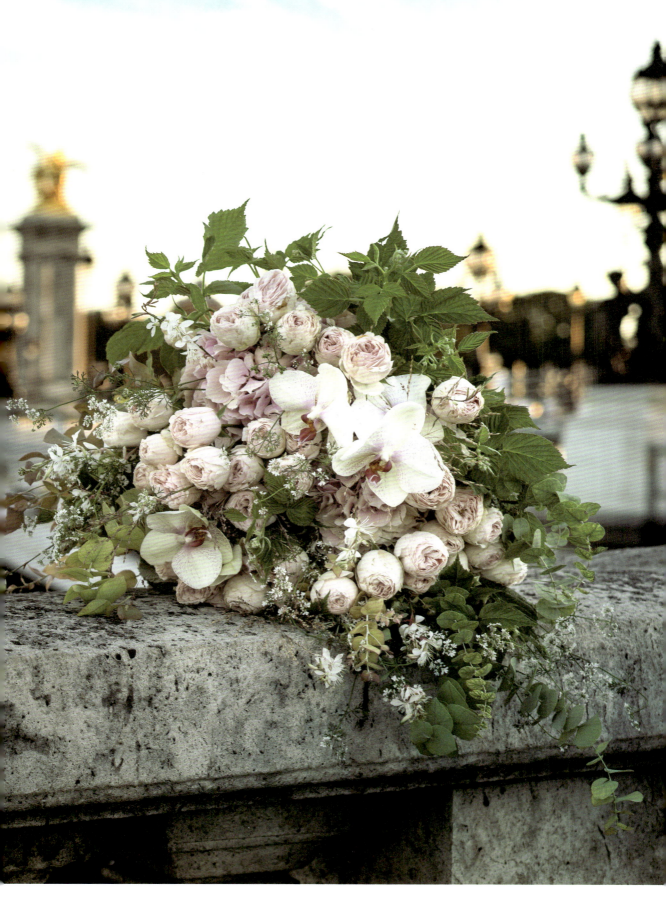

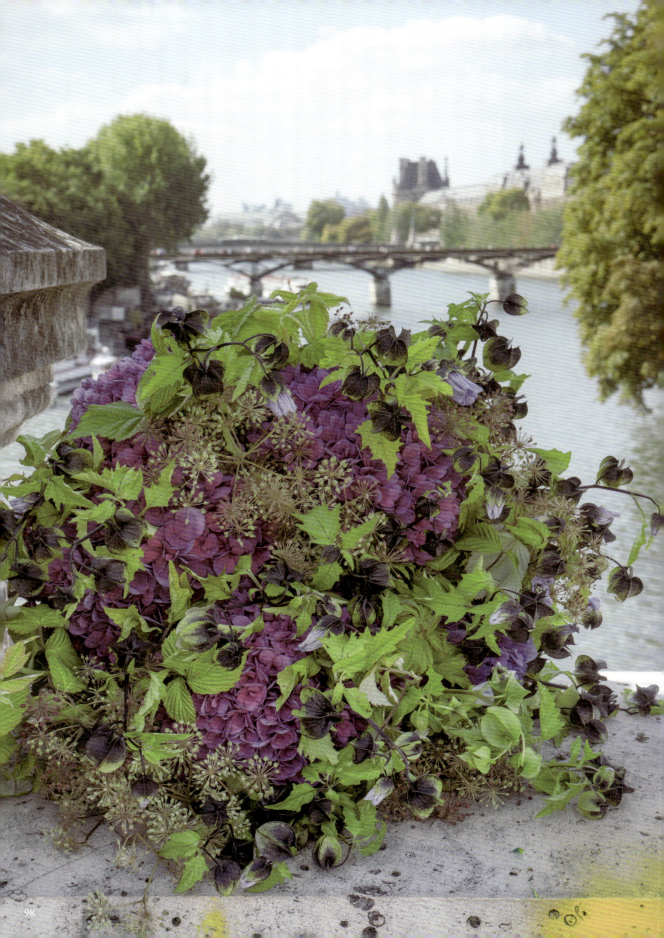

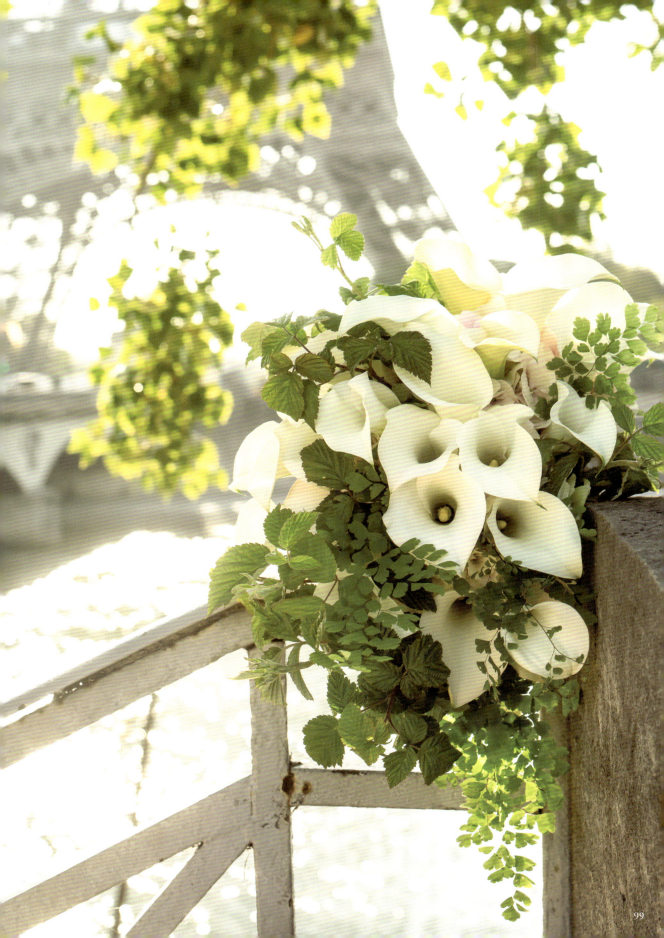

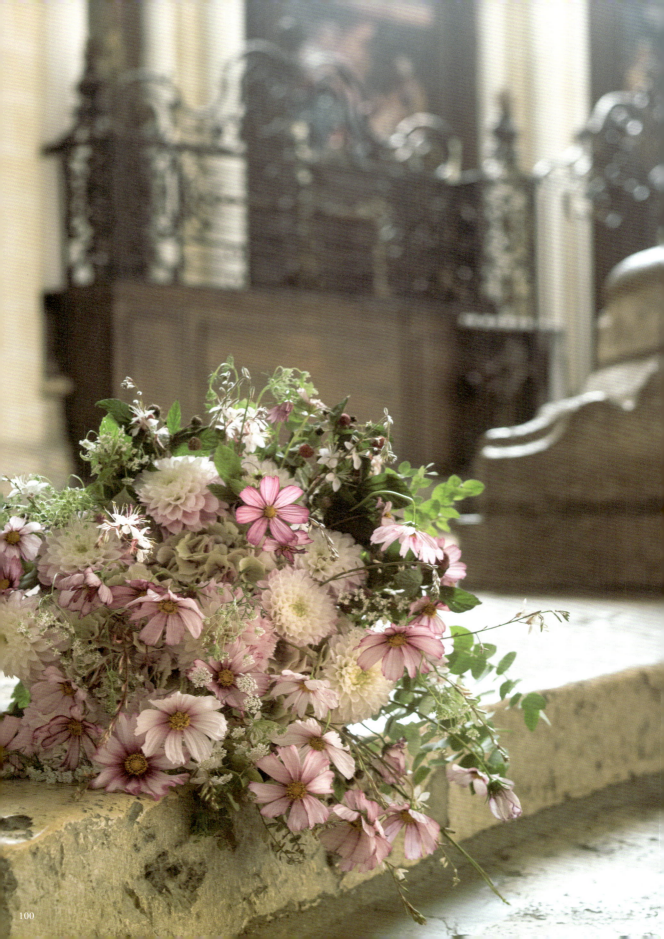

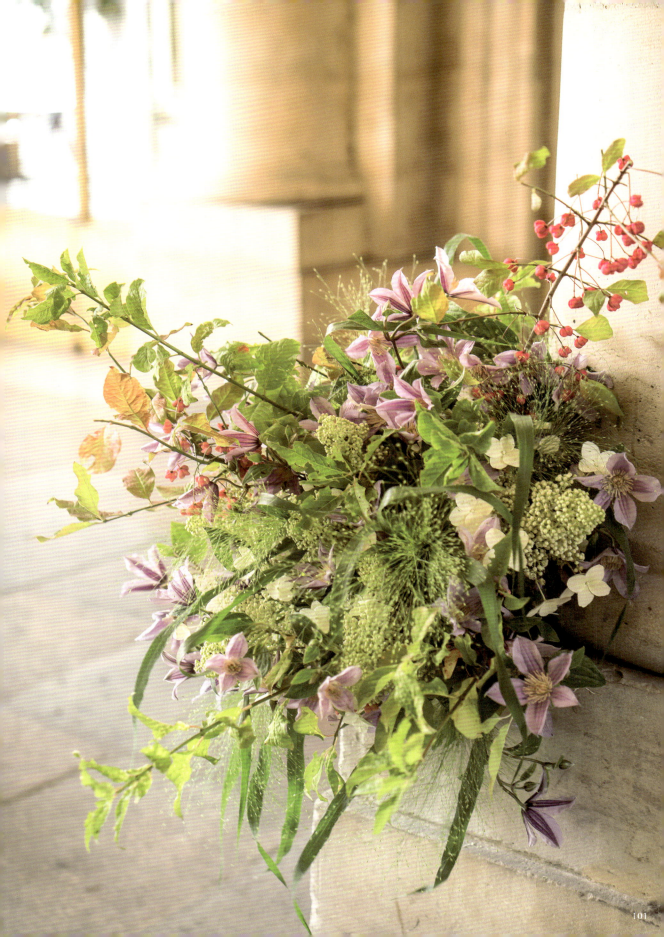

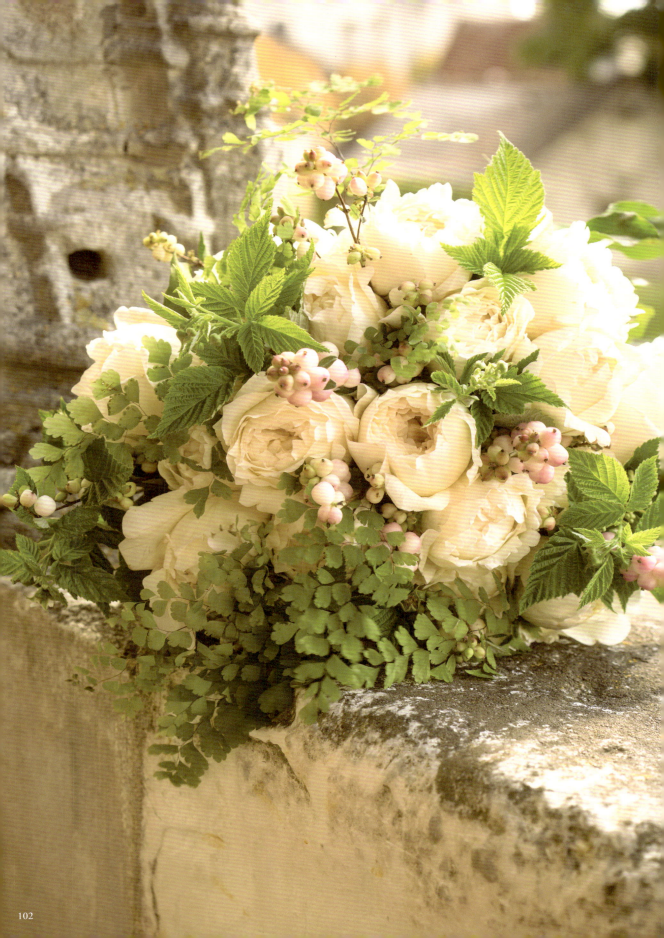

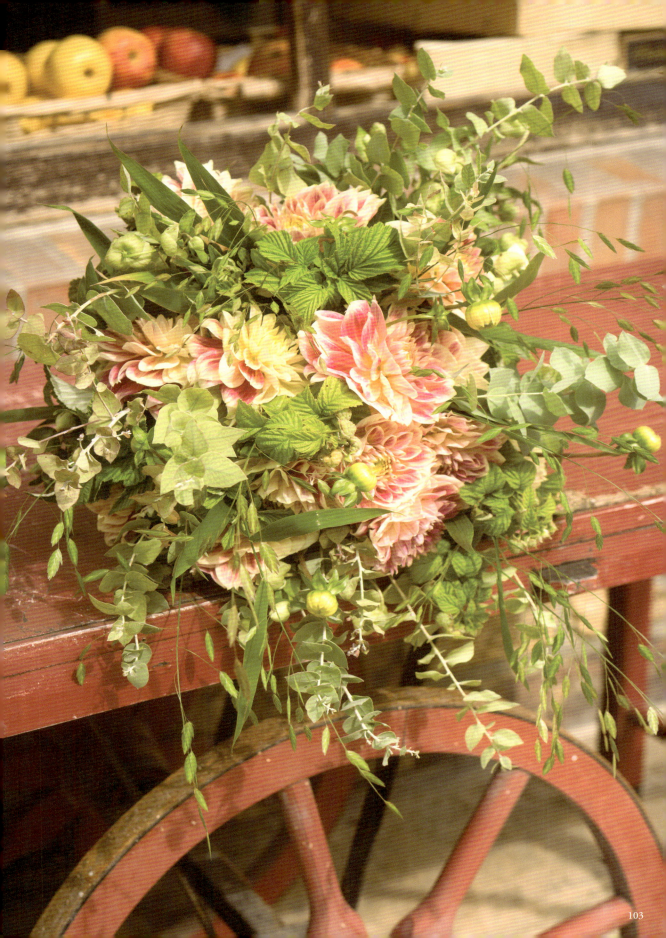

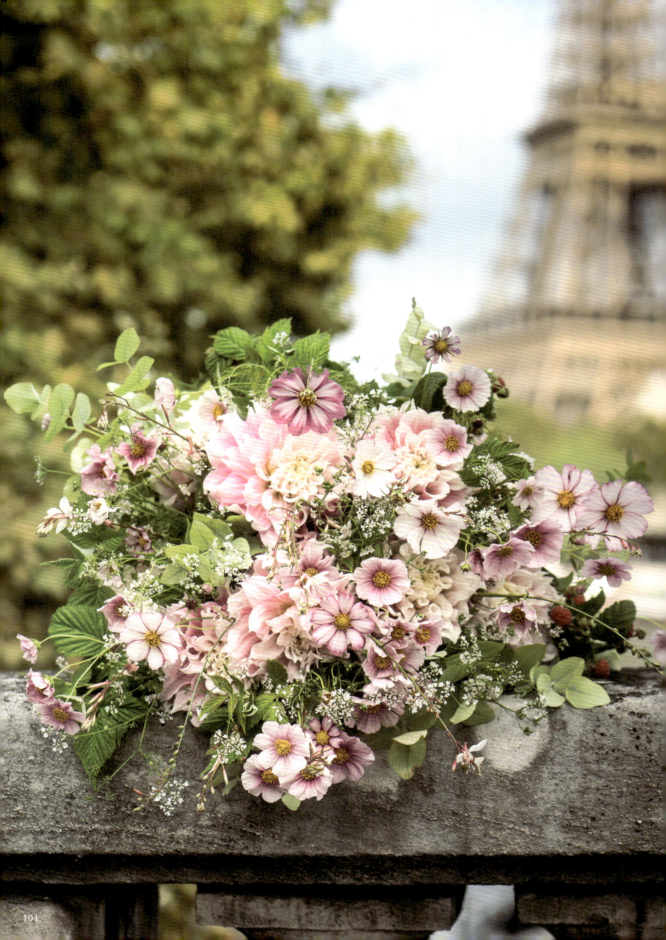

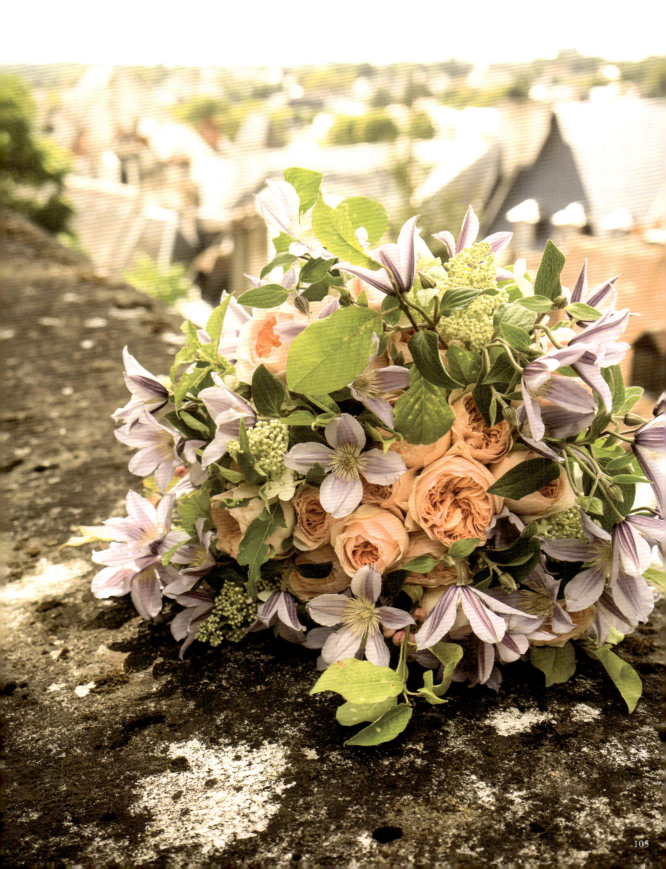

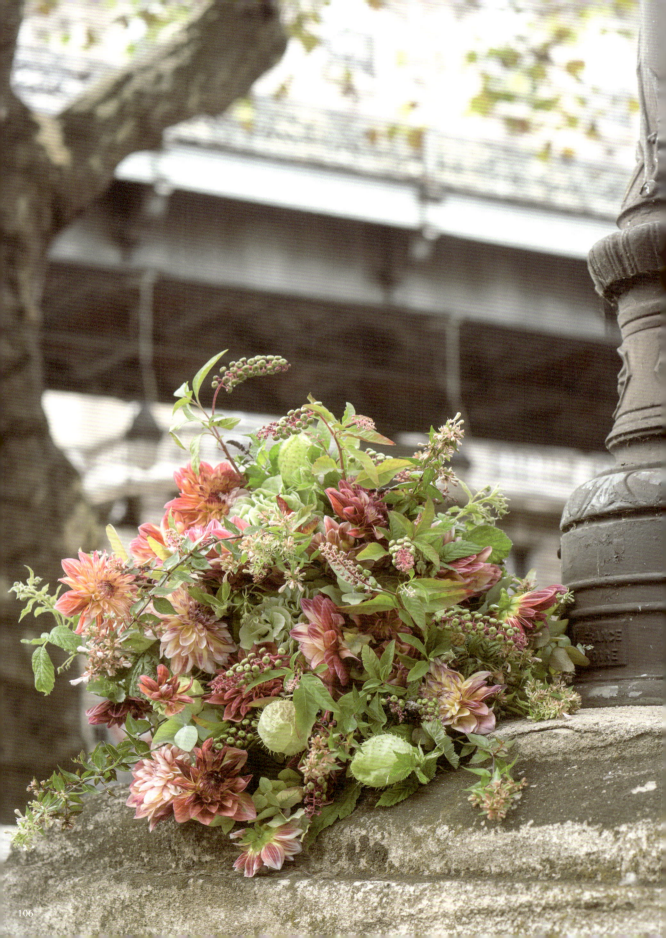

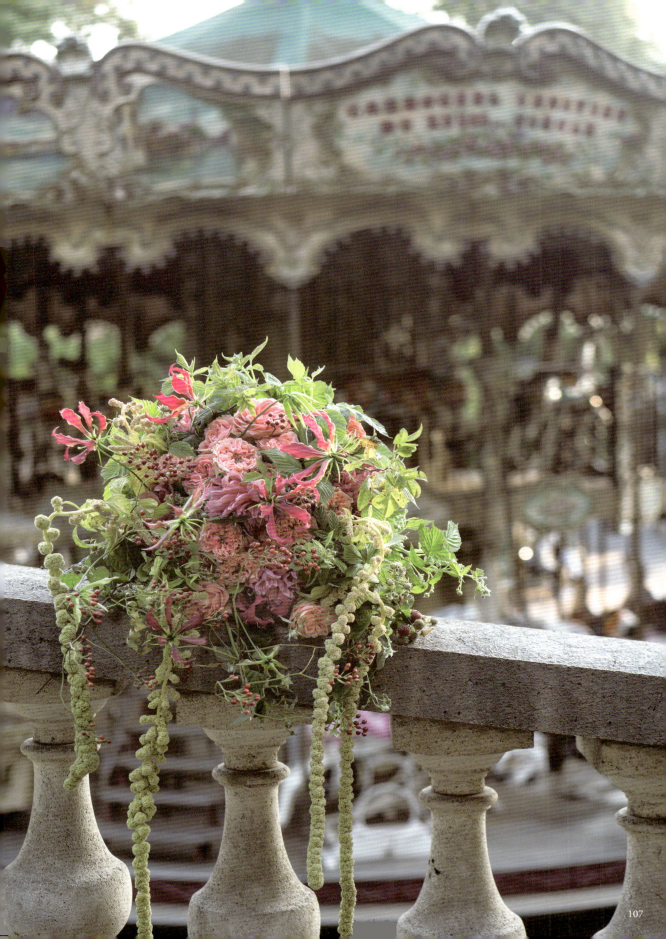

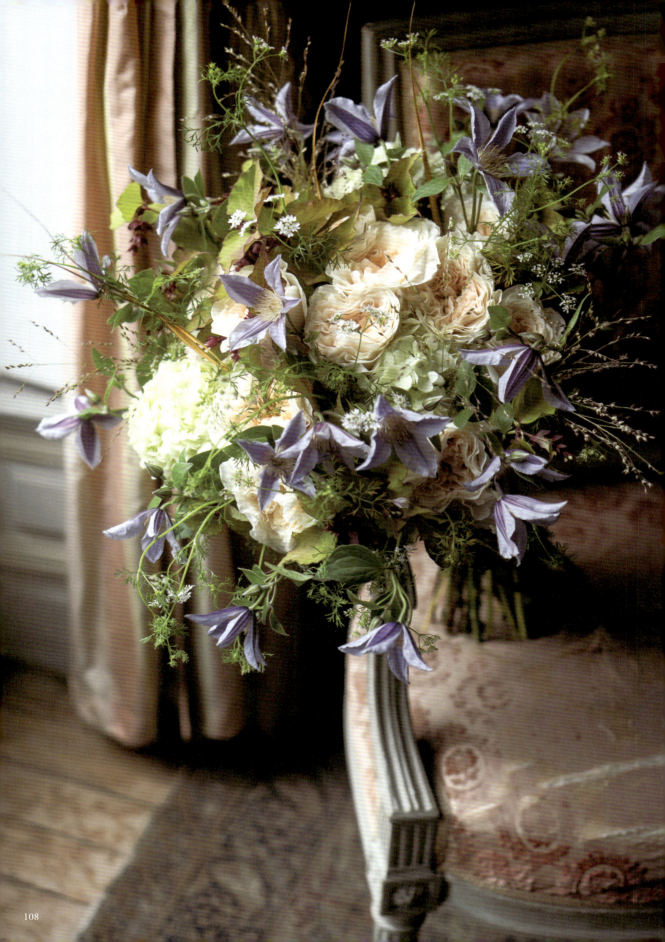

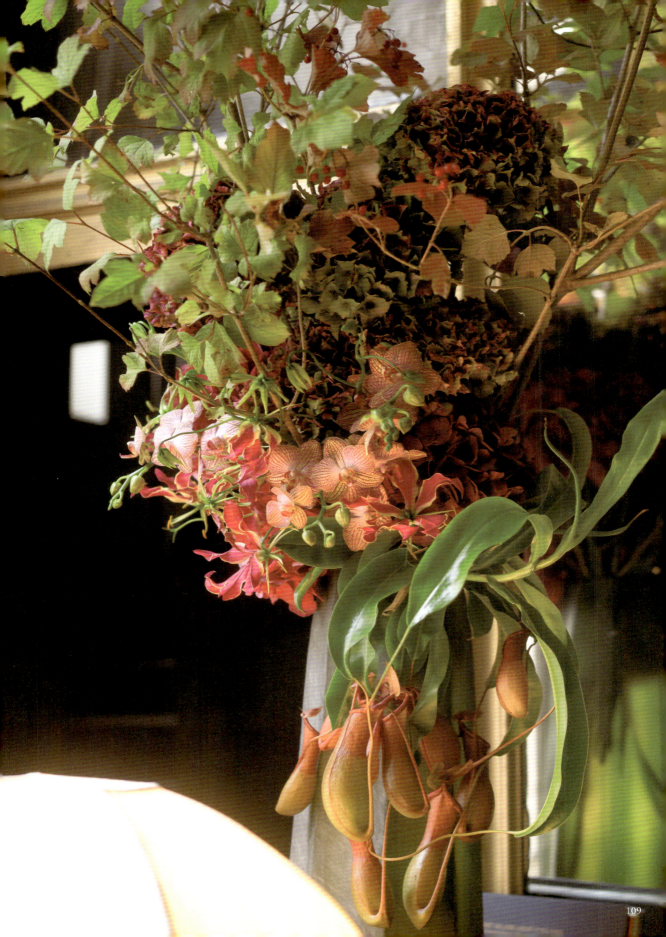

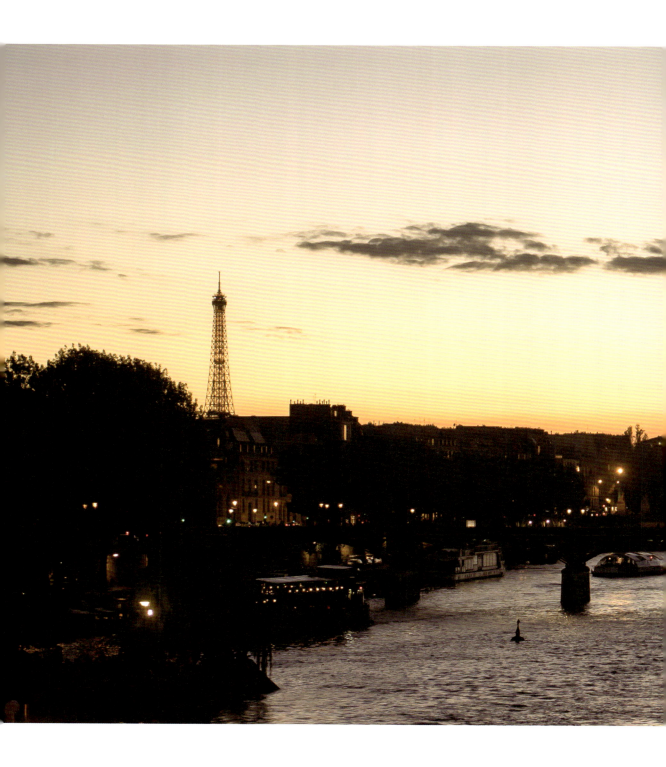

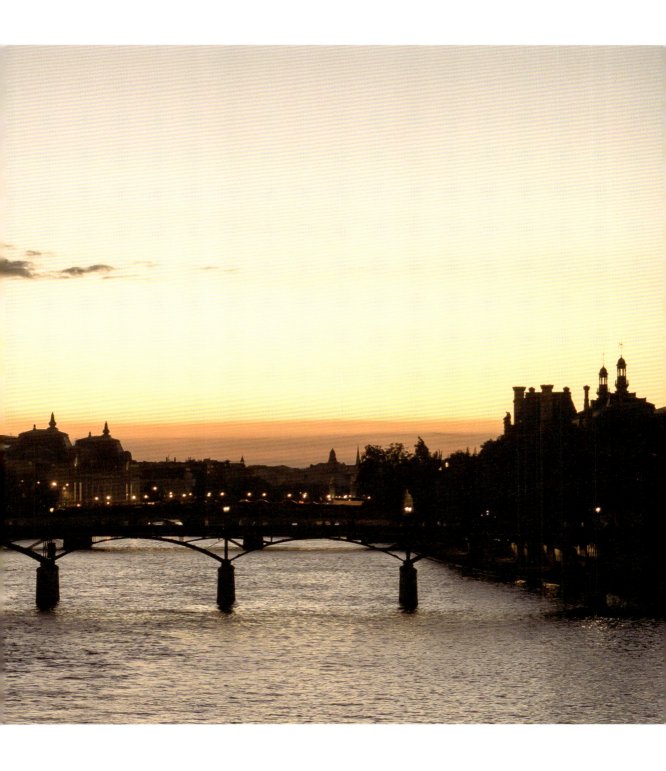

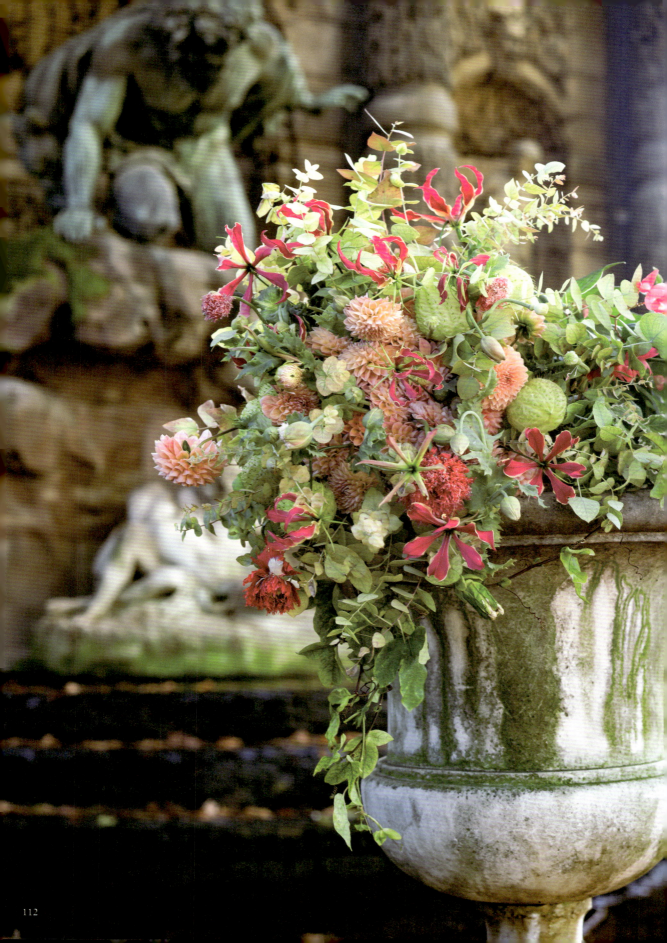

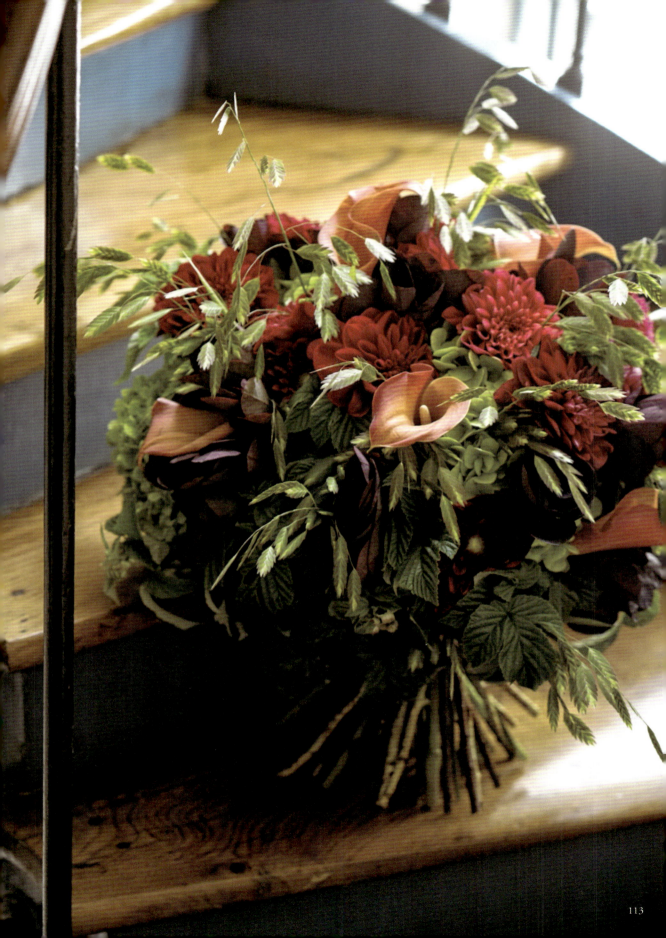

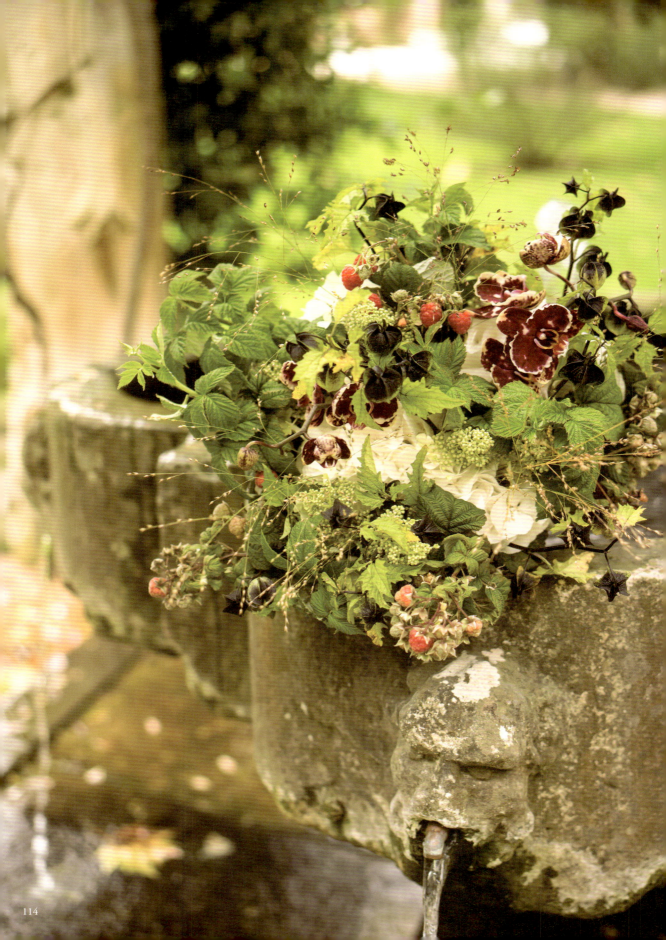

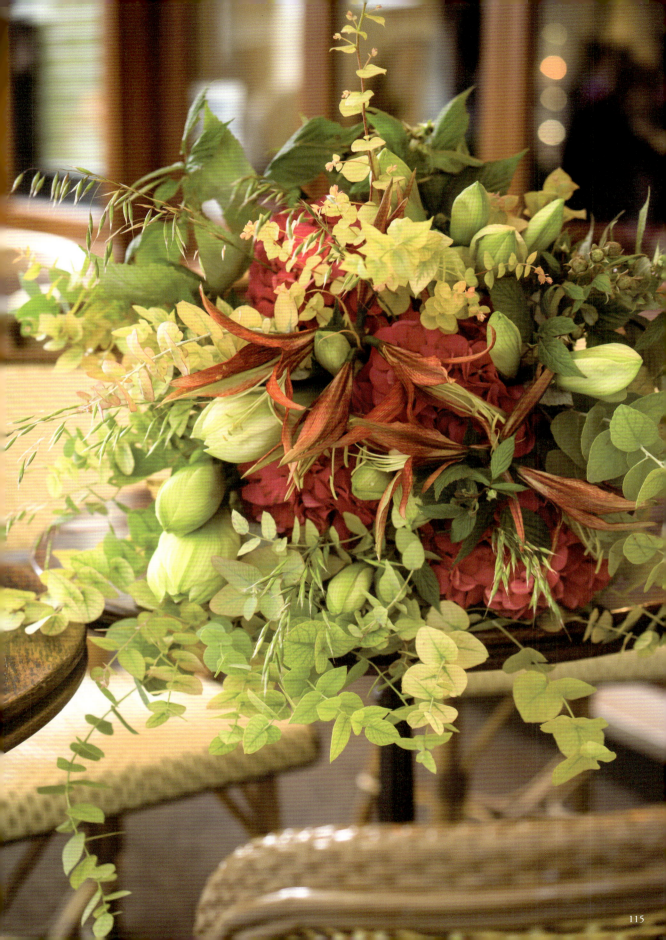

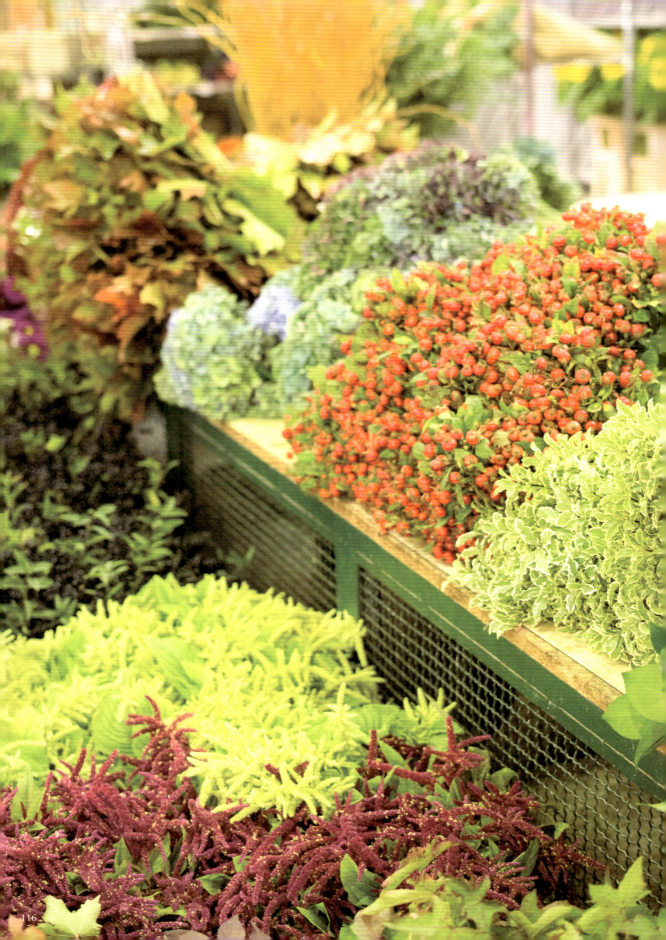

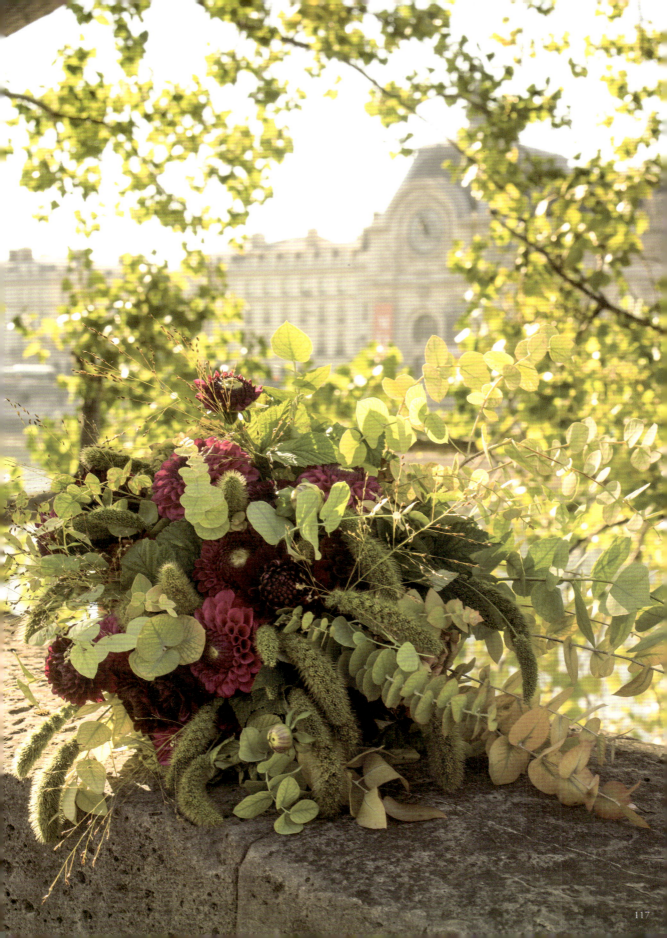

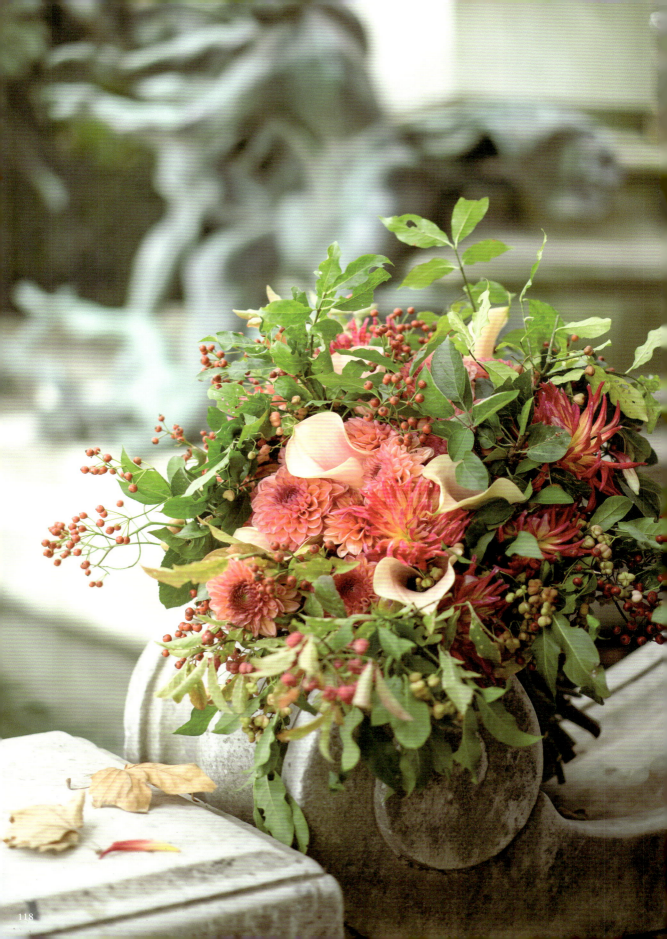

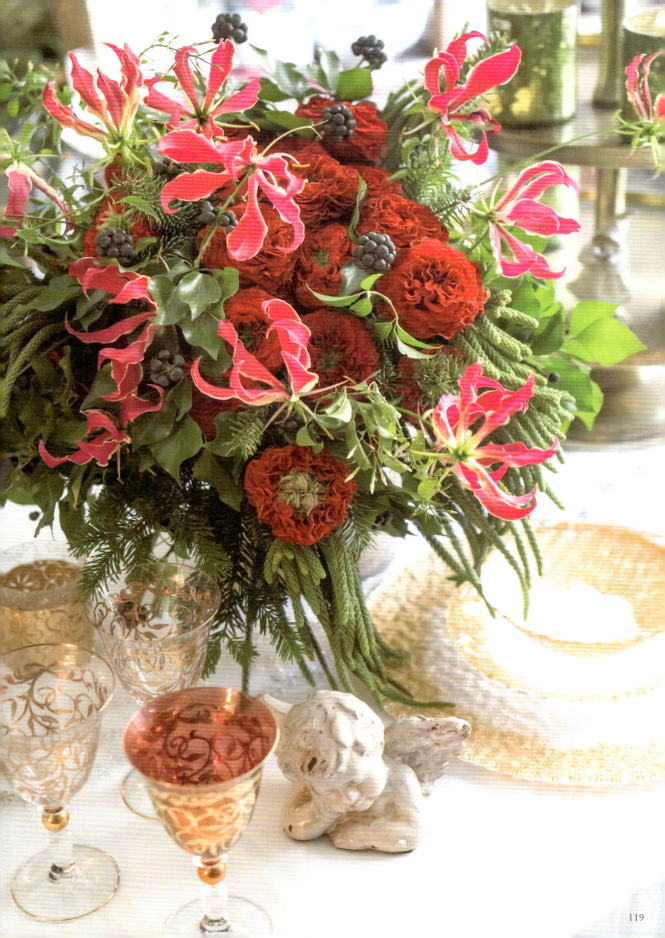

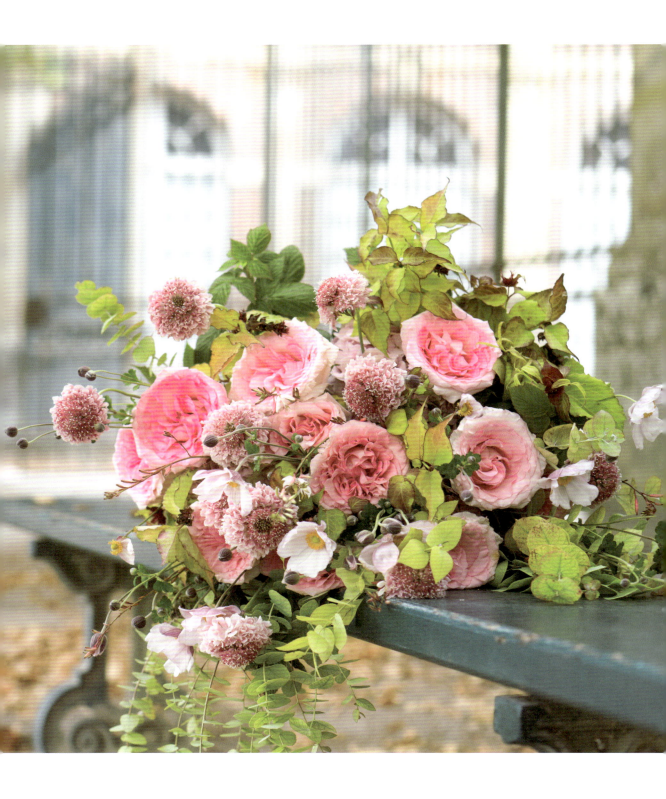

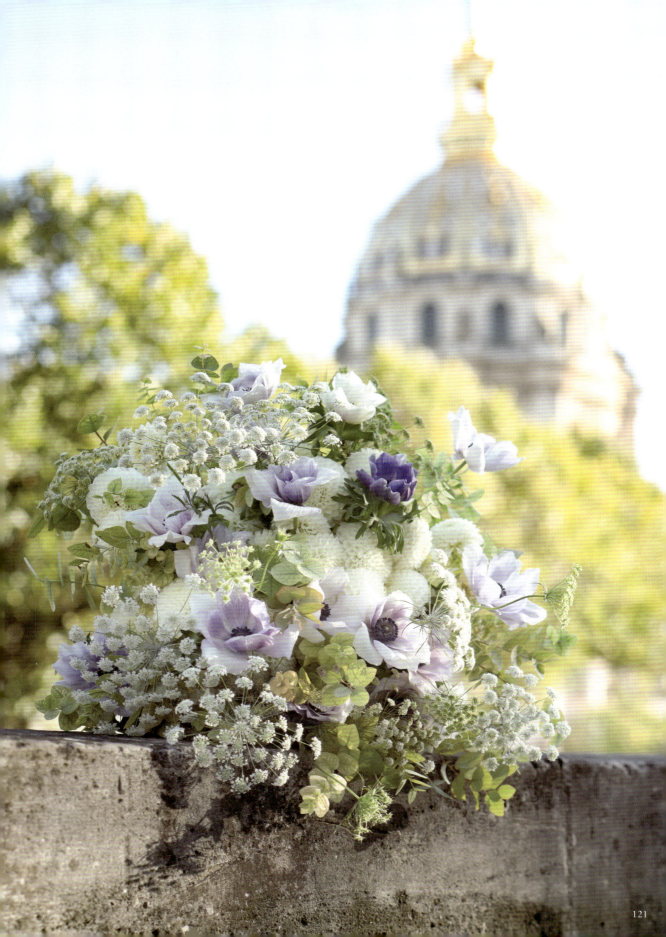

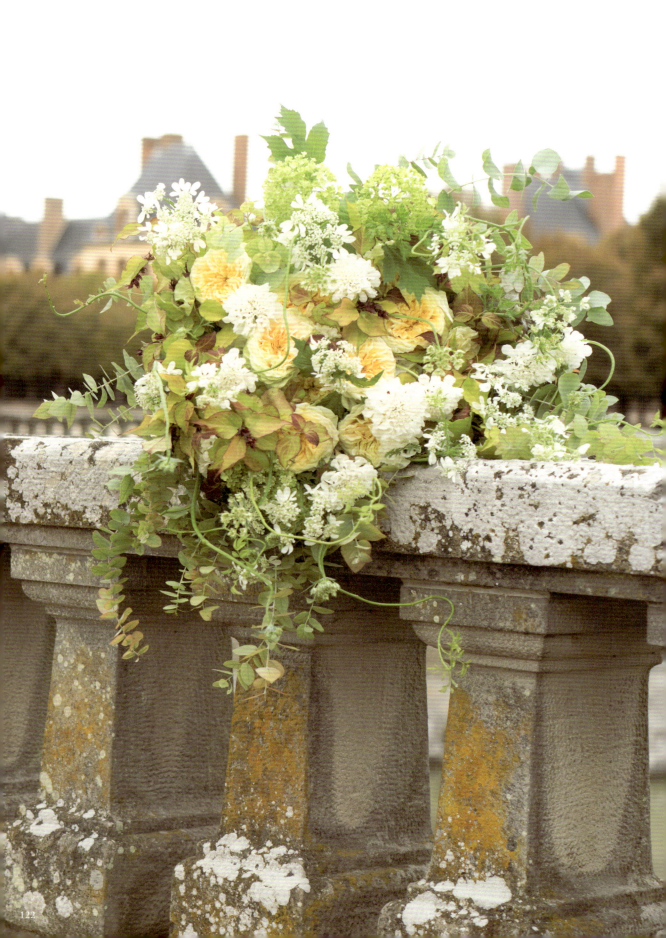

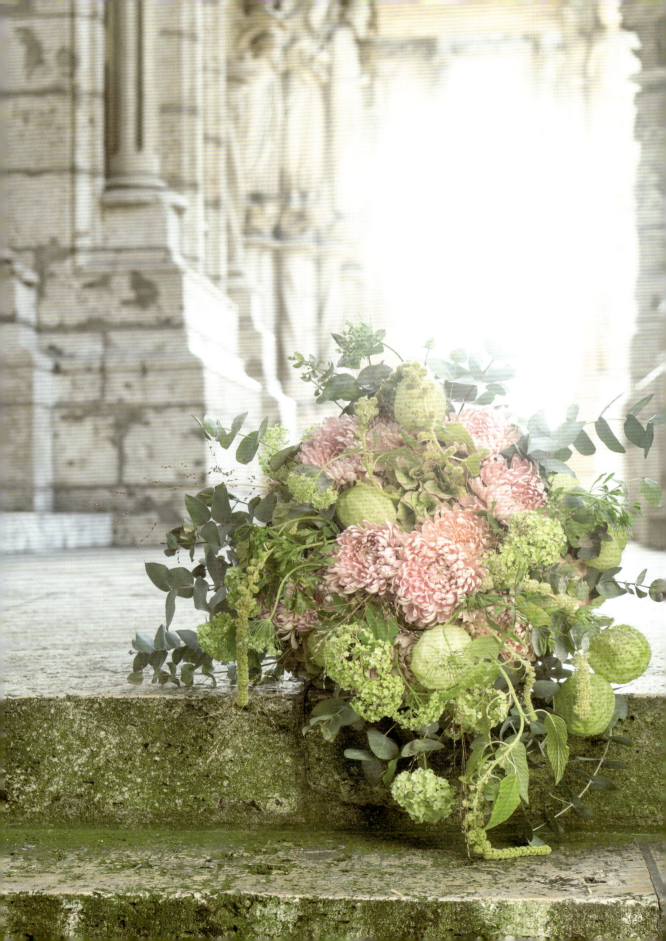

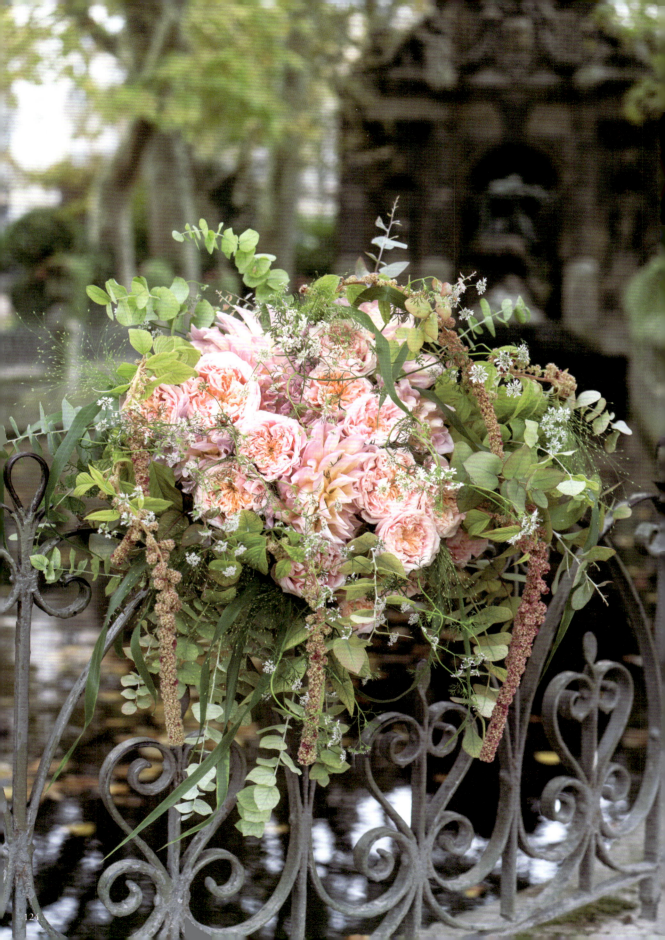

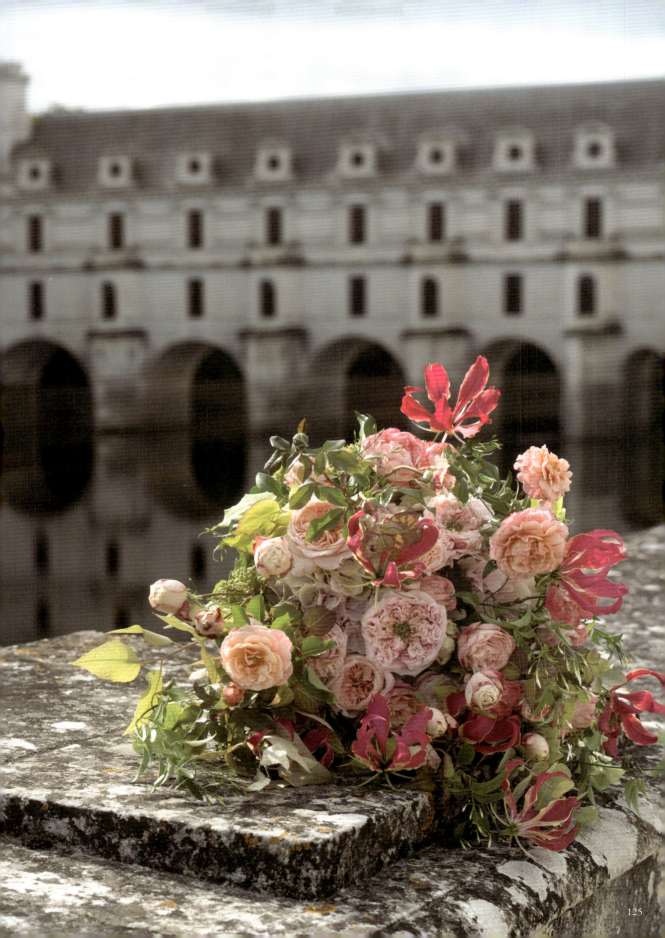

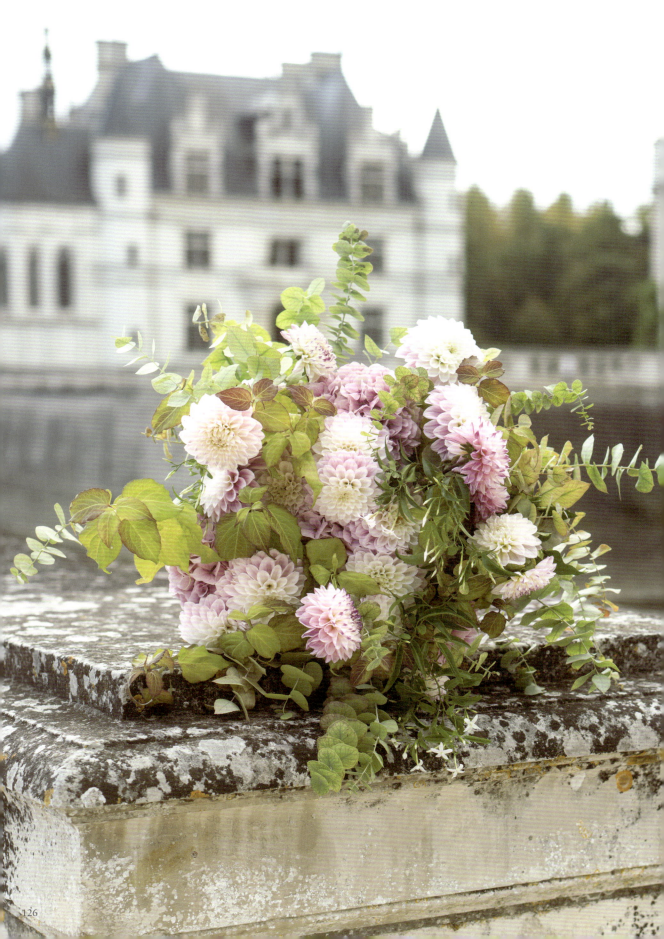

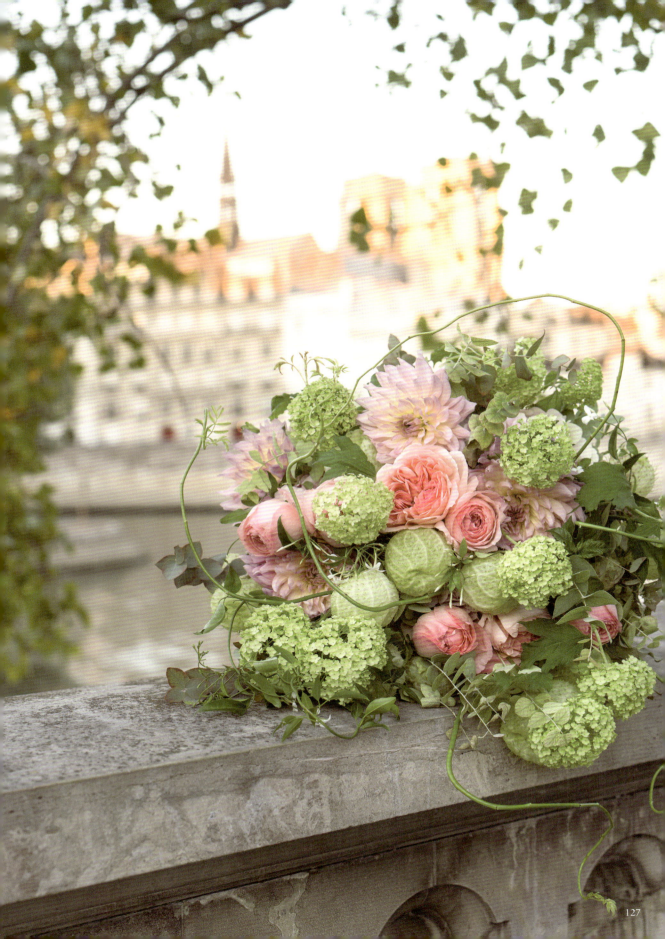

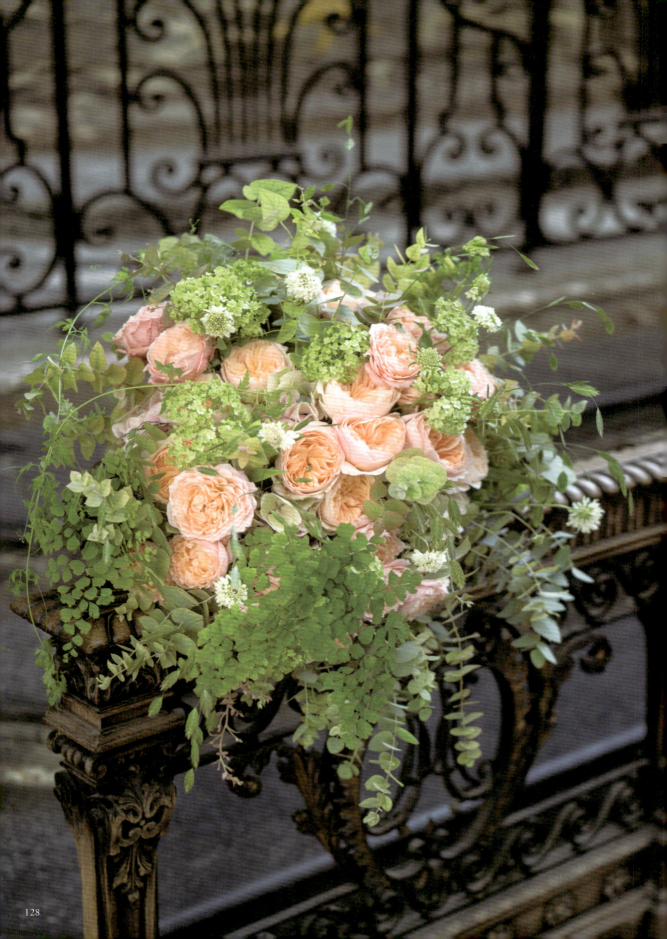

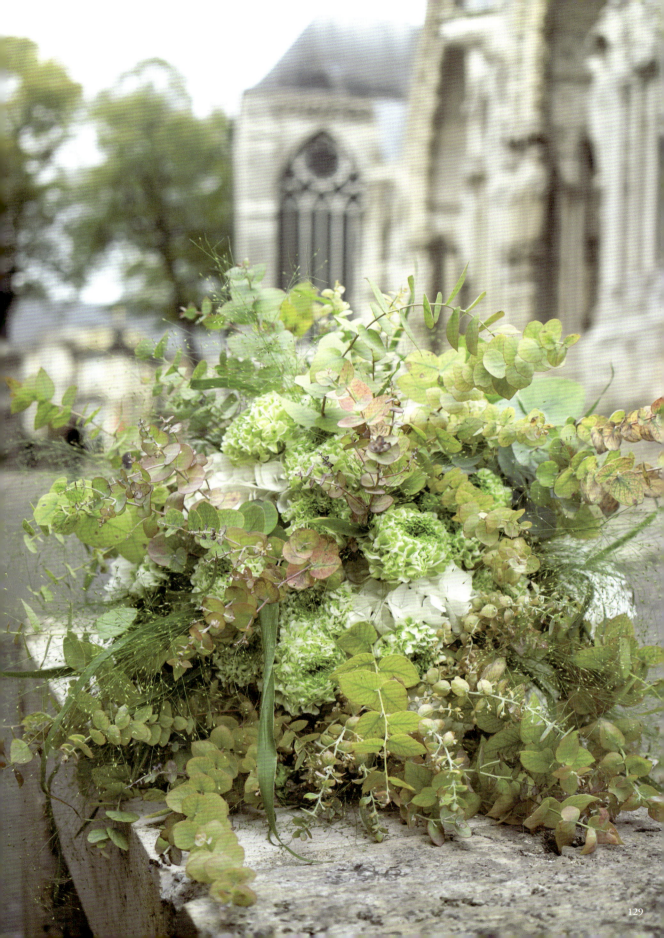

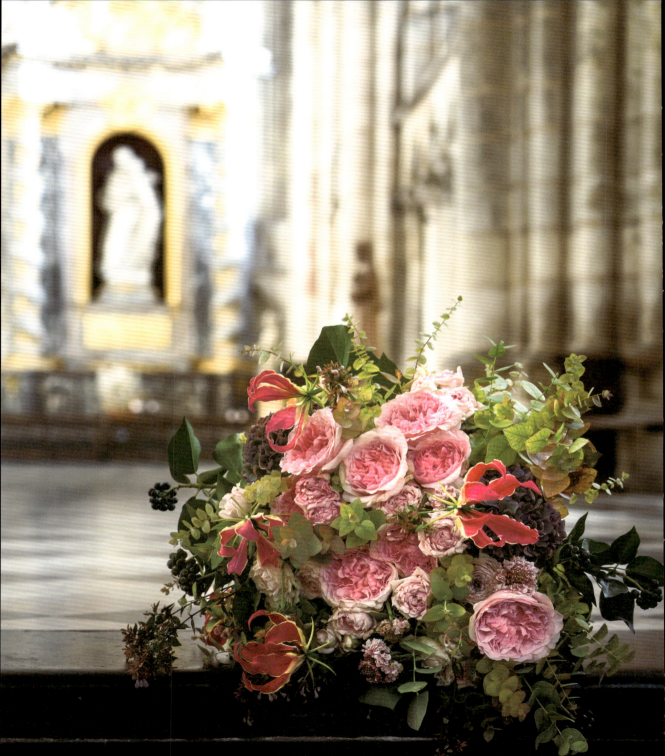

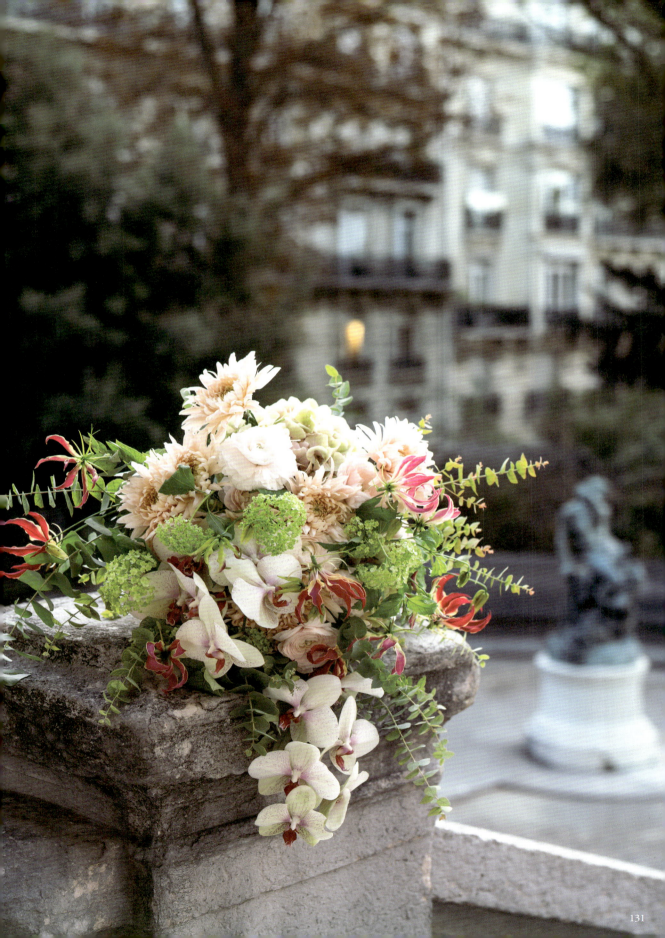

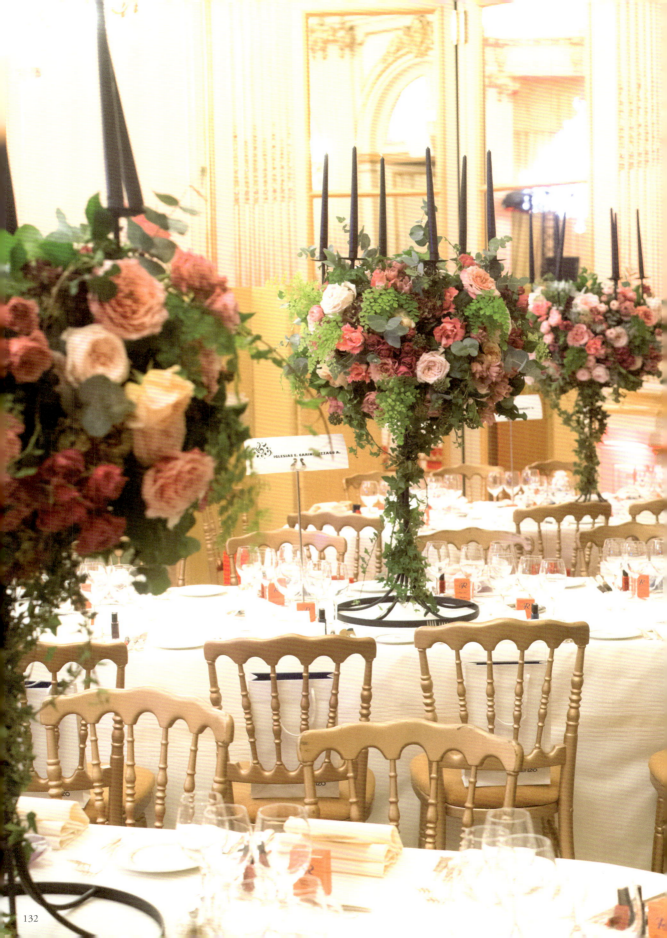

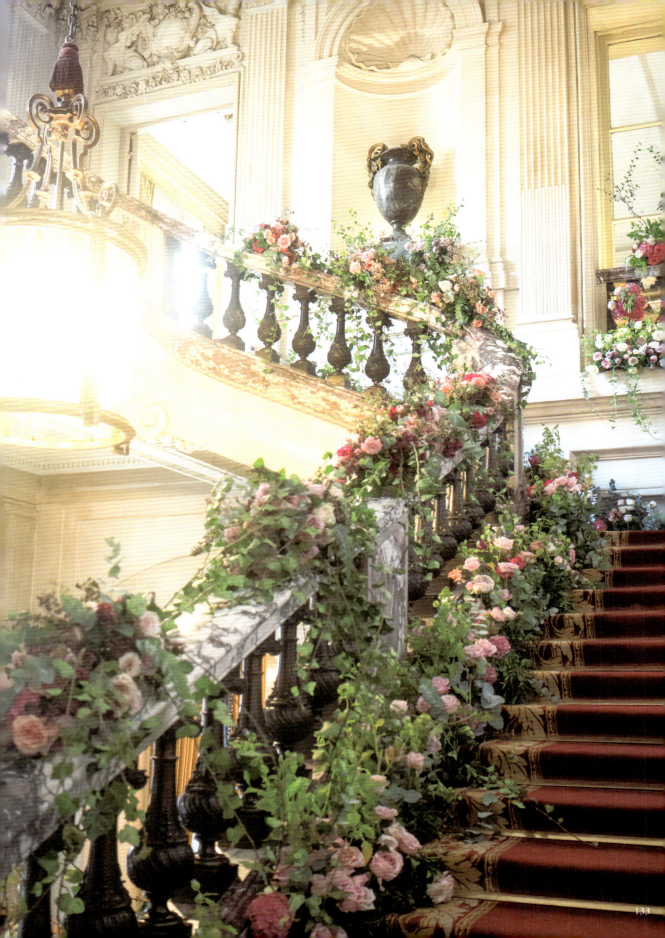

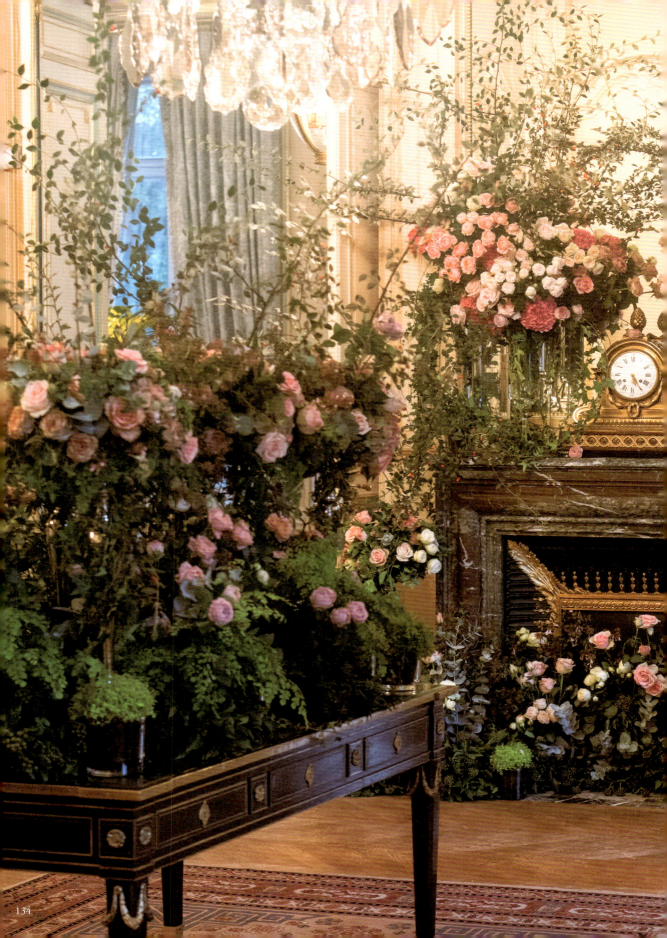

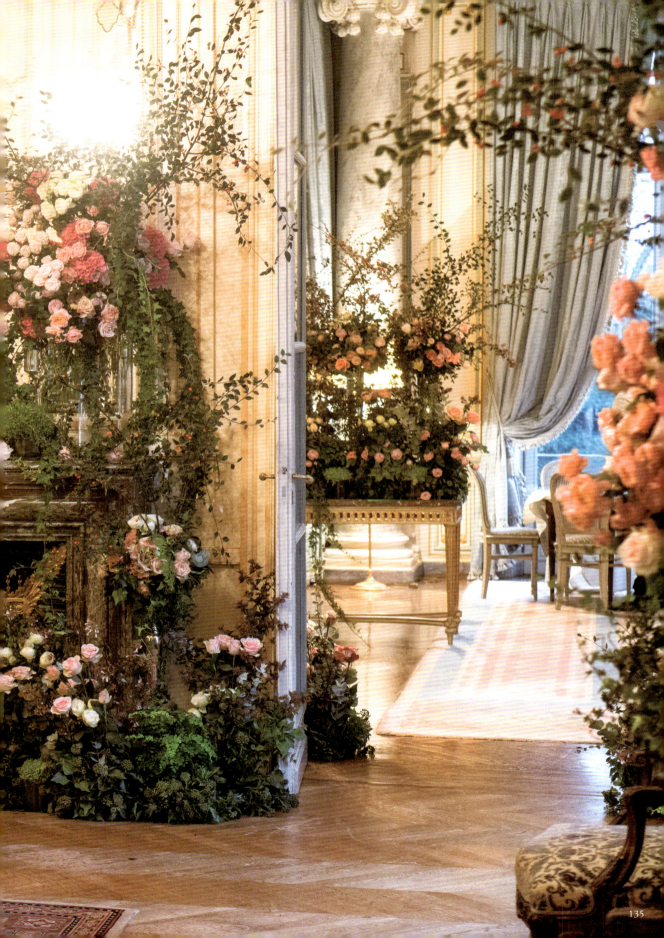

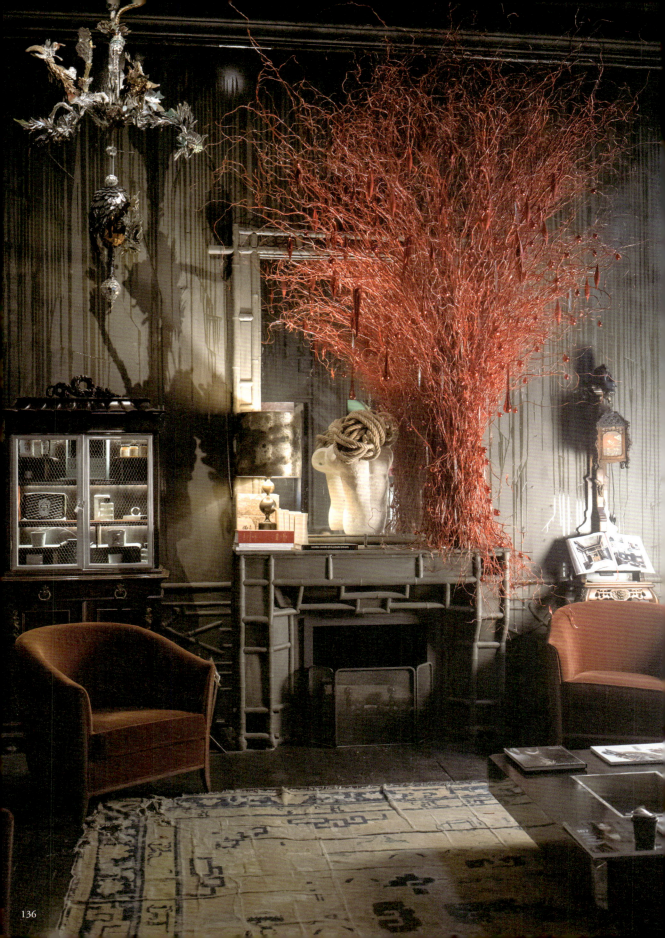

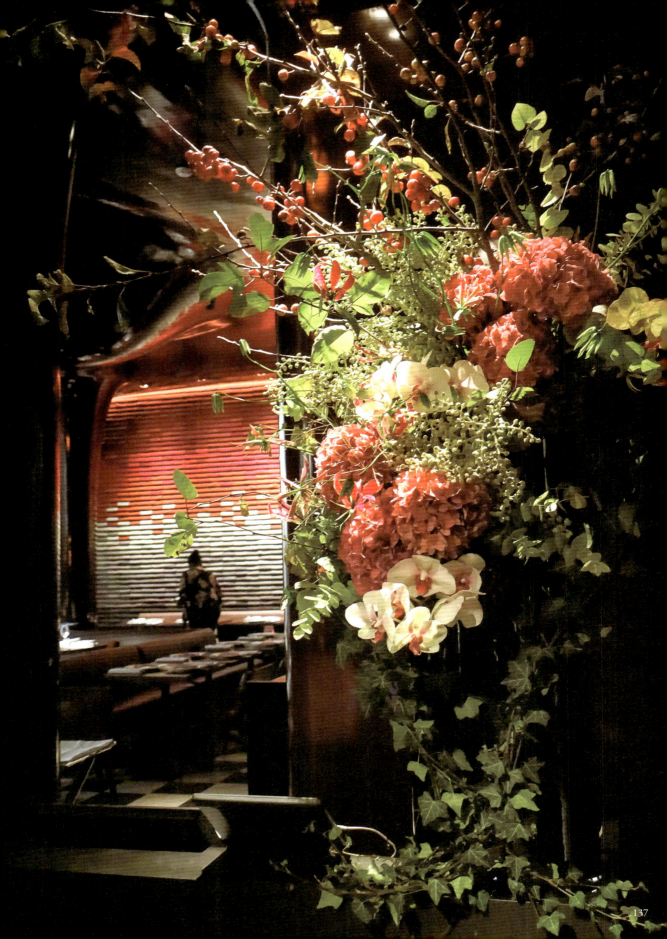

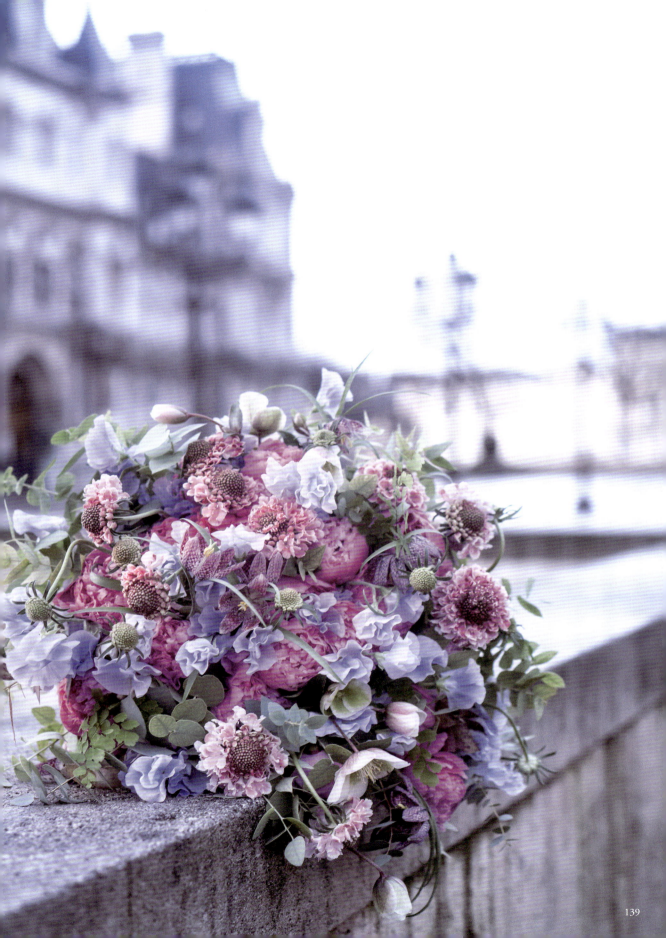

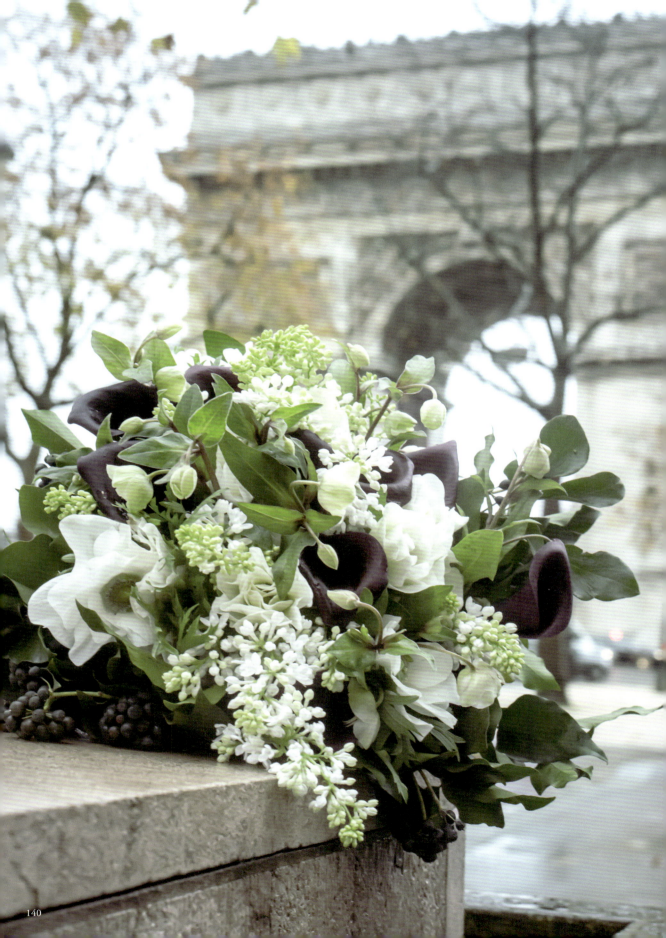

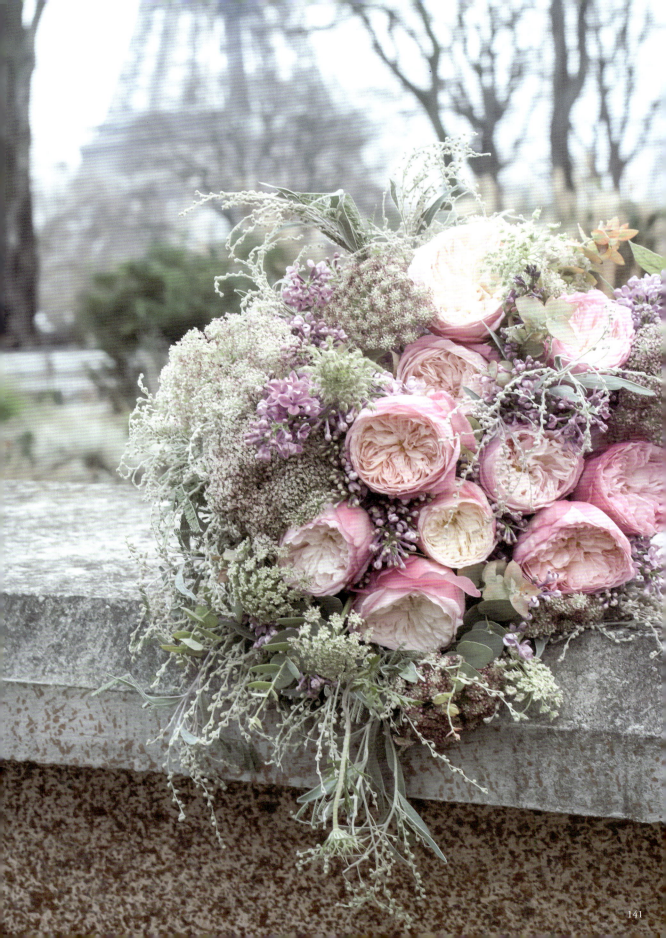

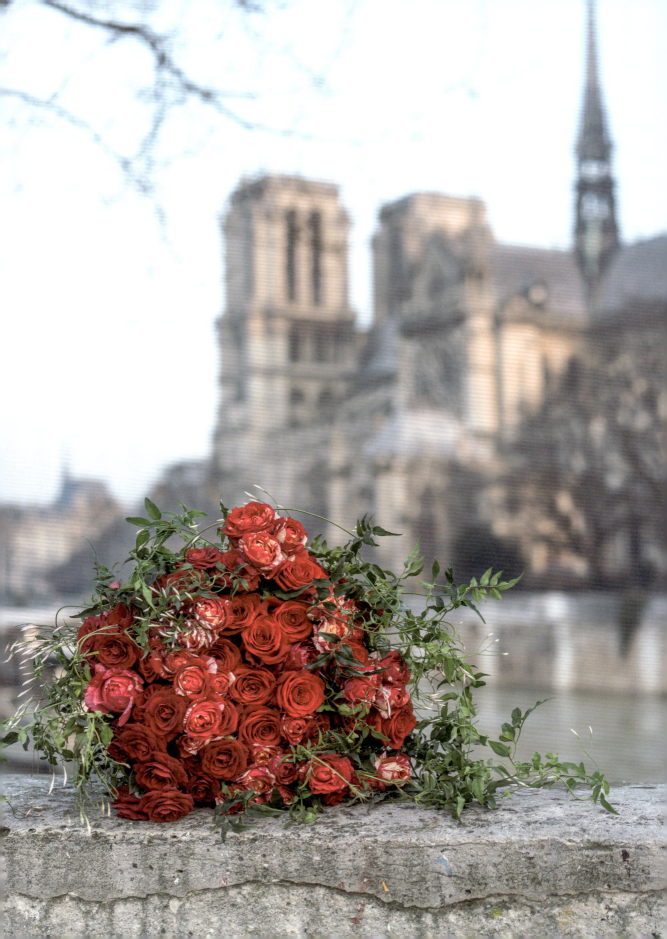

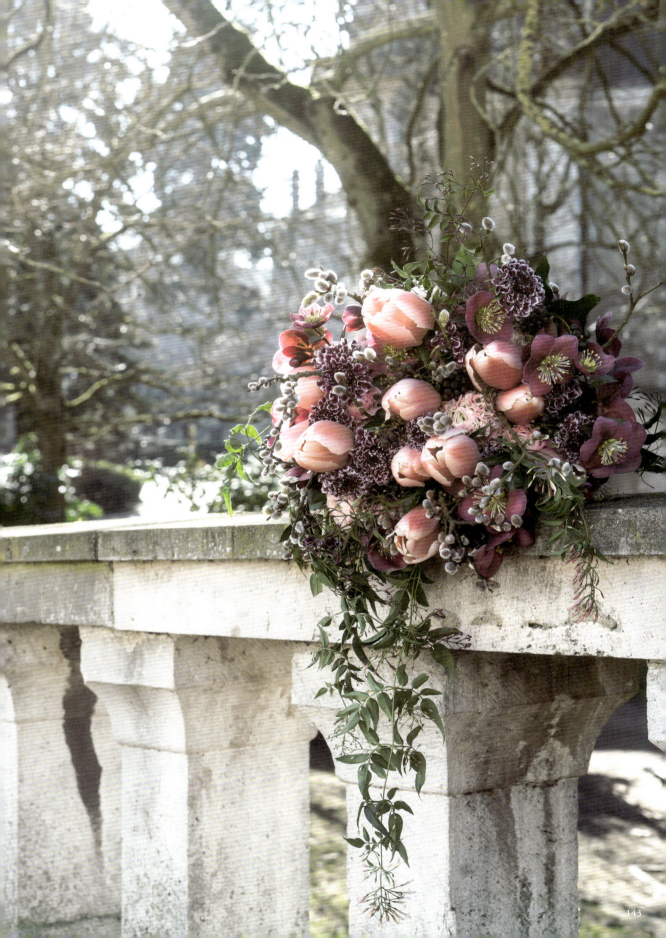

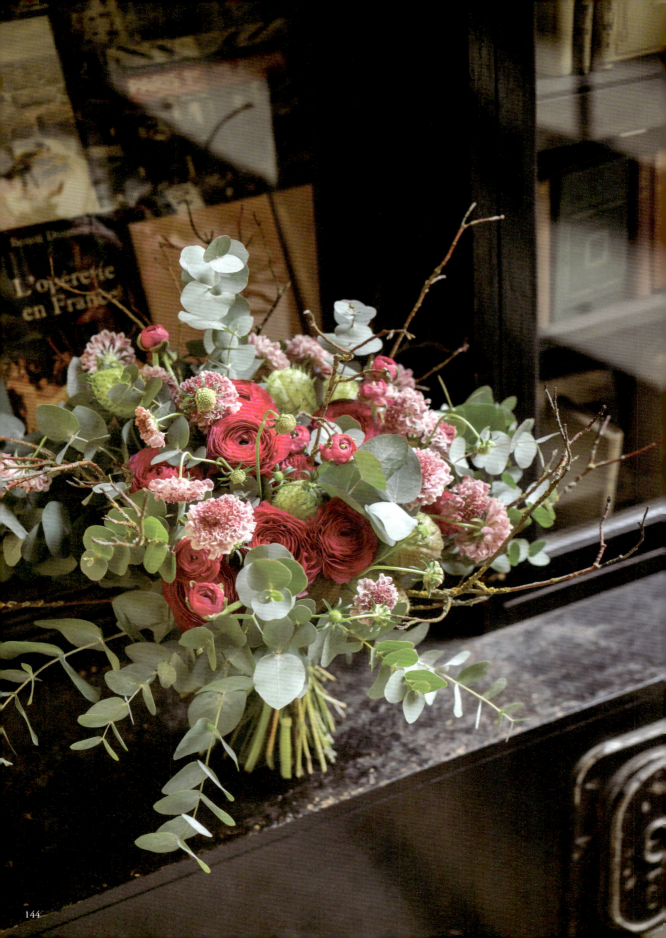

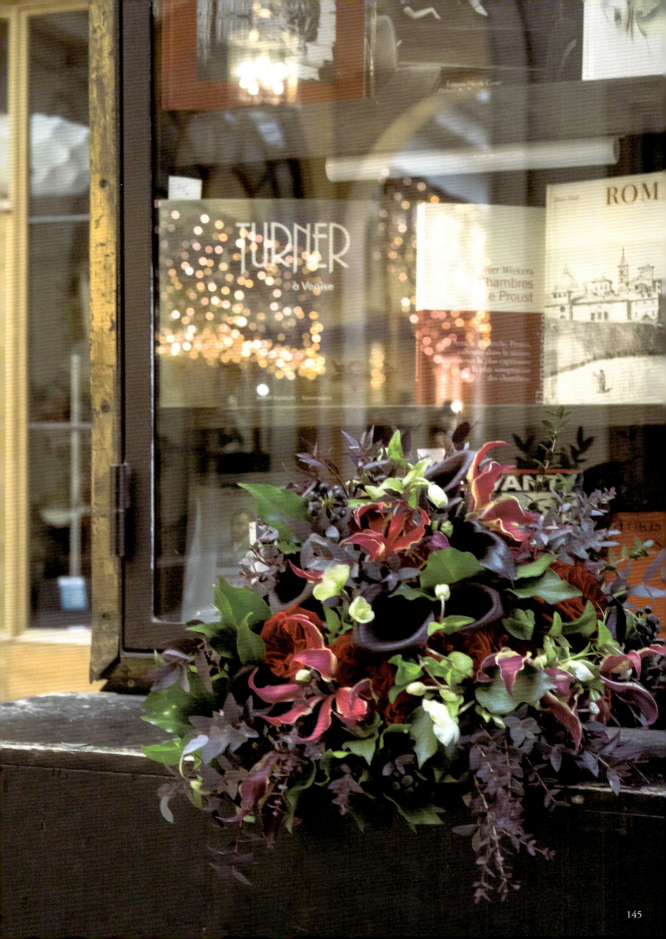

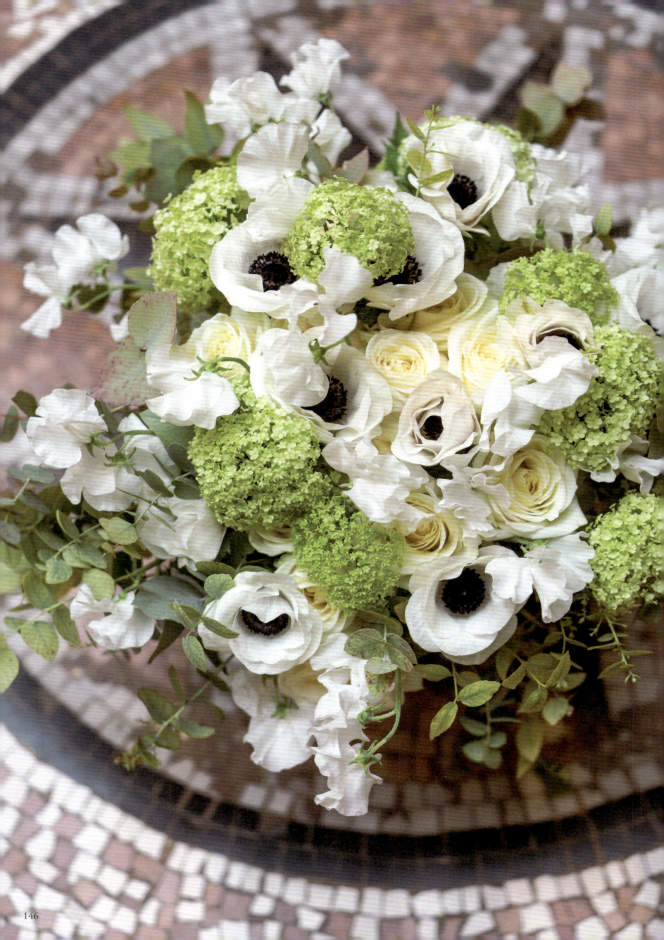

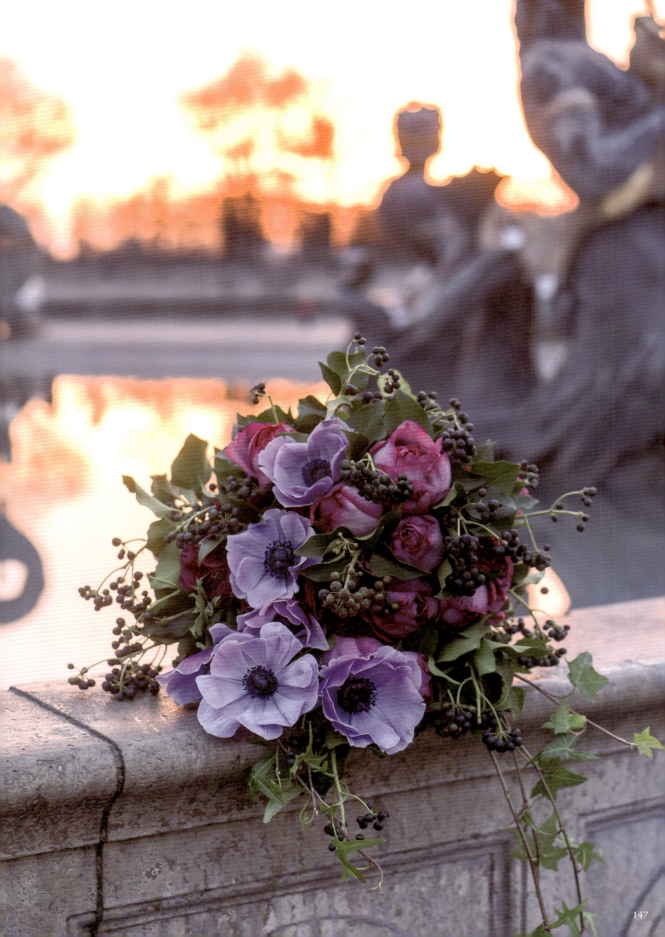

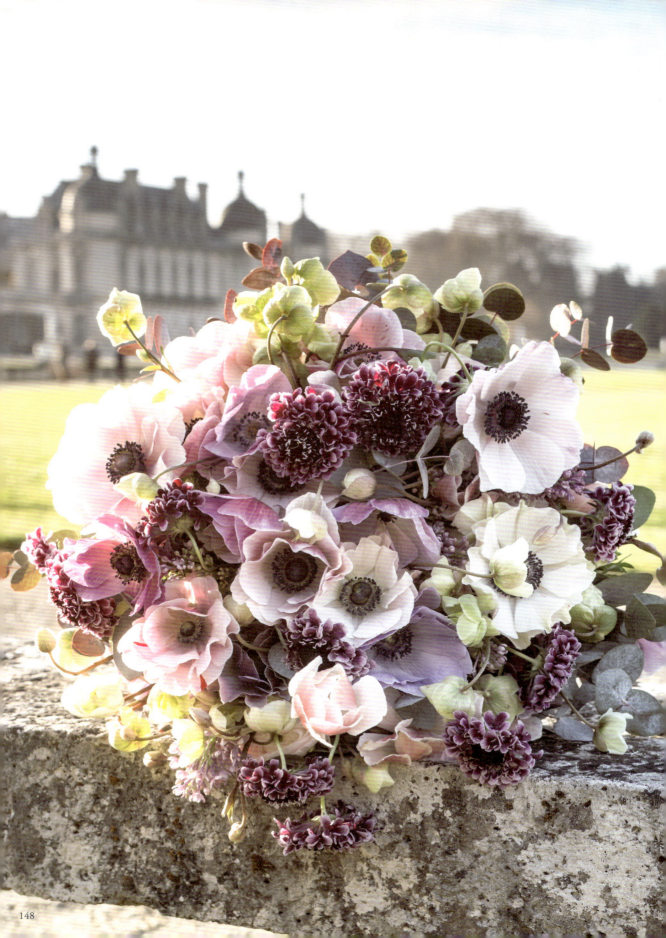

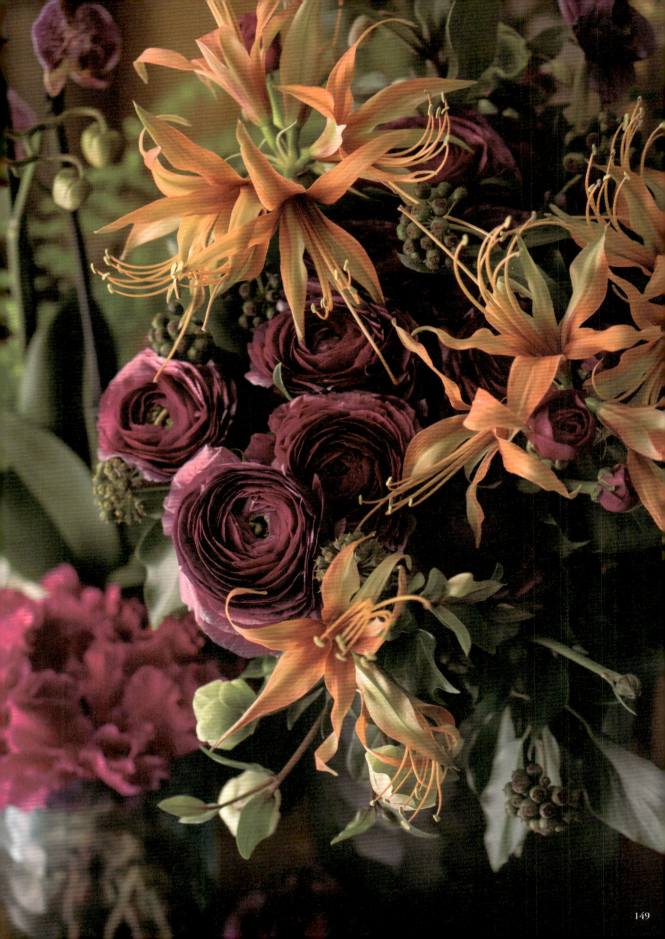

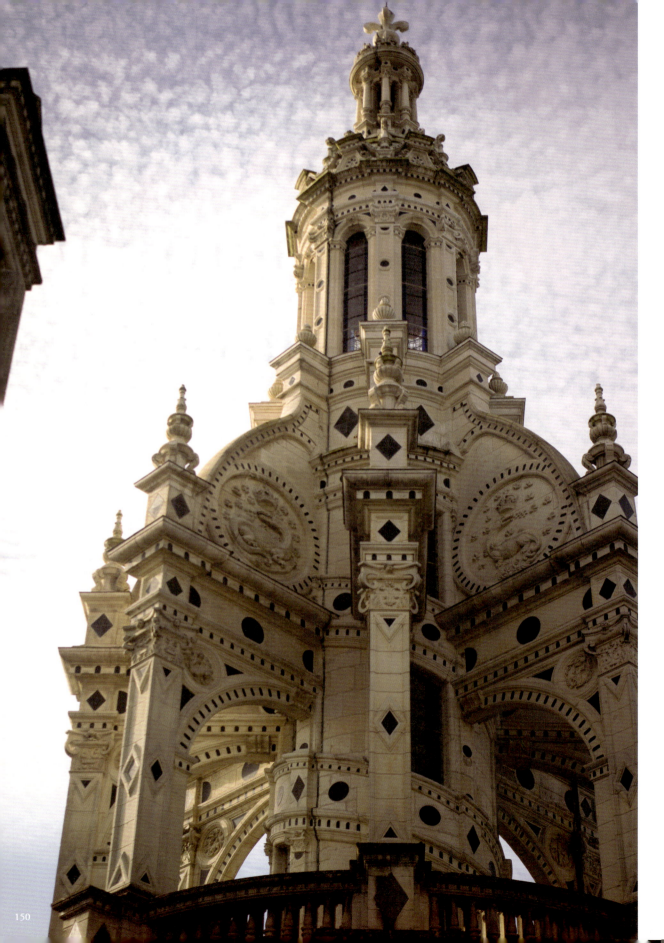

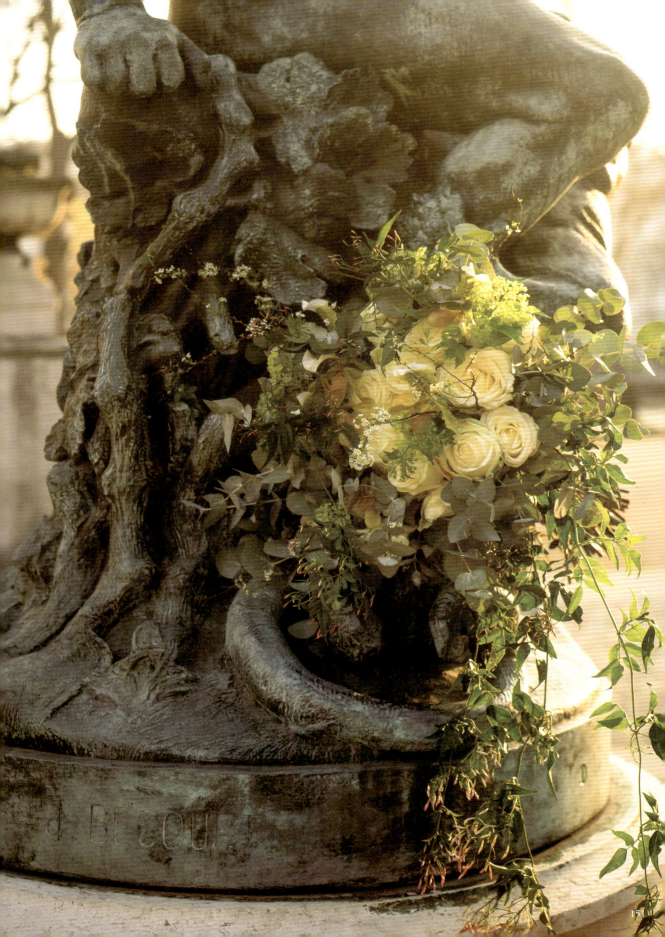

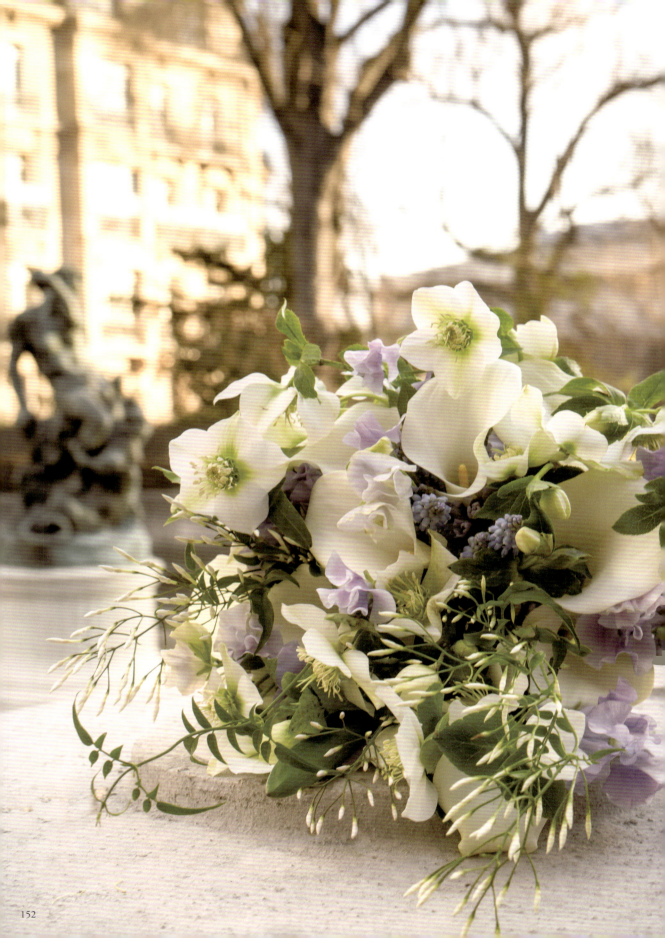

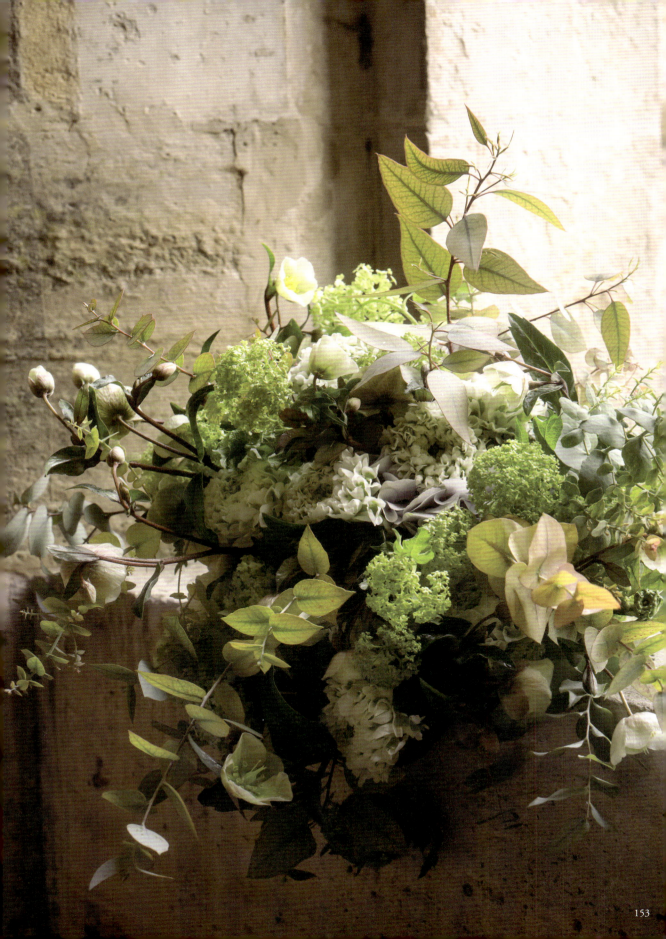

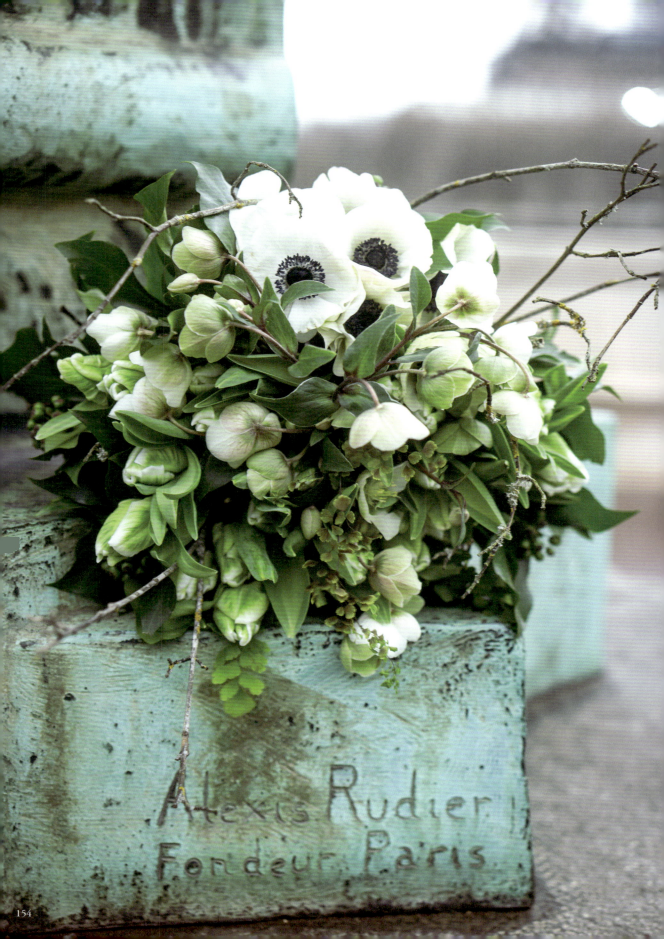

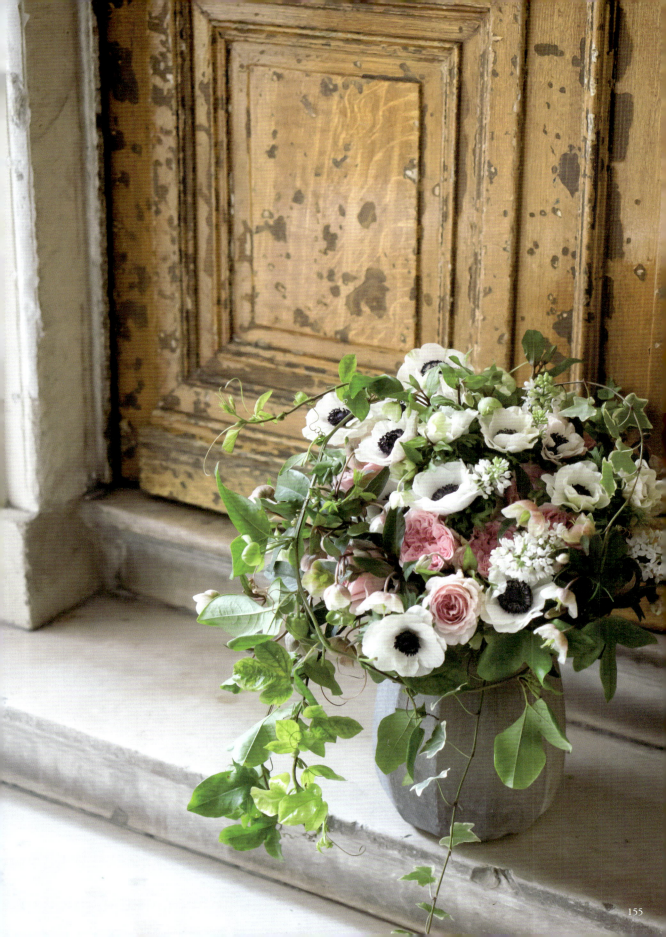

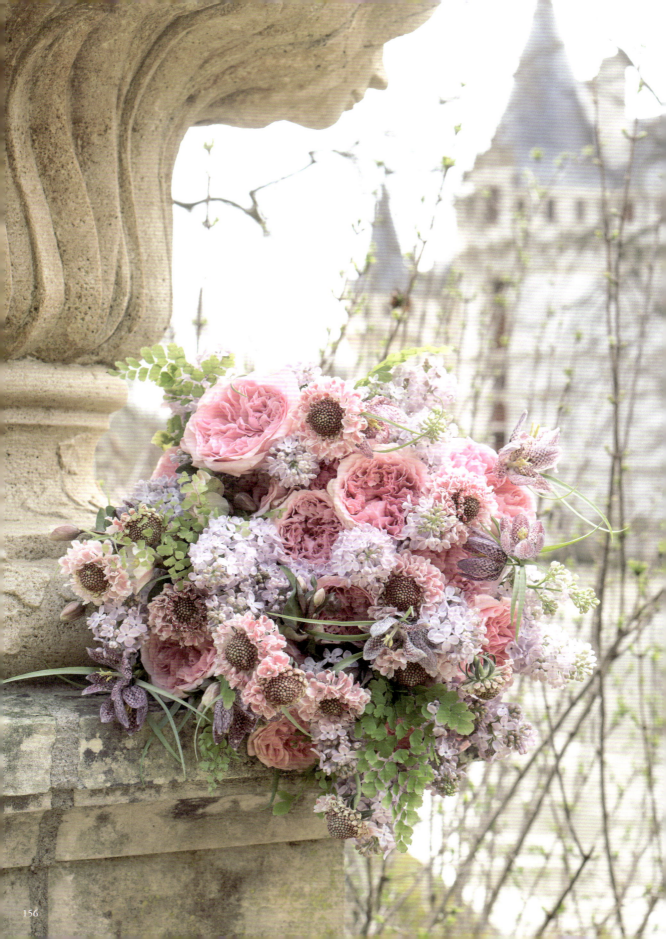

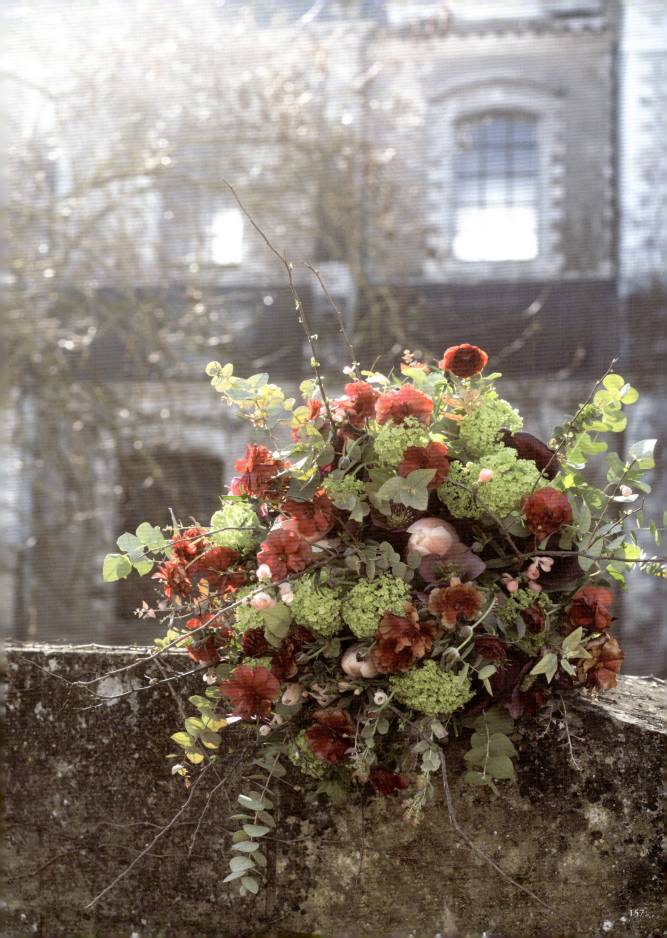

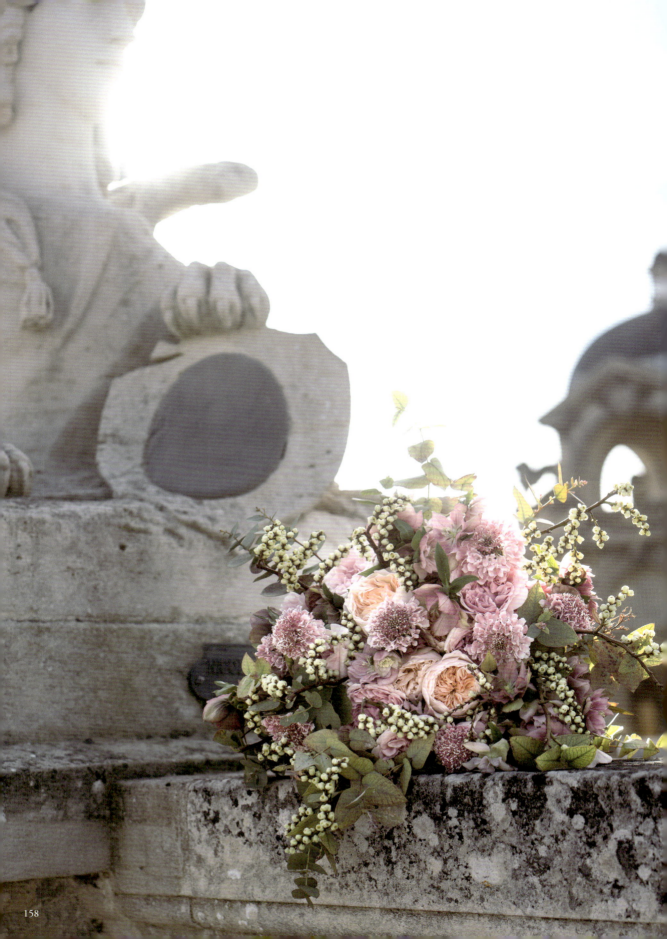

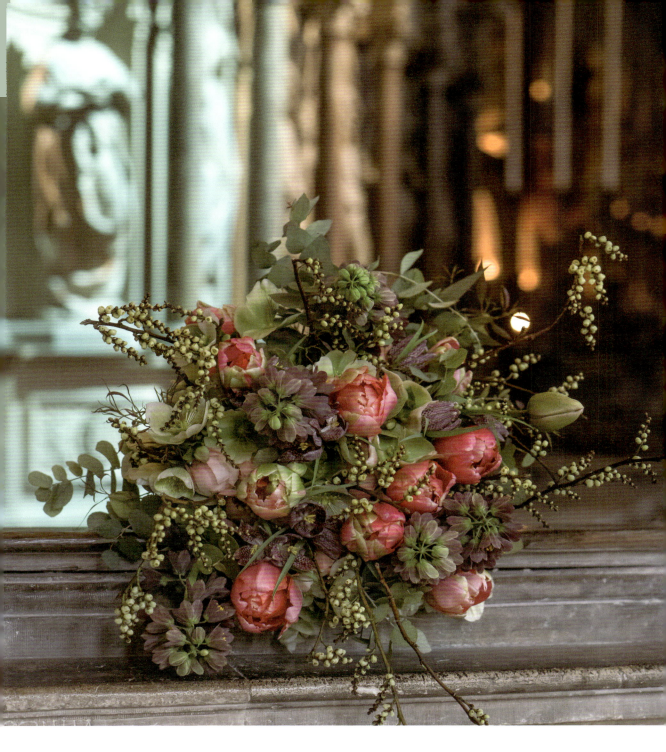

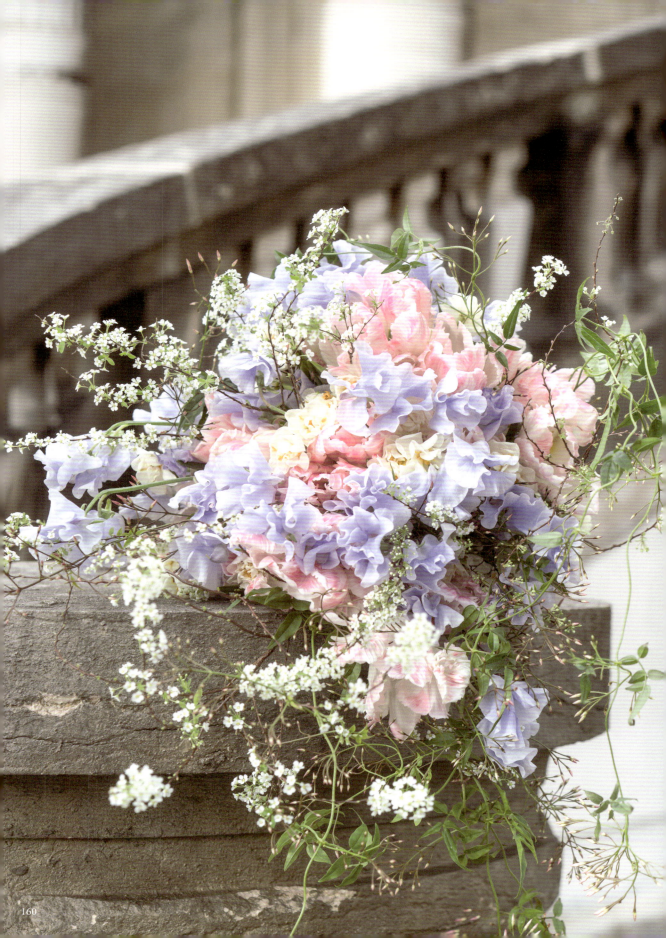

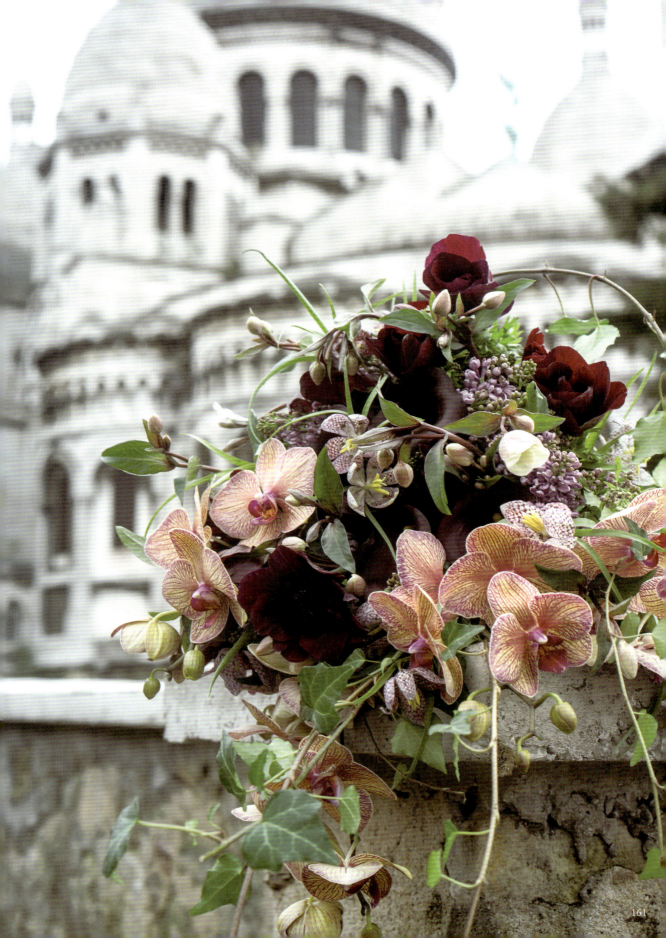

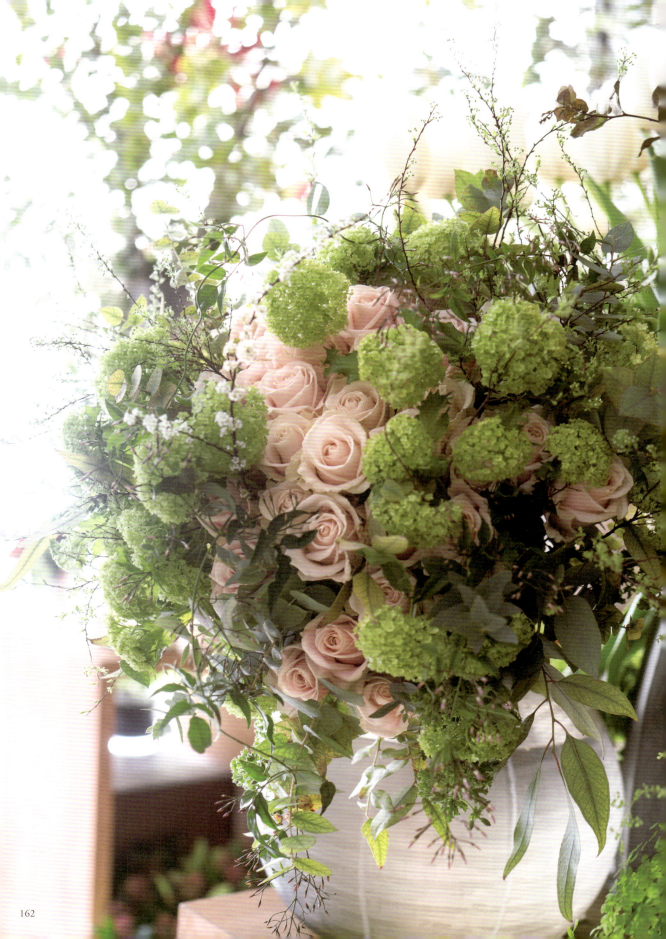

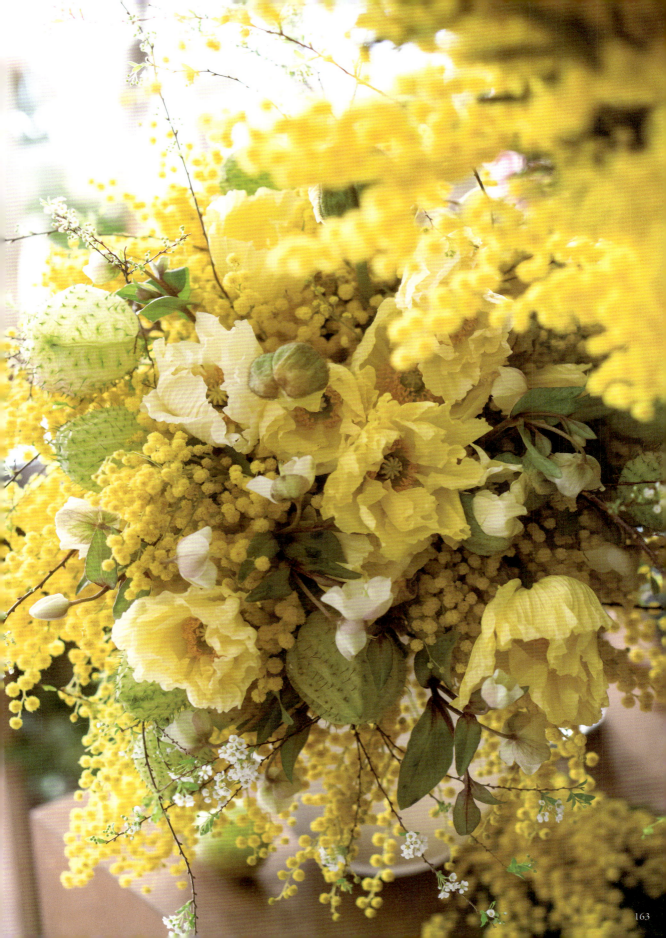

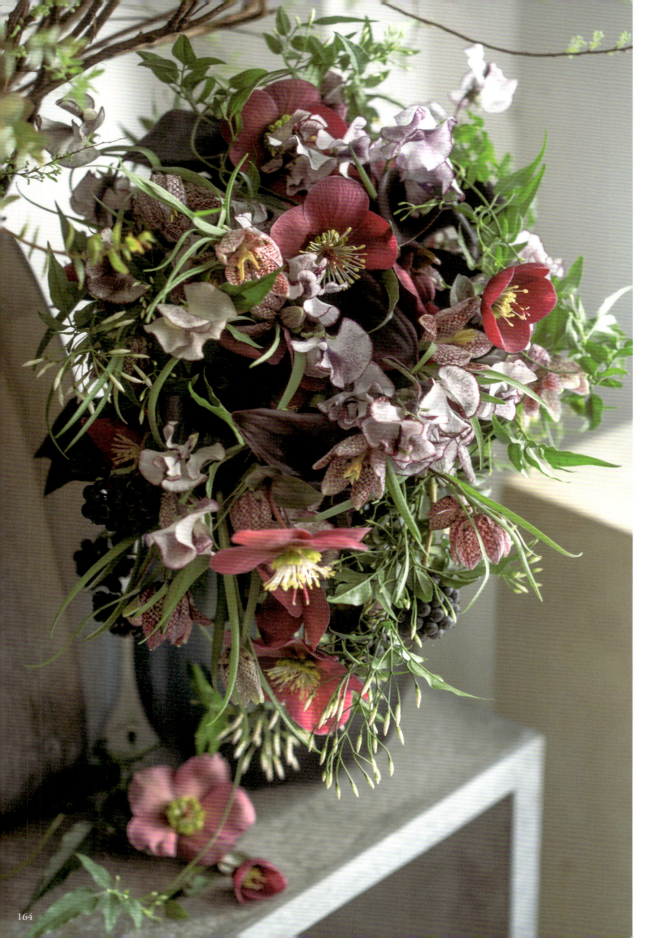

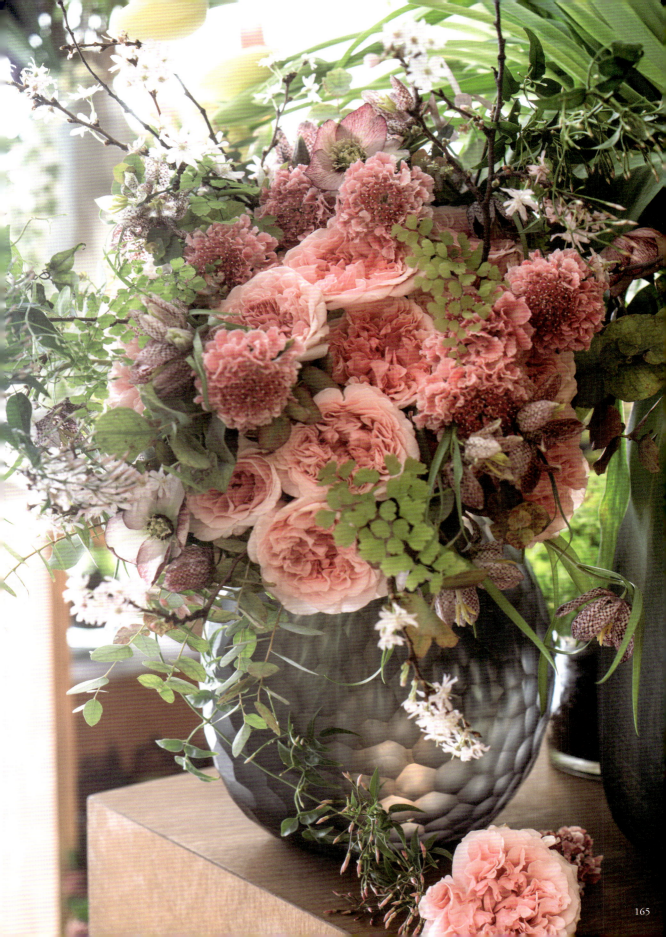

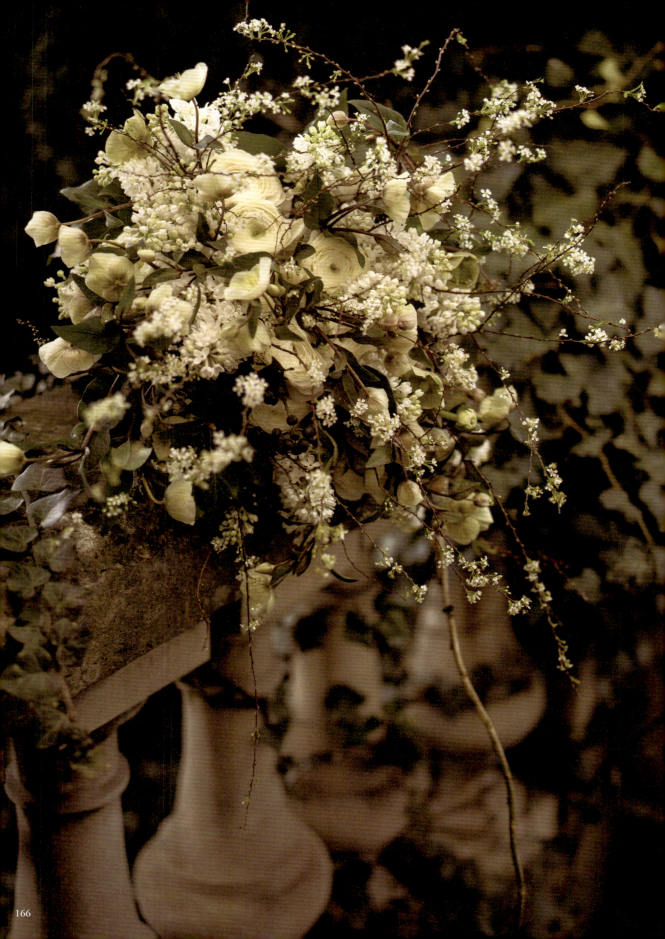

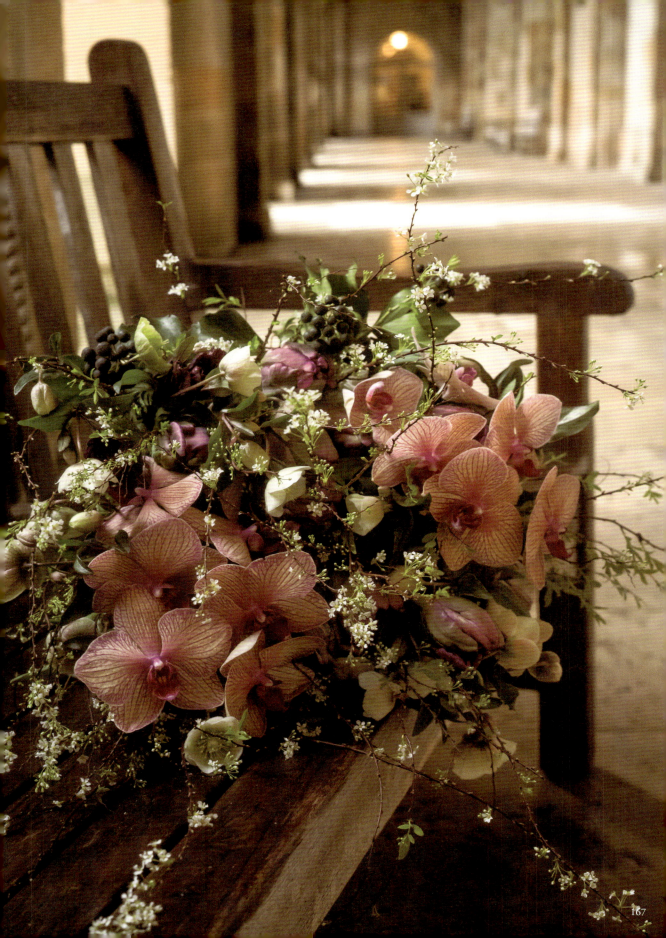

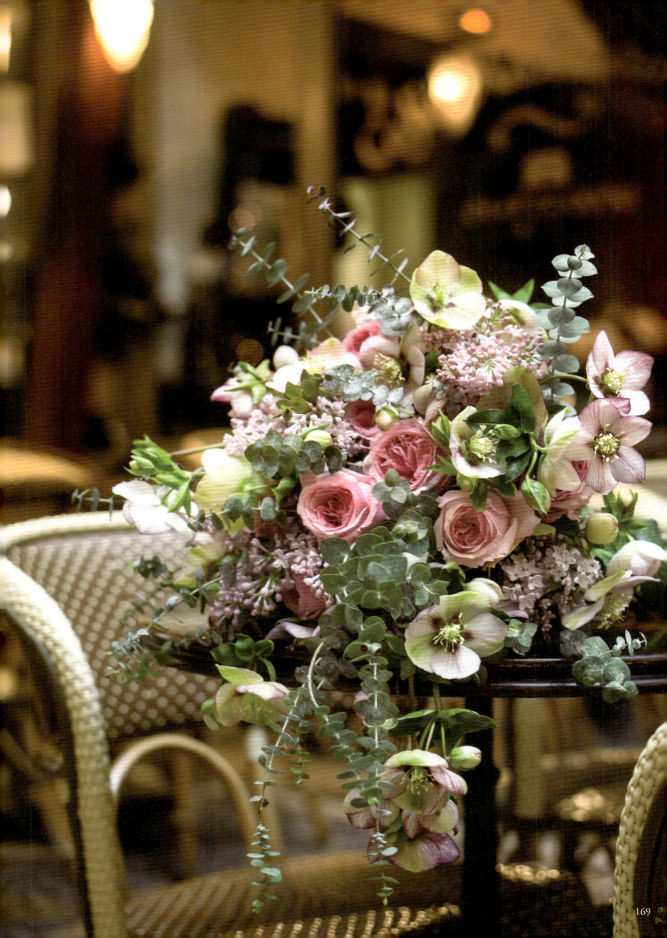

Index *Printemps*

P. 3

バラ（シンベリン）	Rose (Cymbeline)
スイトピー	Sweet pea
ライラック	Lilac
オダマキ	Columbine
クリスマスローズ	Helleborus
レースフラワー	White dill
ビバーナム・コンパクター	Viburnum opulus compactum

P. 4

バラ（イブピアジェ）	Rose (Yves Piaget)
レースフラワー	White dill
カシス	Black currant
ノバラ	Wild rose
ビバーナム・コンパクター	Viburnum opulus compactum
ディセントラ	Dicentra

P. 5

シャクヤク	Peony
ライラック	Lilac
ラナンキュラス	Ranunculus
レースフラワー	White dill
ビバーナム・コンパクター	Viburnum opulus compactum

P. 6-7

バラ	Rose
グロリオサ	Gloriosa
チューリップ	Tulip
フリチラリア・メレアグリス	Fritillaria meleagris
ビバーナム・スノーボール	Viburnum opulus snowball
シラカバ	White birch
ビバーナム・コンパクター	Viburnum opulus compactum

P. 8

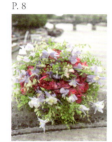

バラ（イブピアジェ）	Rose (Yves Piaget)
スイトピー	Sweet pea
オダマキ	Columbine
アジアンタム	Adiantum
コバンソウ	Briza maxima

P. 9

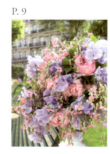

シャクヤク	Peony
スイトピー	Sweet pea
サボナリア	Cow herb
カシス	Black currant

P. 10

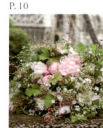

シャクヤク	Peony
サボナリア	Cow herb
ヒューケラ	Coral bells
ビバーナム・コンパクター	Viburnum opulus Compactum
カシス	Black currant
コバンソウ	Briza maxima

P. 11

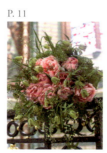

シャクヤク	Peony
フリチラリア・アクモペタラ	Fritillaria acmopetala
ヒメコバンソウ	Briza minor
ジャスミン	Jasmine
ビバーナム・コンパクター	Viburnum opulus compactum

P. 12

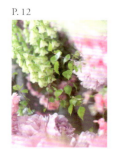

シャクヤク	Peony
フリチラリア・アイボリーベル	Fritillaria (Ivory Bells)
シラカバ	White birch

P. 13

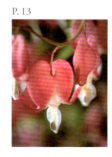

| ディセントラ | Dicentra |

P. 14

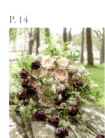

バラ（キーラ）	Rose (Keira)
ライラック	Lilac
コデマリ	Reeves spirea
チューリップ	Tulip

P. 15

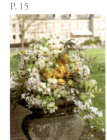

チューリップ	Tulip
ラナンキュラス	Ranunculus
サクラ	Cherry blossom
ユーカリ	Eucalyptus

P. 16

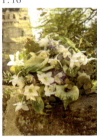

カラー	Calla lily
ユーチャリス	Amazon lily
アジサイ	Hydrangea
オダマキ	Columbine
ユーカリ	Eucalyptus

P. 17

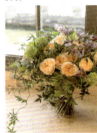

バラ（ベアトリス）	Rose (Beatrice)
フリチラリア・メレアグリス	Fritillaria meleagris
ビバーナム・スノーボール	Viburnum opulus snowball
ジャスミン	Jasmine
ユーカリ	Eucalyptus

P. 18

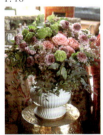

バラ	Rose
ライラック	Lilac
スカビオサ	Scabiosa
ビバーナム・スノーボール	Viburnum opulus snowball
ユーカリ	Eucalyptus

P. 19

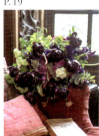

バラ（イブピアジェ）	Rose (Yves Piaget)
スイトピー	Sweet pea
チューリップ	Tulip
ビバーナム・スノーボール	Viburnum opulus snowball
ユーカリ	Eucalyptus

P. 20

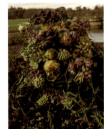

チューリップ	Tulip
フリチラリア・ペルシカ	Fritillaria persica
フリチラリア・メレアグリス	Fritillaria meleagris
ジャスミン	Jasmine
クリスマスローズ	Helleborus

P. 21

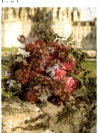

バラ（イブピアジェ）	Rose (Yves Piaget)
スカビオサ	Scabiosa
フリチラリア・メレアグリス	Fritillaria meleagris
スイトピー	Sweet pea
ジャスミン	Jasmine

P. 22

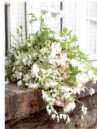

チューリップ	Tulip
ディセントラ	Dicentra
オダマキ	Columbine
クリスマスローズ	Helleborus

P. 23

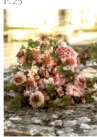

シャクヤク	Peony
スカビオサ	Scabiosa
セイヨウスグリ	Gooseberry
スイトピー	Sweet pea

Printemps

P. 24

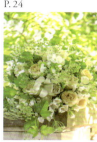

バラ（クリームイブピアジェ）	Rose (White Piaget)
レースフラワー	White dill
ラバテラ	Lavatera
ビバーナム・スノーボール	Viburnum opulus snowball

P. 25

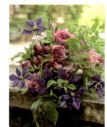

バラ（イブピアジェ）	Rose (Yves Piaget)
クレマチス	Clematis
スモークグラス	Witch grass
ミント	Mint
フランボワーズ	Raspberry

P. 26

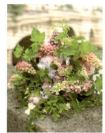

シャクヤク	Peony
ルピナス	Lupine
カシス	Black currant
スイトピー	Sweet pea
ノバラ	Wild rose

P. 27

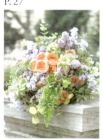

バラ（ジュリエット）	Rose (Juliet)
ライラック	Lilac
クリスマスローズ	Helleborus
スイトピー	Sweet pea
アジアンタム	Adiantum
ユーカリ	Eucalyptus

P. 28

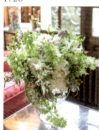

シャクヤク	Peony
フリチラリア・アイボリーベル	Fritillaria (Ivory Bells)
フリチラリア・メレアグリス	Fritillaria meleagris
ディセントラ	Dicentra
コデマリ	Reeves spirea

P. 29

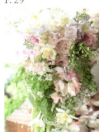

バラ（キーラ、ミランダ）	Rose (Keira, Miranda)
スイトピー	Sweet pea
デルフィニウム	Delphinium
オダマキ	Columbine
アジアンタム	Adiantum
コリアンダー	Coriander
アマランサス	Amaranthus

P. 30

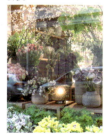

サクラ	Cherry blossom
ビバーナム・スノーボール	Viburnum opulus snowball
フリチラリア・アイボリーベル	Fritillaria (Ivory Bells)
コデマリ	Reeves spirea
クリスマスローズ	Helleborus
チューリップ	Tulip
カラー	Calla lily
ラナンキュラス	Ranunculus
バンダ	Vanda
ハナナス	Potato vine

P. 31

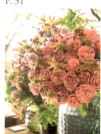

| バラ | Rose |
| サクラ | Cherry blossom |

P. 32

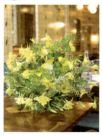

アジサイ	Hydrangea
オダマキ	Columbine
ビバーナム・コンパクター	Viburnum opulus compactum
グラミネ	Guramine
スズメノチャヒキ	Japanese bromegrass

P. 33

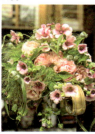

シャクヤク	Peony
ラバテラ	Lavatera
スモークグラス	Witch grass
ポピーシード	Poppyseed
フランボワーズ	Raspberry

P. 34

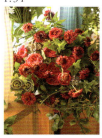

バラ（ダーシー）	Rose (Darcey)
トケイソウ	Passion flower
スカビオサ	Pincushion flower
アジサイ	Hydrangea
カシス	Black currant

P. 35

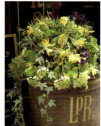

オダマキ	Columbine
スイトピー	Sweet pea
ビバーナム・コンパクター	Viburnum opulus compactum
スズメノチャヒキ	Japanese bromegrass
アイビー	Ivy

P. 36

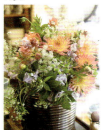

ダリア	Dahlia
アジサイ	Hydrangea
スイトピー	Sweet pea
レースフラワー	White dill
フランボワーズ	Raspberry

P. 37

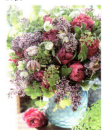

シャクヤク	Peony
ライラック	Lilac
ビバーナム・コンパクター	Viburnum opulus compactum
クリスマスローズ	Helleborus
フリチラリア・メレアグリス	Fritillaria meleagris

P. 38

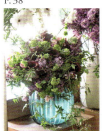

ライラック	Lilac
ビバーナム・スノーボール	Viburnum opulus snowball
カラー	Calla lily
フリチラリア・メレアグリス	Fritillaria meleagris
ジャスミン	Jasmine
スズメノチャヒキ	Japanese bromegrass

P. 39

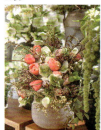

キフジ	Stachyurus praecox
チューリップ	Tulip
クリスマスローズ	Helleborus
フリチラリア・メレアグリス	Fritillaria meleagris
フリチラリア・ペルシカ	Fritillaria persica
ユーカリ	Eucalyptus

P. 40

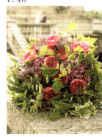

バラ（ダーシー）	Rose (Darcey)
バンダ	Vanda
コバンソウ	Briza maxima
カシス	Black currant
アジサイ	Hydrangea
フランボワーズ	Raspberry

P. 41

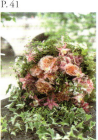

バラ（フォックストロット）	Rose (Foxtrot)
アジサイ	Hydrangea
サボナリア	Cow herb
オダマキ	Columbine
ビバーナム・コンパクター	Viburnum opulus compactum
アイビー	Ivy

P. 42

ディセントラ	Dicentra
フリチラリア・メレアグリス	Fritillaria meleagris
クリスマスローズ	Helleborus
アイビー	Ivy
ライラック	Lilac

P. 43

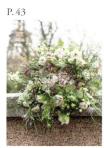

チューリップ	Tulip
ラナンキュラス	Ranunculus
チューベローズ	Tuberose
フリチラリア・メレアグリス	Fritillaria meleagris
ユキヤナギ	Thunberg's meadowsweet
アジアンタム	Adiantum
ユーカリ	Eucalyptus

Printemps / Été

P. 45

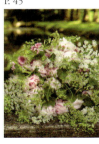

シャクヤク	Peony
スイトピー	Sweet pea
レースフラワー	White dill
コバンソウ	Briza maxima
カシス	Black currant

P. 47

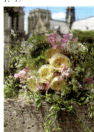

バラ（ペイシェンス）	Rose (Patience)
スイトピー	Sweet pea
ヒメコバンソウ	Briza minor
ジャスミン	Jasmine
フランボワーズ	Raspberry

P. 48

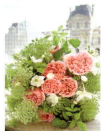

バラ（ミランダ）	Rose (Miranda)
ユーチャリス	Amazon lily
キャロットフラワー	Carrot flower
フランボワーズ	Raspberry

P. 49

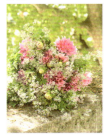

ダリア	Dahlia
コリアンダー	Coriander
フランボワーズ	Raspberry

P. 50

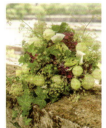

アジサイ	Hydrangea
パフィオペディラム	Paphiopedilum
ウイキョウ	Fennel
フウセントウワタ	Balloon plant
アイビー	Ivy
フランボワーズ	Raspberry

P. 51

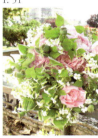

シャクヤク	Peony
ポピーシード	Poppyseed
ホスター	Hosta
サポナリア	Cow herb
フランボワーズ	Raspberry

P. 52

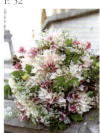

ダリア	Dahlia
コリアンダー	Coriander
フランボワーズ	Raspberry
ブラックベリー	Blackberry
スイトピー	Sweet pea

P. 53

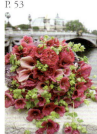

バラ（ダーシー）	Rose (Darcey)
カラー	Calla lily
ラバテラ	Lavatera
アジサイ	Hydrangea

P. 54

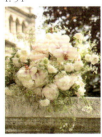

シャクヤク	Peony
スカビオサ	Scabiosa
コリアンダー	Coriander
コチョウラン	Phalaenopsis
フランボワーズ	Raspberry

P. 55

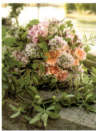

バラ（フォックストロット）	Rose (Foxtrot)
シャクヤク	Peony
アリウム	Allium
スズメノチャヒキ	Japanese bromegrass
フランボワーズ	Raspberry
トケイソウ	Passion flower

P. 56

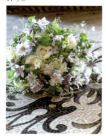

バラ（アバランシェ）	Rose (Avalanche)
スカビオサ	Scabiosa
クレマチス	Clematis
コリアンダー	Coriander
クロホオズキ	Nicandra physalodes

P. 57

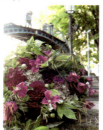

ダリア	Dahlia
アジサイ	Hydrangea
クレマチス	Clematis
カラスムギ	Common wild oats
フランボワーズ	Raspberry

P. 58

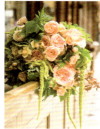

バラ（シャーレーン、フォックストロット）	Rose (Charlene, Foxtrot)
アマランサス	Amaranthus
フランボワーズ	Raspberry
ブラックベリー	Blackberry

P. 59

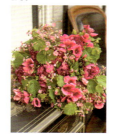

シャクヤク	Peony
ラバテラ	Lavatera
ハシバミ	Hazel
サボナリア	Cow herb

P. 60

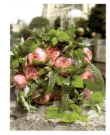

シャクヤク	Peony
リシマキア	Creeping Jenny
フランボワーズ	Raspberry

P. 61

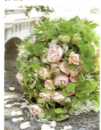

バラ（シャーレーン）	Rose (Charlene)
レースフラワー	White dill
フウセントウワタ	Balloon plant
フランボワーズ	Raspberry

P. 62

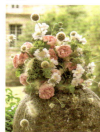

バラ（シャーレーン）	Rose (Charlene)
スカビオサ	Scabiosa
グラミネ	Guramine
フランボワーズ	Raspberry
キャロットフラワー	Carrot flower

P. 63

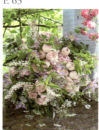

バラ（キャンディフロウ）	Rose (Candy Flow)
アジサイ	Hydrangea
ヤマゴボウ	Pokeweed
コリアンダー	Coriander
フランボワーズ	Raspberry
クレマチス	Clematis

P. 64

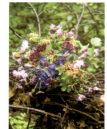

コスモス	Cosmos
アジサイ	Hydrangea
ビバーナム・コンパクター	Viburnum opulus compactum

P. 65

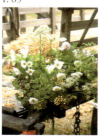

コスモス	Cosmos
キャロットフラワー	Carrot flower
ビバーナム・コンパクター	Viburnum opulus compactum
フランボワーズ	Raspberry
スモークグラス	Witch grass

Été / Automne

P. 66

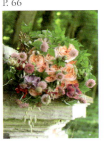

バラ（シャーレーン）	Rose (Charlene)
スカビオサ	Scabiosa
ポピー	Poppy
ビバーナム・コンパクター	Viburnum opulus compactum
コバンソウ	Briza maxima
フランボワーズ	Raspberry

P. 67

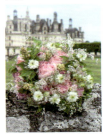

シャクヤク	Peony
ニゲラ	Nigella
コリアンダー	Coriander
チューベローズ	Tuberose
フランボワーズ	Raspberry

P. 68

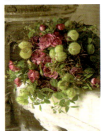

バラ（イブピアジェ）	Rose (Yves Piaget)
フウセントウワタ	Balloon plant
パニカム	Panicum
フランボワーズ	Raspberry

P. 69

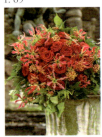

バラ（ナオミ）	Rose (Naomi)
グロリオサ	Gloriosa
ビバーナム・コンパクター	Viburnum opulus compactum
ヘデラベリー	Hedera berry

P. 70-71

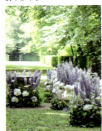

デルフィニウム	Delphinium
アジサイ	Hydrangea
クレマチス	Clematis
フランボワーズ	Raspberry
レースフラワー	White dill

P. 72

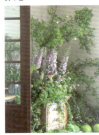

ノバラ	Wild rose
デルフィニウム	Delphinium
ルピナス	Lupine
フランボワーズ	Raspberry
アイビー	Ivy

P. 73

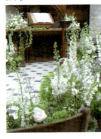

デルフィニウム	Delphinium
オダマキ	Aquilegia
バラ	Rose
ジギタリス	Digitalis
アイビー	Ivy
アジアンタム	Adiantum

P. 74

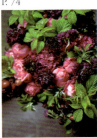

バラ（イブピアジェ）	Rose (Yves Piaget)
アジサイ	Hydrangea
スカビオサ	Scabiosa
リンゴ	Crabapple
フランボワーズ	Raspberry

P. 75

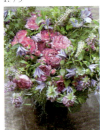

バラ（イブピアジェ）	Rose (Yves Piaget)
クレマチス	Clematis
モナルダ	Monarda
ヤマゴボウ	Pokeweed
スモークグラス	Witch grass
フランボワーズ	Raspberry

P. 76

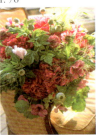

シャクヤク	Peony
スカビオサ	Scabiosa
ポピーシード	Poppyseed
ラバテラ	Lavatera
スモークグラス	Witch grass
フランボワーズ	Raspberry

P. 77

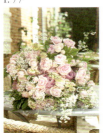

シャクヤク	Peony
バラ（キャンディフロウ）	Rose (Candy Flow)
チューベローズ	Tuberose
コリアンダー	Coriander
フランボワーズ	Raspberry

P. 78-79

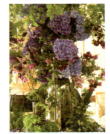

アジサイ	Hydrangea
ビバーナム・スノーボール	Viburnum opulus snowball
スイトピー	Sweet pea
アジアンタム	Adiantum
コチョウラン	Phalaenopsis

P. 80

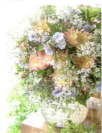

ダリア	Dahlia
スイトピー	Sweet pea
コリアンダー	Coriander
ヒメコバンソウ	Briza minor
フランボワーズ	Raspberry

P. 81

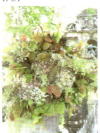

アジサイ	Hydrangea
アワ	Foxtail millet
レースフラワー	White dill
スズメノチャヒキ	Japanese bromegrass

P. 82

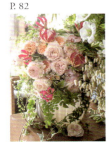

バラ（キーラ、シャーレーン）	Rose (Keira, Charlene)
グロリオサ	Gloriosa
コリアンダー	Coriander
アジアンタム	Adiantum
フランボワーズ	Raspberry
アイビー	Ivy

P. 83

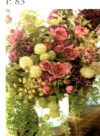

バラ（イブピアジェ）	Rose (Yves Piaget)
フウセントウワタ	Balloon plant
パニカム	Panicum
ウイキョウ	Fennel
フランボワーズ	Raspberry
アジサイ	Hydrangea

P. 84

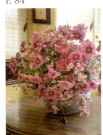

バラ（イブピアジェ）	Rose (Yves Piaget)
コスモス	Cosmos
スイトピー	Sweet pea
サボナリア	Cow herb

P. 85

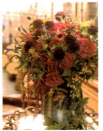

バラ（ダーシー）	Rose (Darcey)
スカビオサ	Scabiosa
ミント	Mint
ビバーナム・コンパクター	Viburnum opulus compactum
アマランサス	Amaranthus

P. 87

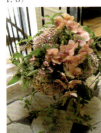

アジサイ	Hydrangea
コチョウラン	Phalaenopsis
ヤマゴボウ	Pokeweed
トケイソウ	Passion flower
シンフォリカルポス	Symphoricarpos

P. 88

バラ（イブピアジェ）	Rose (Yves Piaget)
コスモス	Cosmos
ヤマゴボウ	Pokeweed
クロホオズキ	Nicandra physalodes
フランボワーズ	Raspberry

Automne

P. 89

バラ（イブピアジェ）	Rose (Yves Piaget)
コスモス	Cosmos
ヤマゴボウ	Pokeweed
クロホオズキ	Nicandra physalodes
フランボワーズ	Raspberry

P. 90

コスモス	Cosmos
コリアンダー	Coriander
ダリア	Dahlia

P. 91

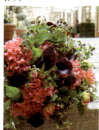

ダリア	Dahlia
カラー	Calla lily
フランボワーズ	Raspberry

P. 92

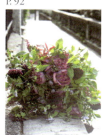

バラ（イブピアジェ）	Rose (Yves Piaget)
スカビオサ	Scabiosa
ヤマゴボウ	Pokeweed
ミント	Mint
クロホオズキ	Nicandra physalodes
フランボワーズ	Raspberry

P. 93

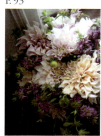

| ダリア | Dahlia |
| モナルダ | Monarda |

P. 94

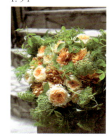

バラ（ベアトリス）	Rose (Beatrice)
ダリア	Dahlia
キャロットフラワー	Carrot flower
フランボワーズ	Raspberry

P. 95

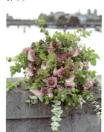

ダリア	Dahlia
カラー	Calla lily
スカビオサ	Scabiosa
ユーカリ	Eucalyptus
クロホオズキ	Nicandra physalodes

P. 96-97

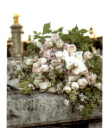

バラ	Rose
アジサイ	Hydrangea
コチョウラン	Phalaenopsis
コリアンダー	Coriander
フランボワーズ	Raspberry
ユーカリ	Eucalyptus
ガウラ	Gaura

P. 98

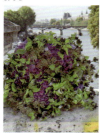

アジサイ	Hydrangea
クロホオズキ	Nicandra physalodes
ウド	Aralia cordata
フランボワーズ	Raspberry

P. 99

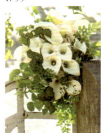

アジサイ	Hydrangea
カラー	Calla lily
アジアンタム	Adiantum
フランボワーズ	Raspberry

P. 100

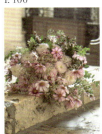

ダリア	Dahlia
コスモス	Cosmos
ガウラ	Gaura
レースフラワー	White dill
ユーカリ	Eucalyptus
フランボワーズ	Raspberry

P. 101

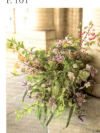

マユミ	Spindle tree
クレマチス	Clematis
スモークグラス	Witch grass
アジサイ	Hydrangea

P. 102

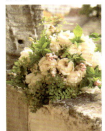

バラ（クリームイブピアジェ）	Rose (White Piaget)
シンフォリカルポス	Symphoricarpos
アジアンタム	Adiantum
フランボワーズ	Raspberry

P. 103

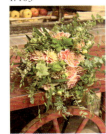

ダリア	Dahlia
グリーンスケール	Wild oats
ユーカリ	Eucalyptus
フランボワーズ	Raspberry

P. 104

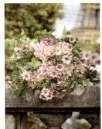

ダリア	Dahlia
コスモス	Cosmos
ガウラ	Gaura
コリアンダー	Coriander
ユーカリ	Eucalyptus
フランボワーズ	Raspberry

P. 105

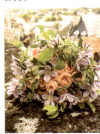

バラ	Rose
クレマチス	Clematis
ノリウツギ	Panicled hydrangea

P. 106

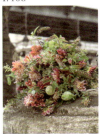

ダリア	Dahlia
ヤマゴボウ	Pokeweed
フウセントウワタ	Balloon plant
アベリア	Abelia
フランボワーズ	Raspberry

P. 107

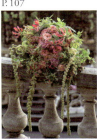

バラ	Rose
グロリオサ	Gloriosa
アマランサス	Amaranth
ノバラの実	Rose hip
フランボワーズ	Raspberry

P. 108

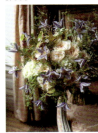

バラ（ペイシェンス）	Rose (Patience)
アジサイ	Hydrangea
クレマチス	Clematis
コリアンダー	Coriander
パニカム	Panicam
リセステリア	Leycesteria

P. 109

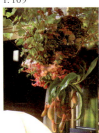

アジサイ	Hydrangea
グロリオサ	Gloriosa
ネペンテス	Nepenthes
コチョウラン	Phalaenopsis
ビバーナム・コンパクター	Viburnum Opulus compactum

Automne

P.112

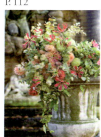

ダリア	Dahlia
グロリオサ	Gloriosa
ポピー	Poppy
ユーカリ	Eucalyptus
トケイソウ	Passion flower
フウセントウワタ	Balloon plant

P.113

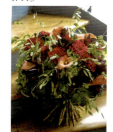

ダリア	Dahlia
カラー	Calla lily
アジサイ	Hydrangea
グリーンスケール	Wild oats
コチヌス	Smoke tree
フランボワーズ	Raspberry

P.114

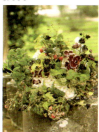

アジサイ	Hydrangea
コチョウラン	Phalaenopsis
クロホオズキ	Nicandra physalodes
パニカム	Panicum
フランボワーズ	Raspberry

P.115

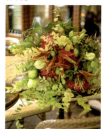

アジサイ	Hydrangea
アマリリス	Amaryllis
ユーカリ	Eucalyptus
カラスムギ	Common wild oats
フランボワーズ	Raspberry

P.116

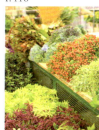

| ランジス市場 | Rungis Market |

P.117

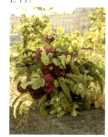

ダリア	Dahlia
アワ	Foxtail millet
パニカム	Panicum
ユーカリ	Eucalyptus
フランボワーズ	Raspberry

P.118

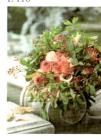

ダリア	Dahlia
カラー	Calla lily
ノバラの実	Rose hip
マユミ	Spindle tree

P.119

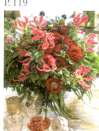

バラ（レッドアイ）	Rose (Red Eye)
グロリオサ	Gloriosa
ヘデラベリー	Hedera berry
ジャスミン	Jasmine
モミ	Fir
ナンヨウスギ	Araucaria

P.120

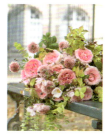

バラ（ピエール・ド・ロンサール）	Rose (Pierre de Ronsard)
スカビオサ	Scabiosa
ガウラ	Gaura
リセステリア	Leycesteria
ユーカリ	Eucalyptus
フランボワーズ	Raspberry
シュウメイギク	Japanese anemone

P.121

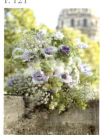

ダリア	Dahlia
アネモネ	Anemone
レースフラワー	White dill
ユーカリ	Eucalyptus

P. 122

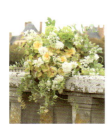

バラ	Rose
スカビオサ	Scabiosa
ビバーナム・スノーボール	Viburnum opulus snowball
リセステリア	Leycesteria
ユーカリ	Eucalyptus
バラのツル	Rose vine

P. 123

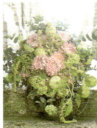

キク	Mum
フウセントウワタ	Balloon plant
アマランサス	Amaranth
ビバーナム・スノーボール	Viburnum opulus snowball
ユーカリ	Eucalyptus

P. 124

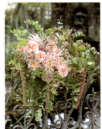

バラ	Rose
ダリア	Dahlia
コリアンダー	Coriander
アマランサス	Amaranth
スモークグラス	Witch grass
ユーカリ	Eucalyptus
フランボワーズ	Raspberry

P. 125

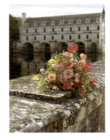

バラ	Rose
グロリオサ	Gloriosa
アジサイ	Hydrangea
ジャスミン	Jasmine
ユーカリ	Eucalyptus
リセステリア	Leycesteria

P. 126

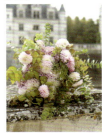

ダリア	Dahlia
ユーカリ	Eucalyptus
リセステリア	Leycesteria
ジャスミン	Jasmine

P. 127

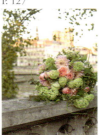

バラ（ロマンティックアンティーク）	Rose (Romantic Antike)
ダリア	Dahlia
ビバーナム・スノーボール	Viburnum opulus snowball
フウセントウワタ	Balloon plant
ジャスミン	Jasmine
バラのツル	Rose vine
ユーカリ	Eucalyptus

P. 128

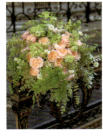

バラ（ジュリエット、シャーレーン）	Rose (Juliet, Charlene)
ビバーナム・スノーボール	Viburnum opulus snowball
ユーカリ	Eucalyptus
スカビオサ	Scabiosa
アジアンタム	Adiantum
グリーンスケール	Wild oats
フウセンカズラ	Balloon vine

P. 129

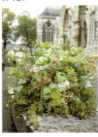

アジサイ	Hydrangea
ラナンキュラス	Ranunculus
ユーカリ	Eucalyptus
スモークグラス	Witch grass

P. 130

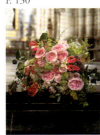

バラ（ミランダ）	Rose (Miranda)
グロリオサ	Gloriosa
ユーカリ	Eucalyptus
ヘデラベリー	Hedera berry

P. 131

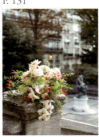

アジサイ	Hydrangea
ラナンキュラス	Ranunculus
キク	Mum
コチョウラン	Phalaenopsis
グロリオサ	Gloriosa
ユーカリ	Eucalyptus
ビバーナム・スノーボール	Viburnum opulus snowball

Automne / Hiver

P. 132

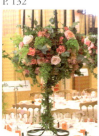

バラ（かおりかざり、雅、旋律、かなた、葵、風月）	Rose
アジアンタム	Adiantum
ユーカリ	Eucalyptus
アイビー	Ivy
ヘデラベリー	Hedera berry

P. 133

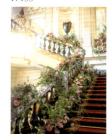

バラ	Rose
アベリア	Abelia
ユーカリ	Eucalyptus
アイビー	Ivy
クロホオズキ	Nicandra physalodes
ピラカンサス	Pyracantha

P. 134-135

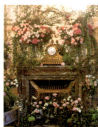

バラ	Rose
ピラカンサス	Pyracantha
アジアンタム	Adiantum
ヘデラベリー	Hedera berry
アイビー	Ivy

P. 136

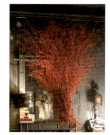

| ウンリュウヤナギ | Corkscrew willow |

P. 137

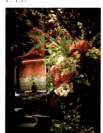

リンゴ	Crab apple
アジサイ	Hydrangea
コチョウラン	Phalaenopsis
ユーカリ	Eucalyptus
アイビー	Ivy
グロリオサ	Gloriosa

P. 139

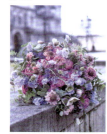

シャクヤク	Peony
スカビオサ	Scabiosa
スイトピー	Sweet pea
クリスマスローズ	Helleborus
フリチラリア・メレアグリス	Fritillaria meleagris
ユーカリ	Eucalyptus

P. 140

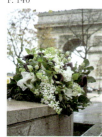

アネモネ	Anemone
カラー	Calla lily
ライラック	Lilac
クリスマスローズ	Helleborus
ヘデラベリー	Hedera berry

P. 141

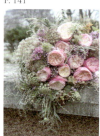

バラ（コンスタンス）	Rose (Constance)
ライラック	Lilac
アカシア	Acacia
レースフラワー	White dill
ユーカリ	Eucalyptus

P. 142

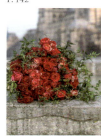

| バラ | Rose |
| ジャスミン | Jasmine |

P. 143

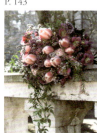

チューリップ	Tulip
スカビオサ	Scabiosa
ラナンキュラス	Ranunculus
ネコヤナギ	Pussy willow
ジャスミン	Jasmine
ヘデラベリー	Hedera berry

P. 144

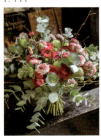

ラナンキュラス	Ranunculus
フウセントウワタ	Physocarpus
ユーカリ	Eucalyptus
スカビオサ	Scabiosa
コケボク	Branch with moss

P. 145

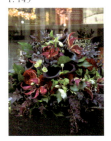

カラー	Calla lily
グロリオサ	Gloriosa
クリスマスローズ	Helleborus
ユーカリ	Eucalyptus
ヘデラベリー	Hedera berry

P. 146

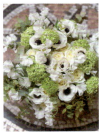

バラ（アバランシェ）	Rose (Avalanche)
アネモネ	Anemone
ビバーナム・スノーボール	Viburnum opulus snowball
ユーカリ	Eucalyptus

P. 147

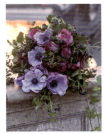

アネモネ	Anemone
バラ（イブピアジェ）	Rose (Yves Piaget)
ヘデラベリー	Hedera berry
アイビー	Ivy

P. 148

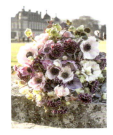

アネモネ	Anemone
スカビオサ	Pincushion flower
クリスマスローズ	Helleborus
ライラック	Lilac
ユーカリ	Eucalyptus

P. 149

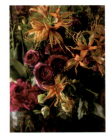

アマリリス	Amaryllis
ラナンキュラス	Ranunculus
ヘデラベリー	Hedera berry

P. 151

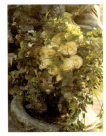

バラ（アバランシェ）	Rose (Avalanche)
ユーカリ	Eucalyptus
ジャスミン	Jasmine
ビバーナム・スノーボール	Viburnum opulus snowball
ユキヤナギ	Thunberg's meadowsweet

P. 152

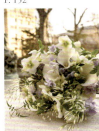

カラー	Calla lily
クリスマスローズ	Helleborus
ムスカリ	Grape hyacinth
ジャスミン	Jasmine
スイトピー	Sweet pea

P. 153

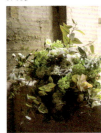

ラナンキュラス	Ranunculus
クリスマスローズ	Helleborus
ビバーナム・スノーボール	Viburnum opulus snowball
ユーカリ	Eucalyptus

P. 154

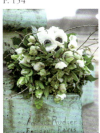

アネモネ	Anemone
クリスマスローズ	Helleborus
チューリップ	Tulip
コケボク	Branch with moss
アジアンタム	Adiantum
ヘデラベリー	Hedera berry

Hiver

P. 155
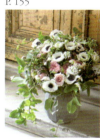

アネモネ	Anemone
バラ（ミランダ）	Rose (Miranda)
トケイソウ	Passion flower
ライラック	Lilac
クリスマスローズ	Helleborus

P. 156

バラ（ミランダ）	Rose (Miranda)
ライラック	Lilac
スカビオサ	Scabiosa
フリチラリア・メレアグリス	Fritillaria meleagris
アジアンタム	Adiantum

P. 157
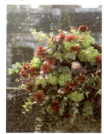

チューリップ	Tulip
クリスマスローズ	Helleborus
ビバーナム・スノーボール	Viburnum opulus snowball
ボケ	Japanese quince
ラナンキュラス	Ranunculus
ユーカリ	Eucalyptus

P. 158
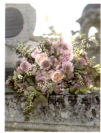

バラ（ジュリエット、ミランダ）	Rose (Juliet, Miranda)
キフジ	Stachyurus praecox
スカビオサ	Scabiosa
ユーカリ	Eucalyptus

P. 159
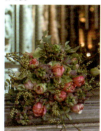

チューリップ	Tulip
フリチラリア・ペルシカ	Fritillaria persica
フリチラリア・メレアグリス	Fritillaria meleagris
キフジ	Stachyurus praecox
ユーカリ	Eucalyptus

P. 159
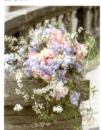

チューリップ	Tulip
スイトピー	Sweet pea
ジャスミン	Jasmine
ユキヤナギ	Thunberg's meadowsweet

P. 161
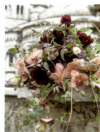

アネモネ	Anemone
カラー	Calla lily
コチョウラン	Phalaenopsis
フリチラリア・メレアグリス	Fritillaria meleagris
クリスマスローズ	Helleborus
ライラック	Lilac
アイビー	Ivy

P. 162
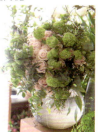

バラ（スウィートアバランシェ）	Rose (Sweet Avalanche)
ビバーナム・スノーボール	Viburnum opulus snowball
ジャスミン	Jasmine
ユキヤナギ	Thunberg's meadowsweet
ユーカリ	Eucalyptus

P. 163
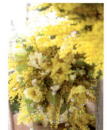

ミモザ	Mimosa
スイセン	Narcissus
クリスマスローズ	Helleborus
フウセントウワタ	Balloon plant
ユキヤナギ	Thunberg's meadowsweet

P. 164
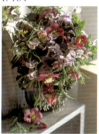

クリスマスローズ	Helleborus
カラー	Calla lily
スイトピー	Sweet Pea
フリチラリア・メレアグリス	Fritillaria meleagris
ジャスミン	Jasmine
ヘデラベリー	Hedera berry

P. 165

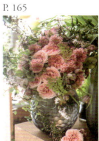

バラ（ミランダ）	Rose (Miranda)
スカビオサ	Scabiosa
フリチラリア・メレアグリス	Fritillaria meleagris
ジャスミン	Jasmine
サクラ	Cherry blossom
ユーカリ	Eucalyptus

P. 166

ラナンキュラス	Ranunculus
ライラック	Lilac
クリスマスローズ	Helleborus
ユキヤナギ	Thunberg's meadowsweet

P. 167

チューリップ	Tulip
コチョウラン	Phalaenopsis
ヘデラベリー	Hedera berry
クリスマスローズ	Helleborus
ユキヤナギ	Thunberg's meadowsweet

P. 169

バラ（ミランダ）	Rose (Miranda)
クリスマスローズ	Helleborus
ユーカリ	Eucalyptus
ライラック	Lilac

＊バラは品種名がわかるもののみ詳細を記載しています。

＊ Specific rose names have been provided for identifiable varieties only.

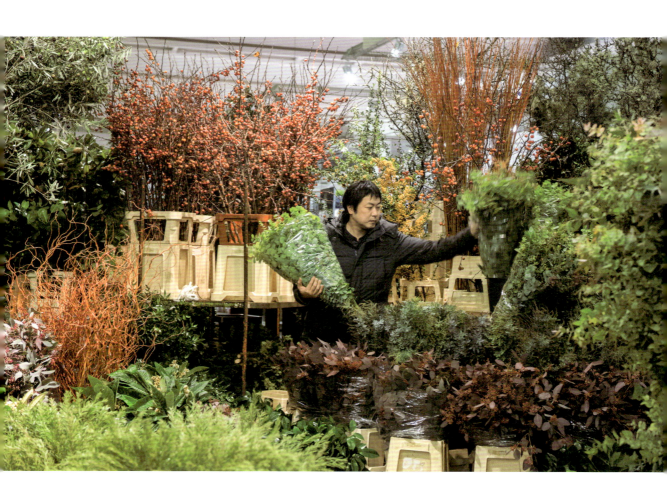

ある冬の日の早朝の仕入れ。パリ郊外のランジスの市場にて。
Procuring flowers on a crisp winter morning; Rungis Market, outskirts of Paris.

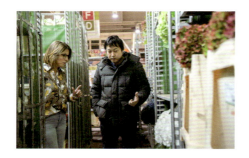

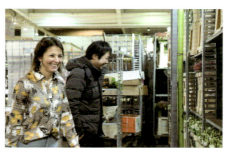

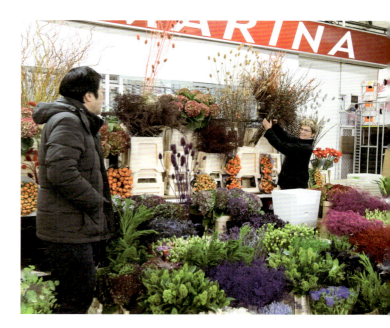

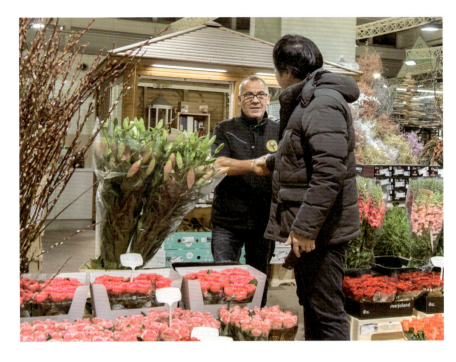
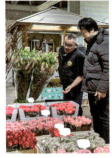
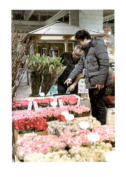
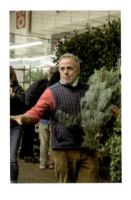

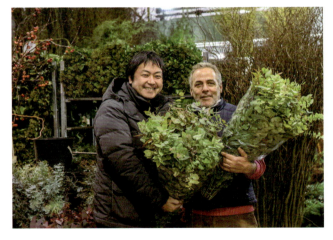
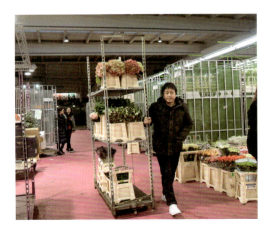
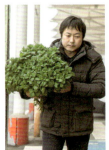
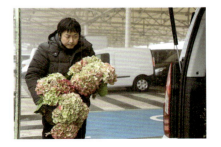

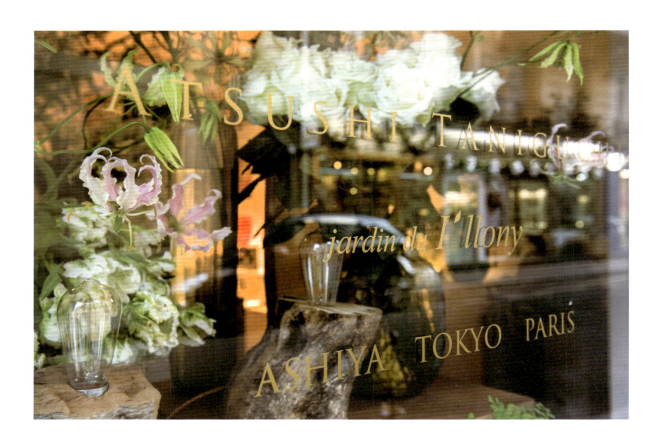

パリ16区にあるアイロニーのブティック。
I'llony boutique in Paris' 16th *arrondissement*.

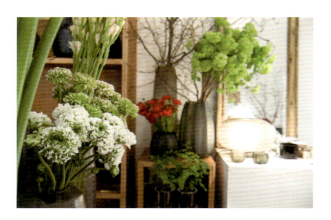

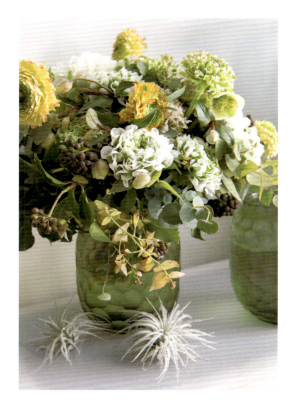

メッセージ

　まだ薄暗い日曜の早朝、土曜のうちに束ねたブーケを車に積み込んで、石畳のヴィクトル・ユゴー広場を抜けてパリの街や郊外のお城などへ撮影に向かう。季節によって光はずいぶん違って、春の明け方がきれいな場所もあるし、夏の昼間の太陽が雲に隠れた一瞬が美しい場所もある。

　選んだ場所と束ねたブーケ、その瞬間の光と背景にかかる空の色。

　いくつかの要素が重なり合って美しい写真が撮れるのは、市場に集まってきた多くの花の中から目が合ったものを仕入れて、それぞれが引き立つ組み合わせを考え、自然に還すように意識して束ねたブーケが、美しいものに仕上がる瞬間の喜びととてもよく似ている。

　写真を撮ることと、ブーケを束ねること。どちらも同じくらいワクワクすることだけど、少し違うのは、本業の「ブーケを束ねる」ということのほうがうまくいきやすいということです。

　フローリストとして、特定の誰かのもとで修行したわけではない私は、たくさんの花の本を読みあさって、自分の好きなものとそうでないものを見つけてきました。2002年に兵庫県の芦屋市で始めた「アイロニー」という店は、目の肥えたマダムたちに鍛えられ、いつしかフランスの宝飾ブランド店の装飾をまかせてもらえるようになりました。そして、芦屋店をオープンして7年後、東京・青山に店舗を出すことが決まったころから、いつかパリにも店を出すと心に決めました。

　私が影響を受けた多くのフローリストたちのルーツは、みなパリにありました。

　多くのパリのフローリストたちの花を見る一方で、それでも、日本の素材を使い、長い年月をかけてできあがったブーケは自分にしか作れない独自のものに感じて、その花を憧れたパリに飾ってみたいと考えるようになるまで、時間はかかりませんでした。

　この本に収められているブーケは、そんな思いを抱き始めた頃に、たくさんの人からオーダーをいただき撮影したものです。依頼主をイメージしたブーケを束ね、パリの街角で写真を撮ってお送りする。『パリであなたの花束を』と名付けたこの企画は、パリ店をオープンして4年経った今でもずっと続けています。

　会ったことのない方には、メールでたったひとつ、「好きなものやことは何ですか？」と質問をするだけで、イメージを膨らませてブーケを束ねます。4年間、そんな風に作り続けてきた約150のブーケを、春夏秋冬にわけて1冊の本にまとめました。

　パリという街には花が似合います。歴史のある美しい街並みは、ずっと昔からそこにあり、その瞬間を咲き誇る花と対比をなしているように見えます。花の美しさは、枯れてしまうという儚さゆえ。それを歴史あるパリの街がより美しく輝かせているのだと感じるのです。

　ページをめくりながら、そんなブーケの写真に自分を映して、日々眺めてみてください。花は見る人の心によって印象が変わります。花びらの1枚1枚や、グリーンの色、いろいろな部分に自分を重ねて、ブーケを愛でるように自分を見つめてもらえればと思います。そして、長くそばに置いて、ときどき気に入った音楽を聴いたり、映画を観たりするようにこの本を楽しんでいただければ、こんなに嬉しいことはありません。

　この本を手に取ってくださったあなたと、ご依頼いただいた方々への感謝をこめて。

2019年2月　パリにて
谷口敦史

Message

Early Sunday mornings, before twilight gives way to dawn, I load the bouquets created Saturday into the car and drive across the cobblestoned Victor Hugo Square on my way to shoot photos in Parisian suburbs and castles. The light changes with the seasons; some spots are lovely at dawn in springtime, while others are beautiful when the sun pops out from behind a cloud on a summer's day. It is all about the place, the bouquet, the light at that very moment, and the color of the sky forming the backdrop… The momentary joy of taking a beautiful photograph, in which loveliness depends on those converging factors, is much like the pleasure achieved from creating a bouquet of flowers fit to release back into nature. I select whatever catches my eye from the vast array of flowers at the market, and from them combine blossoms and greenery that naturally complement each other.

Taking a photograph, creating a floral bouquet—each produces a similar thrill. Yet I find success easier when bundling flowers, as that is my profession. In becoming a florist, I did not train under anybody particular; instead, I read everything on flowers that I could, gradually discovering my likes and dislikes. I opened Jardin du l'Ilony in 2002 in Ashiya, a small city between Osaka and Kobe. After honing my aesthetic sense through insight from discerning customers, I soon found myself creating floral arrangements for high-end French jewelry shops. Seven years later, I launched a shop in Tokyo's posh Aoyama neighborhood. It was at this turning point that I became determined to open a branch in Paris someday.

I have long been influenced by florists who have roots in Paris. Although I idealized various Parisian florists, I spent many years developing my own unique bouquet style using Japanese materials. After reaching this point, I soon developed the desire to display my floral creations in Paris, the city I adored from afar for so long.

The bouquets in this book are an actualization of that dream. I started photographing the results of the many orders gratefully received in my early days of Paris life. I would create a bouquet inspired by the image described by the client, photograph it on a Paris street corner, and then send the photo with the bouquet to the cherished recipient. I coined this the "Your bouquet in Paris" Project and continue the ritual even now, four years after opening the shop.

I would e-mail clients whom I never met, asking them just one question—tell me your most favorite thing or activity—and then create a bouquet based on the image I form in my mind. This book presents roughly 150 of the many bouquets which emerged during that four-year project, organized according to the four seasons of winter, spring, summer, and fall.

Paris is a perfect city for flowers. The well-preserved historical townscape stands in stylish contrast to the flowers which bloom momentarily within it. The beauty of the flowers is transient. Yet the ancient backdrop of Paris seems to afford the blossoms greater radiance when they open their petals.

I hope you will project yourself into the photos of these bright bouquets as you turn the pages and find pleasure in them every day. Flowers create differing impressions, depending on the heart of the viewer. As you gaze at each photo, finding yourself in each of the petals, the shade of the greenery, and the many other parts of the flowers, cherish yourself as you would a beautiful bouquet. Finally, I hope that you will long keep this book close at hand, savoring it occasionally much as you would enjoy experiencing your favorite music or movie yet again.

I am greatly appreciative to all of those who take the time to enjoy this book as well as to those who placed bouquet orders, allowing me to create beauty with flowers.

Atsushi Taniguchi
February 2019 Paris

PROFILE
谷口敦史

パリ・芦屋・南青山に店舗を構える花屋「アイロニー」のオーナーフローリスト。独学ながら自然のバランスと花の持つ色気をコンセプトにしたデザインが多くのブランドに認められ、店内装花やイベント装花などを手がけている。2015年には日本人で初めてフランス・パリに支店を出店。伝説的なクラブを改装し話題になったパリ5つ星ホテル LES BAINS PARIS の装花、モナコ公国プリンスアルベール後援、イタリアコロンナ家のプリンセスキャサリン主催の舞踏会 BAL DE L'ETEへの装花などを手がける。

www.illony.com

芦屋本店　jardin du I'llony ASHIYA
兵庫県芦屋市打出小槌町14-9　TEL 0797-38-8741

南青山店　jardin du I'llony TOKYO
東京都港区南青山6丁目7-14　チガー南青山1F　TEL 03-6805-1622

パリ店　jardin du I'llony PARIS
3 Rue Mesnil 75116 Paris　TEL +33 (0)1 42 56 09 48

PROFILE
Atsushi Taniguchi

Owner of "jardin du I'llony" with flower shops in Paris, Ashiya (Kobe) and Minami-Aoyama (Tokyo). A self-trained florist, Taniguchi designs arrangements based on his exceptional concept of the balance of nature and the allure of flowers. Recognized by many brand names, he creates floral displays for store interiors and special events. In 2015, Taniguchi was the Japanese florist to set up a branch in Paris. His many achievements include floral designs for the noted 5-star LES BAINS PARIS Hotel which was renovated from the legendary but defunct nightclub, and floral decorations for the Bal de L'Ete, the famed summertime gala conceived by Princess Catherine Colonna de Stigliano under the High Patronage of H.S.H. Prince Albert II of Monaco.

www.illony.com

Paris Bouquets
パリの花束

2019年 3月10日　初版第1刷発行
2021年 8月12日　　　第2刷発行

著者：谷口敦史
Author: Atsushi Taniguchi

デザイン：佐藤美穂（PIE Graphics）
Design: Miho Sato（PIE Graphics）

撮影（P.186-189）：井田純代
Photography (P186-189): Sumiyo Ida

英訳：木下マリアン / ステファニー・クック
English translation: Marian Kinoshita & Stephanie Cook

校正：株式会社鷗来堂
Proofreading: Ouraidou K.K.

編集：長谷川卓美
Editing: Takumi Hasegawa

発行人：三芳寛要
Published by: Hiromoto Miyoshi

発行元　株式会社パイインターナショナル
〒170-0005　東京都豊島区南大塚2-32-4
TEL 03-3944-3981　FAX 03-5395-4830　sales@pie.co.jp

PIE International Inc.
2-32-4 Minami-Otsuka, Toshima-ku, Tokyo 170-0005 JAPAN
sales@pie.co.jp

印刷・製本　シナノ印刷株式会社

©2019 Atsushi Taniguchi / PIE International
ISBN 978-4-7562-5180-0 C2077
Printed in Japan

本書の収録内容の無断転載・複写・複製等を禁じます。
ご注文、乱丁・落丁本の交換等に関するお問い合わせは、小社までご連絡ください。